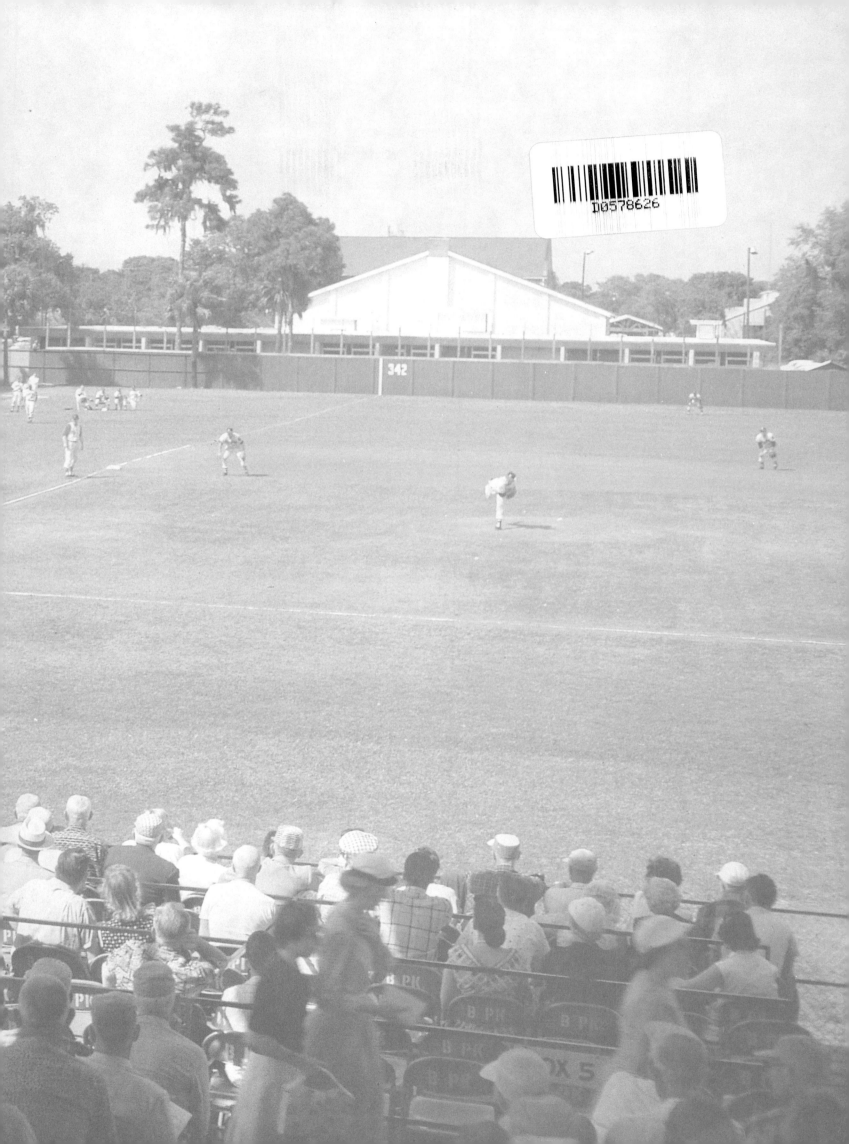

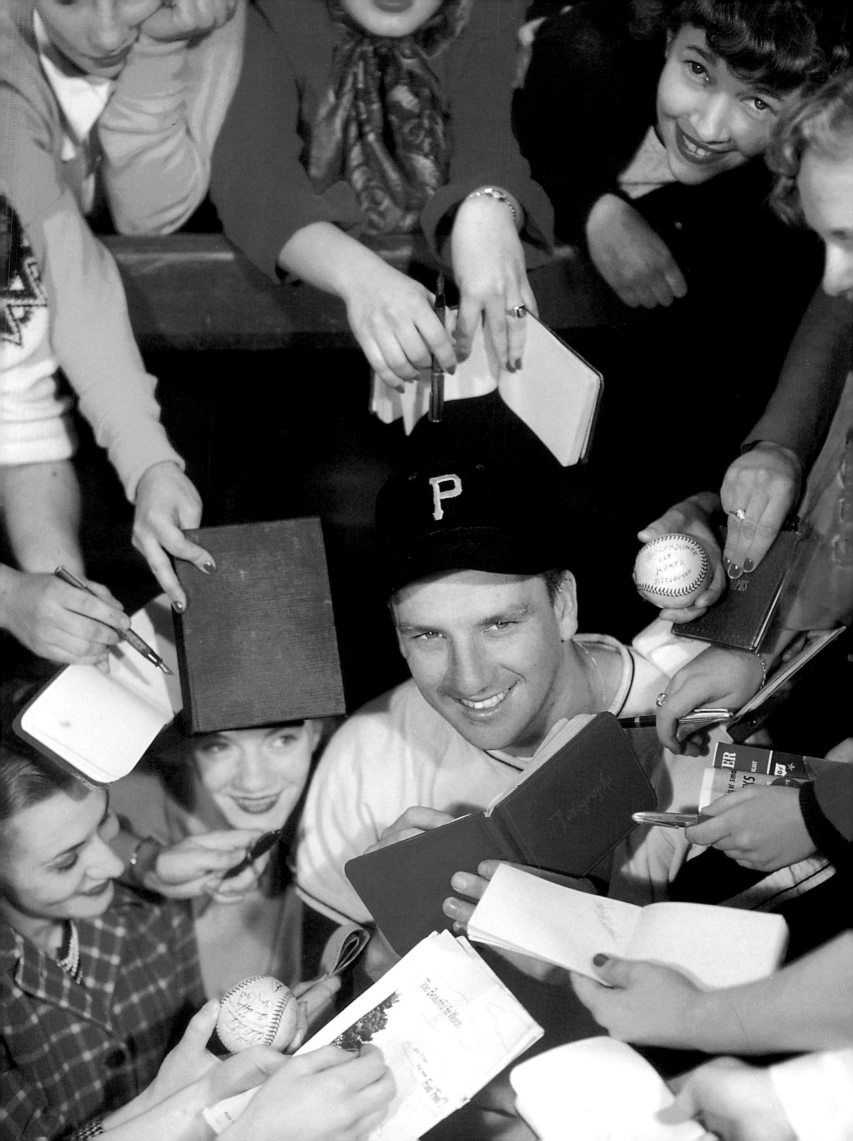

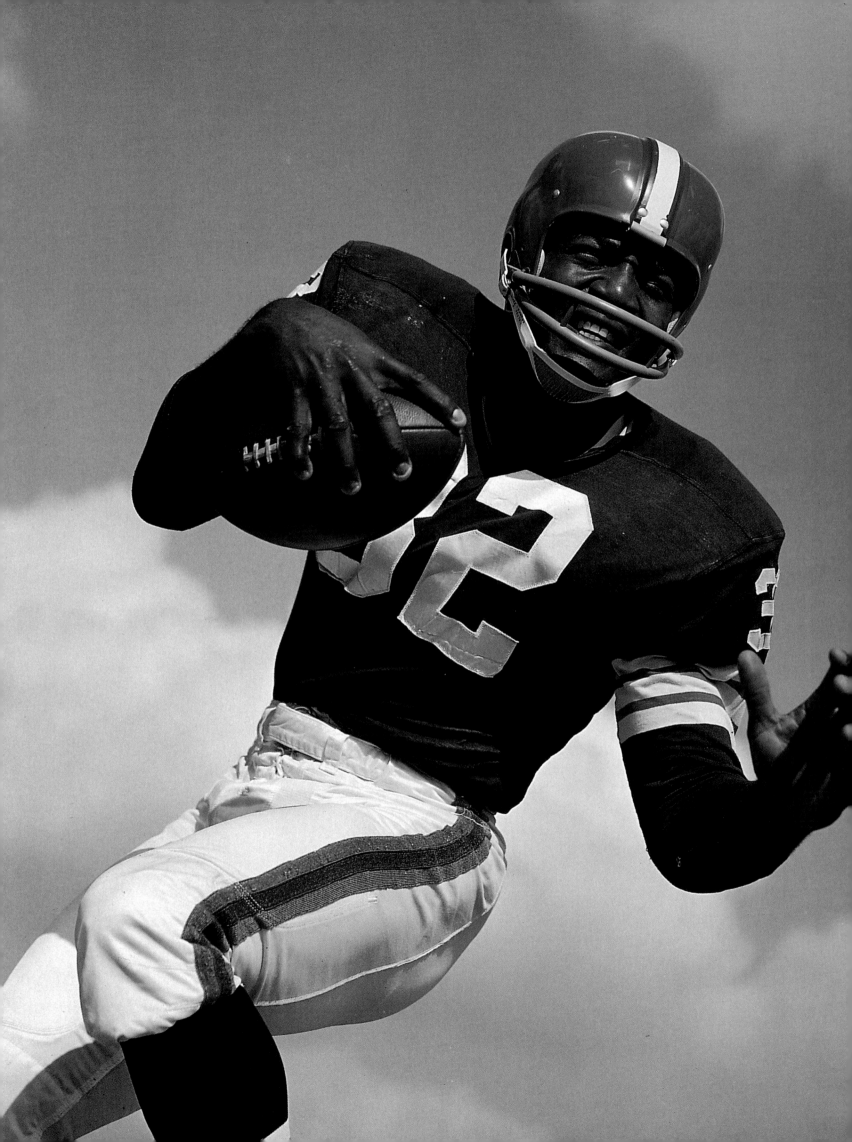

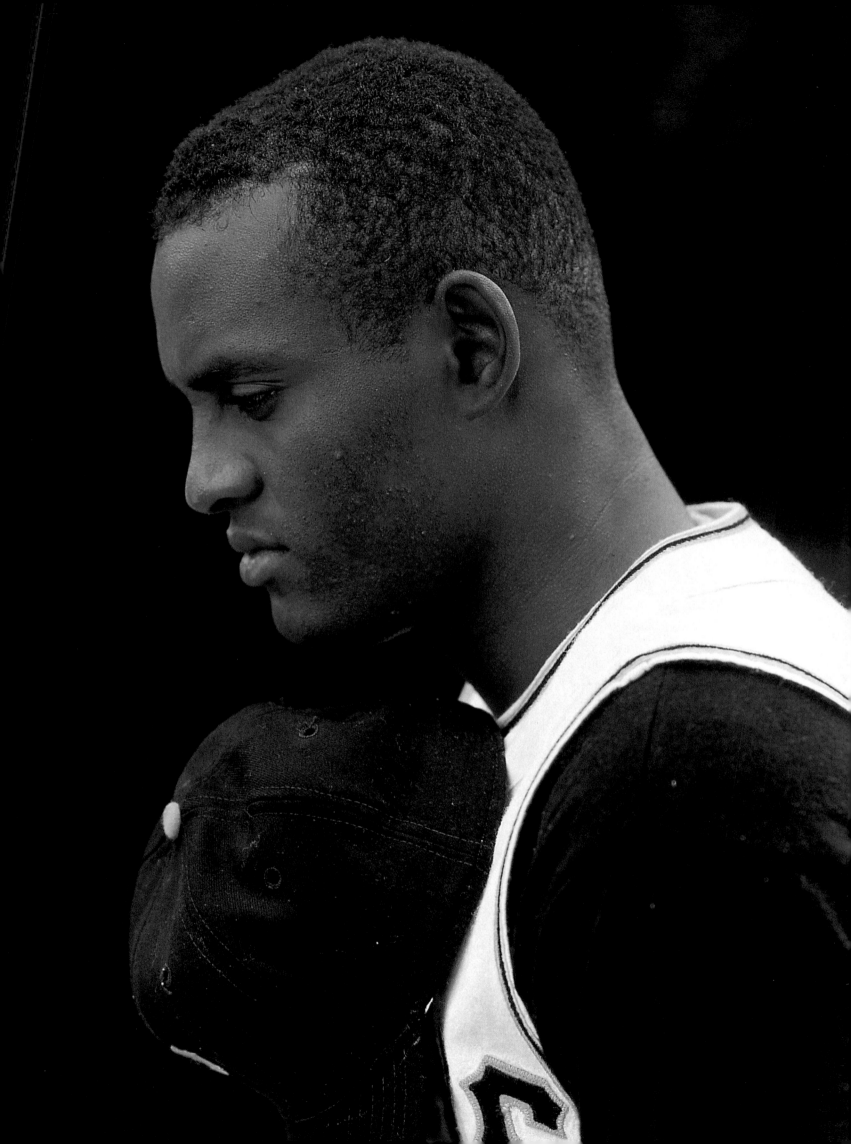

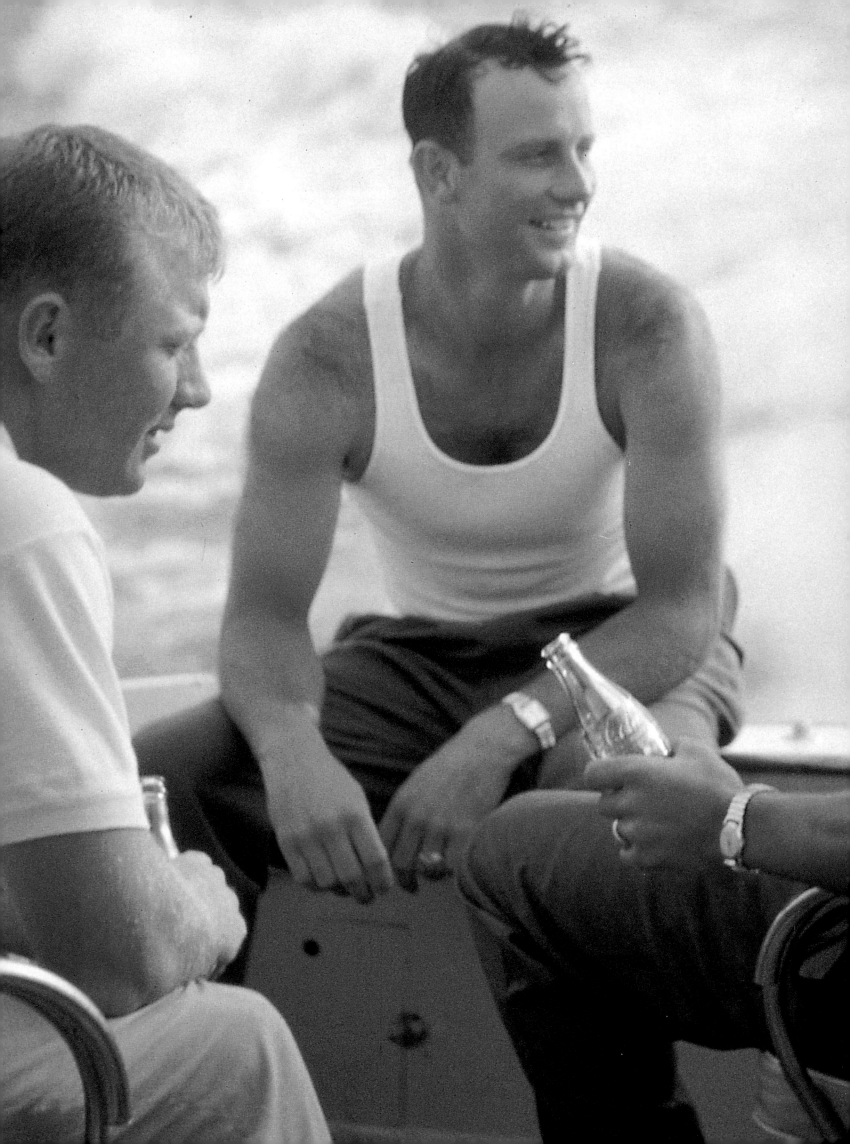

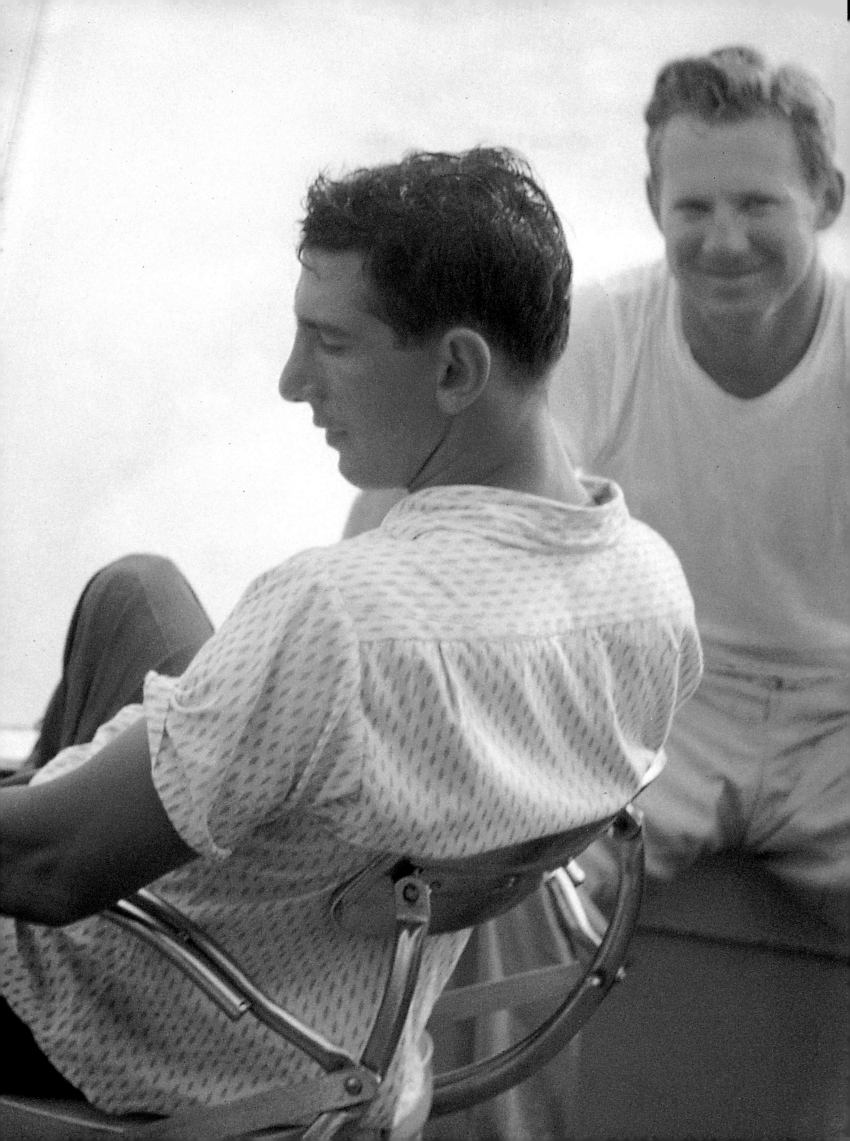

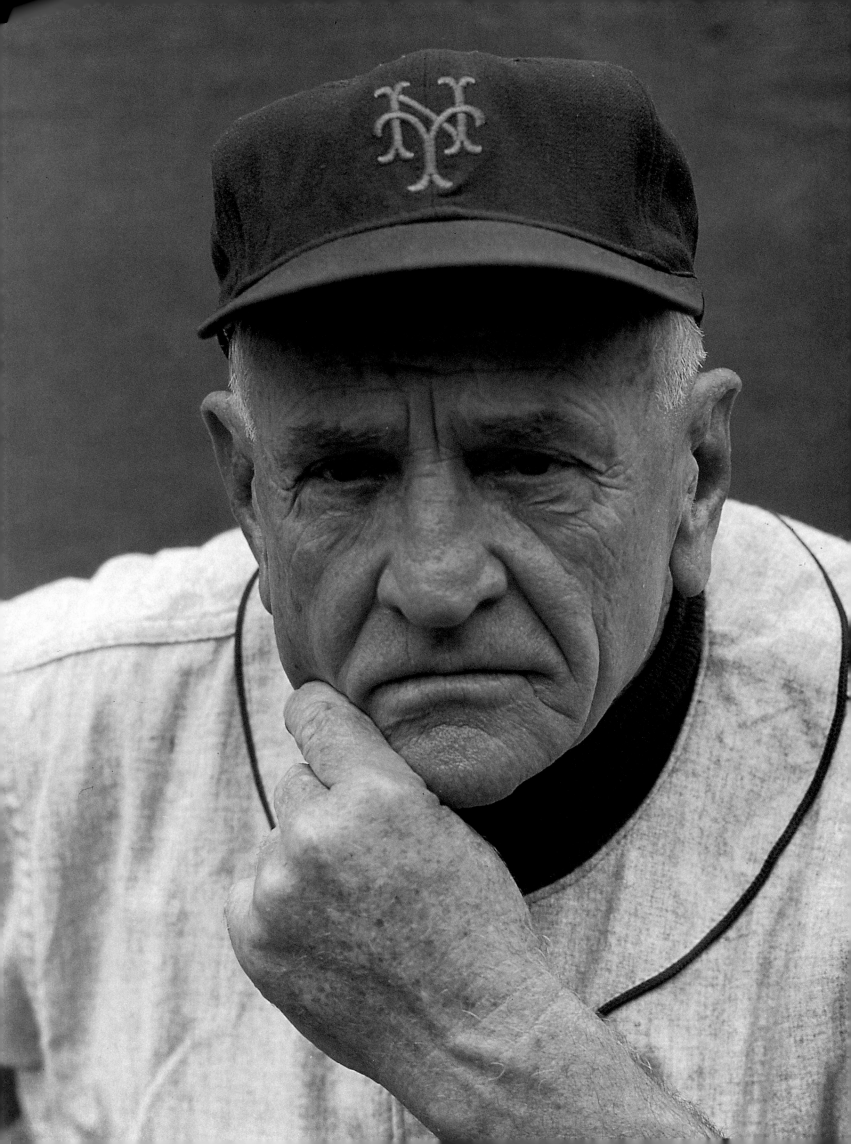

LEGENDS OF THE FIELD

THE CLASSIC SPORTS PHOTOGRAPHY OF

Ozzie Sweet

TEXT BY

Steve Wulf

INTRODUCTION BY

Ed Fitzgerald

DESIGN BY JOSEPH RUTT

VIKING
STUDIO
BOOKS

PAGE 1: Pirate slugger and heartthrob Ralph Kiner

PAGE 2: The Browns' great running back Jim Brown

PAGE 3: Pirate Roberto Clemente, shortly before his death

PAGES 4–5: Yankees Mickey Mantle, Bob Grim, Billy Martin, and Whitey Ford on a fishing trip

PAGE 6: The Old Perfesser, Mets manager Casey Stengel

VIKING STUDIO BOOKS
Published by the Penguin Group
Penguin Books USA Inc.,
375 Hudson Street,
New York, New York 10014, U.S.A.
Penguin Books Ltd, 27 Wrights Lane,
London W8 5TZ, England
Penguin Books Australia Ltd, Ringwood,
Victoria, Australia
Penguin Books Canada Ltd, 10 Alcorn Avenue,
Toronto, Ontario, Canada M4V 3B2
Penguin Books (N.Z.) Ltd, 182–190 Wairau Road,
Auckland 10, New Zealand

Penguin Books Ltd, Registered Offices:
Harmondsworth, Middlesex, England

First published in 1993 by Viking Penguin,
a division of Penguin Books USA Inc.

1 3 5 7 9 10 8 6 4 2

Grateful acknowledgment is made for permission to reproduce the following works:
Magazine cover featuring photographs of Lou Boudreau and Joe Gordon (page 18)
and Bob Feller (page 25) from *Sport Magazine*. © Sport Magazine.
Magazine cover featuring photograph of Bob Feller (page 23)
from *Newsweek*, June 2, 1947. © 1947 Newsweek, Inc.
All rights reserved. Used by permission.

Wulf, Steve.
Legends of the field : the classic sports photography of Ozzie Sweet /
text by Steve Wulf : introduction by Ed Fitzgerald : design by Joseph Rutt.
p. cm.
ISBN 0-670-84826-3
1. Sports—History—20th century—Pictorial works. 2. Athletes—Portraits.
I. Sweet, Ozzie. II. Title.
GV576.W85 1993 93–1307
796'.022—dc20

Printed in the United States of America
Set in Goudy

Designed by Joseph Rutt

To my wife, Diane, my two daughters, Pamela and Linnea, and my son, Blair, who were always loving and supportive and helped me on hundreds of assignments through the years

$Contents$

A LEGEND IN HIS FIELD

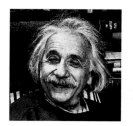

OZZIE SWEET

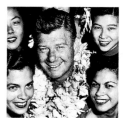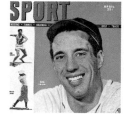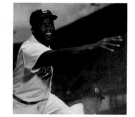

SPRING TRAINING

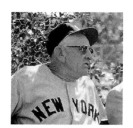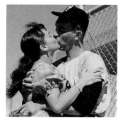

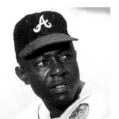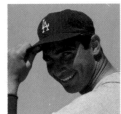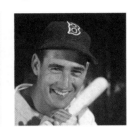
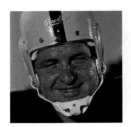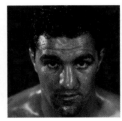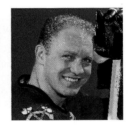

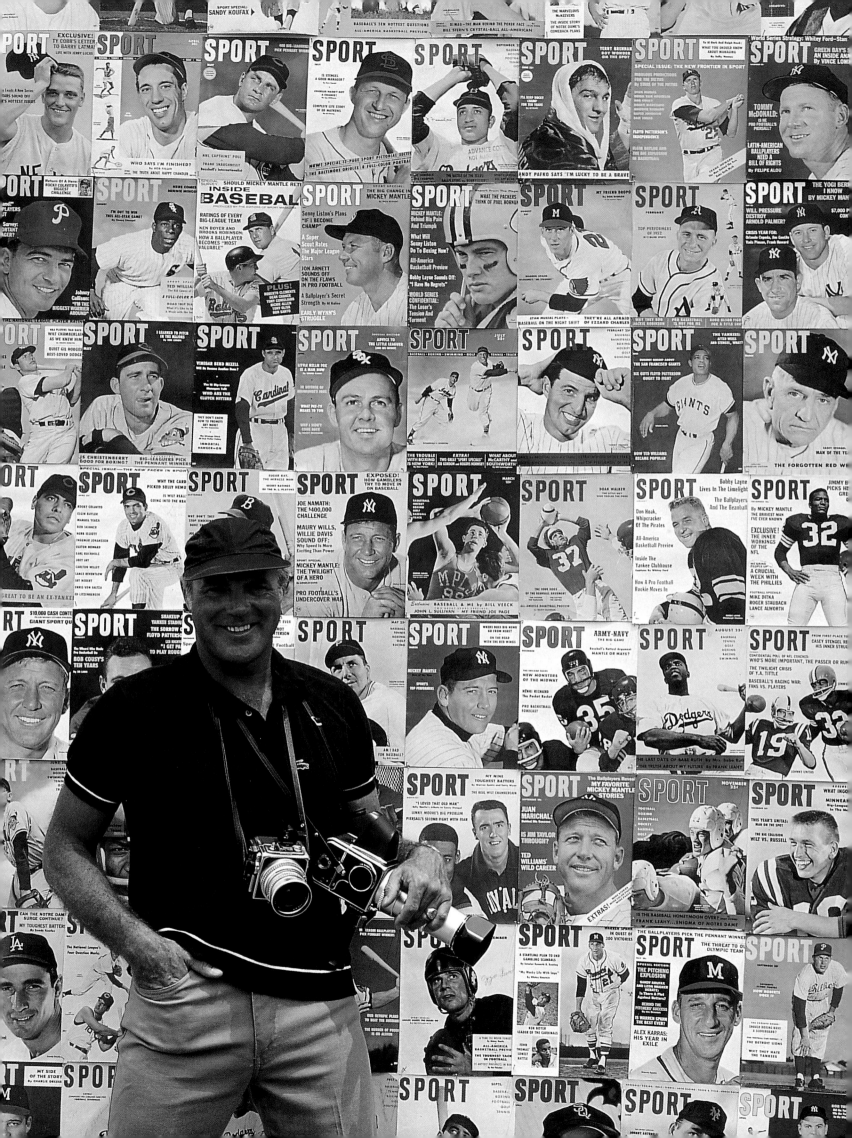

A Legend in His Field

BY STEVE WULF

Walls of fame we called them. Some thirty years ago, my friends and I would cut out these wonderfully colorful, colorfully wonderful pictures of athletes from *SPORT* magazine and tape them up in our bedrooms. Our own particular shrines were in Troy, N.Y., but there must have been countless numbers of kids in countless numbers of towns across America who did much the same thing.

I can still see my wall, with the top row devoted to my beloved Phillies: Johnny Callison, Jim Bunning, Richie Allen. There was, of course, the Yankee row (Mickey Mantle, Roger Maris, Yogi Berra), but there were other trios of total strangers—a row of Bobby Hull, Floyd Patterson, Gene Littler comes to mind. I would glance over while doing my homework and imagine Floyd talking to Bobby about fighting, or Bobby talking to Gene about their comparative stickwork.

That was the one thing all of the pictures had in common: they were alive. There was an almost palpable feeling of celebration in each of the subjects, a joy and delight in their calling that they were quite willing to share with us. Long before color television became a household staple, long before autographs became a big deal, these pictures were the connection between them and us. The extra-ordinarily vivid colors and sometimes preposterous poses helped put us on the field with them. But more important, the photographer had, as if by magic, captured the essence of the hero.

Make that two things all the pictures had in common. The photographer was Ozzie Sweet.

OPPOSITE: Ozzie with his wall of fame circa 1970 (Photo by Nick Scutti)

13

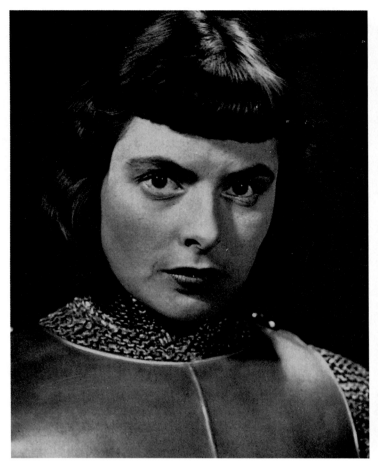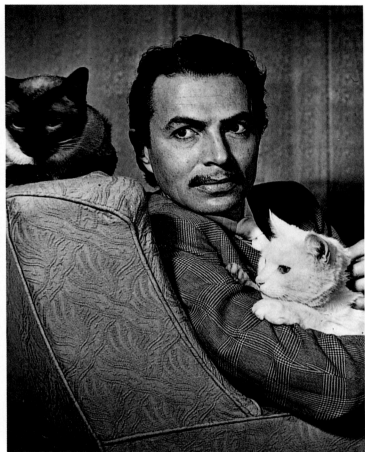

The name itself had a kind of magic to it. The land of this Oz was peopled by Ted Williams and Ted Kluszewski, Sandy Koufax and Rocky Colavito, Jimmy Brown and Bill White. And a sweet land it was. We could look at one of the photographs and feel the warmth of the sunshine, smell the liniment, listen to the chatter around the batting cage.

Back then Ozzie was just a name to us. Little did we know that he was living a life equally magical. In later years, I came to know Ozzie, and marvel in a man whose own story reads like fiction. In fact, he grew up as a sort of Huck Finn, rafting through the Adirondacks before dropping anchor in Hollywood. He acted in B Westerns alongside John Wayne and Hopalong Cassidy until the Army—and photography—called. Before too long, he was posing Ingrid Bergman and James Mason for *Newsweek*.

In his fifty years as a shooter, Ozzie has photographed more celebrities than you can possibly imagine. Why, two of his scalps

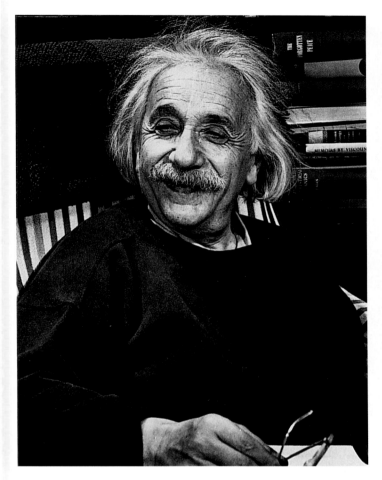

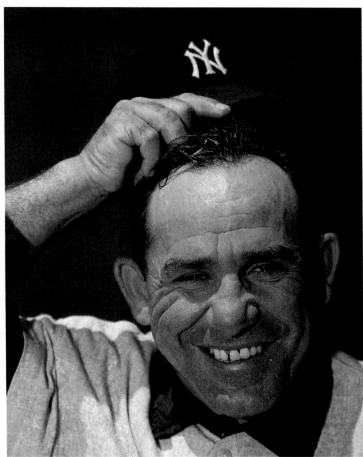

ABOVE, LEFT: Albert Einstein, genius, photographed by Ozzie Sweet

ABOVE, RIGHT: Yogi Berra, genius, photographed by Ozzie Sweet

were two of the greatest minds of the twentieth century, namely Albert Einstein and Yogi Berra. That about says it all.

But there's more. Ozzie once made a deal with a young Philadelphia model, promising her 10 percent of any of the money her pictures might bring. In later years, Ozzie scrupulously sent the money—true royalty checks—to Princess Grace of Monaco. And, he is happy to report, the former Miss Kelly cashed them.

Much more. Ozzie Sweet's photographs have appeared on hundreds of magazine covers ranging from *Boy's Life* to *Playboy*, from *Ebony* to *Argosy*. Ozzie does antique auto calendars, hotel brochures and cat calendars. For a while, he practically owned the giant Kodak Colorama in Grand Central Station. His wildlife books are highly acclaimed in the nation's libraries, while his pinups are very popular in America's garages.

When Sylvester Stallone was in knee pants, Ozzie had already shot Rockys I, II and III (Marciano, Graziano, and Colavito). He has

two Presidents (Eisenhower and Hoover), two Dukes (Snider and John Wayne), the aforementioned Princess, a Pope (John Paul II) and The Man (Stan Musial). Ozzie has posed two Nobel novelists (Ernest Hemingway and Sinclair Lewis), as well as these men of letters: Cecil B., Tony C., Joe D., Edward G., John L., the Big O and Pee Wee. He can even slip you two Mickeys (Mantle and Rooney).

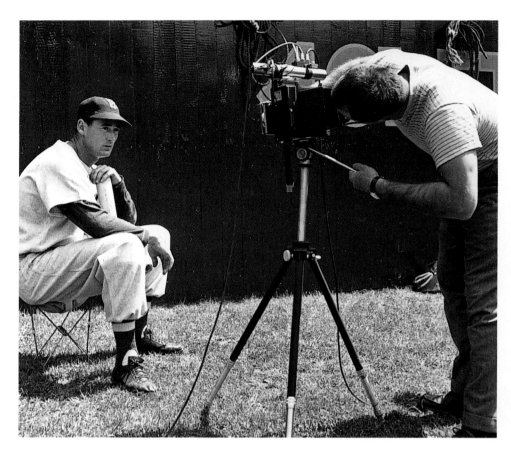

And Ozzie probably made friends with all of them. Oh, there was a female moose who charged him in the Alaska wilderness, but even then, Ozzie got a kick out of it. "I looked at the bull moose she was with, fully expecting him to charge," he recalls. "He didn't though. I believe I detected him smiling." Ozzie could always get a smile out of even the toughest customers: Andrei Gromyko, Arthur Godfrey, Ted Williams. The Splendid Splinter, who was often gruff with reporters and photographers, jilted Ozzie three days in a row. Finally, on the fourth day, Williams said, "You sure are persistent. Let's do it." As Ozzie recalls, "Once he warmed to the camera, he was great. We talked about fishing, of course, but it turns out Ted also had a keen interest in photography. His father, in fact, had been a commercial photographer."

Even the seemingly serious Albert Einstein responded to the Sweet magic. Ozzie found him to be delightful, and as the picture on page 15 shows, vice versa. "What a jolly man," Ozzie recalls. "He would walk around Princeton campus in an old gray sweatshirt and unlaced Oxford shoes. The backs of the shoes were totally broken down because he would just slip his feet in. When you're preoccupied with relativity, shoelaces don't matter."

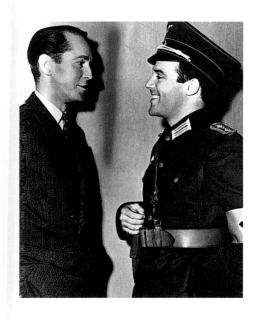

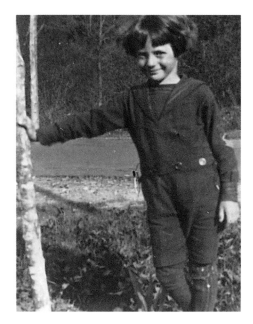

ABOVE: Ozzie, in Nazi uniform, with Franchot Tone

RIGHT: Ozzie, as a boy in the Adirondacks, snapped by Aunt Edna with a $3 box Brownie camera

BELOW: Ozzie astride one of his Hollywood horses

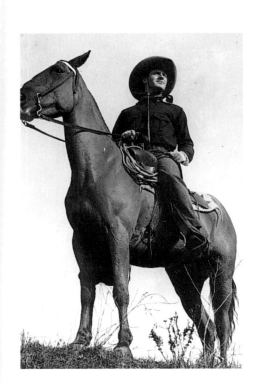

Ozzie operated by his own Theory of Relativity. He simply related to his subjects, thanks to his storehouse of experiences and his storytelling ability. Growing up on the farm in Elizabethtown, N.Y. Going to school in a one-room schoolhouse, lunching on venison sandwiches. Waving to the bootleggers as they sped from Montreal to Albany. Selling his mother's flowers to the summer folk in Lake Placid. Camping out on the raft he built from the planks of an old bridge. Walking seven miles home in the winter after his high-school basketball games. Getting chased by a bear while picking blueberries. "The bear caught up to me," Ozzie will say with a straight face, drawing in his listener. "I stuck my hand inside his mouth, reached as far as I could, all the way to the tail, and pulled him inside out. The bear ran off the other way." And then Ozzie will apologize for being so corny.

Ozzie's first grand ambition was to become a sculptor in the style of Gutzon Borglum, the artist of Mount Rushmore. If you come across an Indian chief carved into the rocks near New Russia, N.Y., that's Ozzie's. So he went west in 1938 to study sculpture and photography at the Los Angeles Art Center. Partly because his given name is Oscar, and partly because he had matinee idol looks, he caught the acting bug. In order to catch the attention of Cecil B. DeMille, he once pitched a tent in the Paramount parking lot. He stayed there twenty-four nights, until C.B. gave him a part as a pirate in *Reap the Wild Wind*. Ozzie also made a good cowboy, riding with William Boyd and John Wayne, and a bad Nazi opposite Franchot Tone. To this day, he's kept his Screen Actors Guild membership—and his looks.

Because the other side of the camera also appealed to Ozzie, he started taking professional pictures while he was stationed in the

Signal Corps in Southern California. His first magazine cover appeared on the October 12, 1942, issue of *Newsweek*. Under the billing "Train Right to Win the Fight," there was a picture of a GI from Camp Callan with a knife in his teeth. Ozzie actually went over the head of a superior officer to send the photo in, but the response was so overwhelmingly positive that the officer gulped down his crow. While Ozzie was in the service from '42 to '47, he regularly shot *Newsweek* covers. But it wasn't until June 2, 1947, that he had his first sports cover, a tight shot of Cleveland pitcher Bob Feller in his windup. That picture opened a whole new world for Ozzie because it caught the eyes of the editors of *SPORT*.

Perhaps the most amazing thing about Ozzie's career is that, except for the few years when he was on the staff of *Newsweek*, he has been his own master. That has enabled him to photograph almost everything under the sun, from "The Girls of New England" (for *Playboy*) to the Eskimos of Alaska (for *National Geographic*). And he is as proud of his covers for *Successful Farming* as he is of his *SPORT* covers. "The real trick," he says, "to successful night shooting on a dairy farm is not to let the moist milking parlors short out your lighting equipment."

Because he is still a mountain boy at heart, Ozzie lives in Francestown, New Hampshire, in an eighteenth-century farmhouse and barn lovingly restored by him and Diane, his beautiful wife and occasional model. "There are no ghosts in the house," says Ozzie, "which is something of a disappointment to us." The Sweets maintain a hectic schedule, shooting cats, cars, caribou, calendars, and covers. About the only concession Ozzie has made to his age, now seventy-four, is his recent retirement as a local volunteer fireman.

In his studio, upstairs in the barn, Ozzie proudly displays a wartime photo of three downed airmen in a life raft. They are hurt and exhausted, and one of them is looking to the heavens, a soggy Bible in his hands. The tableau is a fake. The airmen were actually friends of Ozzie who could hardly keep from laughing, and the North Atlantic was just Tampa Bay.

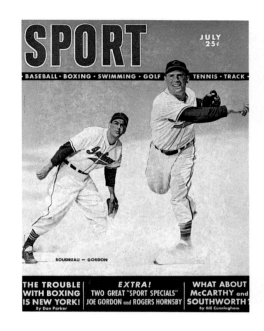

ABOVE: Indians double-play combo Lou Boudreau and Joe Gordon

BELOW: Ozzie and his wife, Diane, in a recent photo.

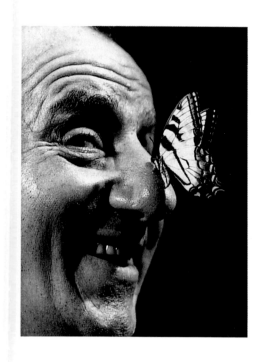

ABOVE: Jimmy Durante and friend

BELOW: Jackie Robinson simulates a slide

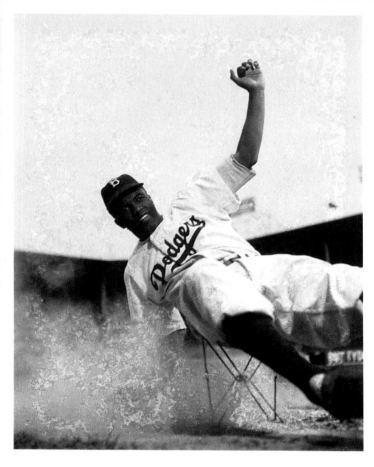

But the picture works, in much the same way that a movie works, and it shows off the genius of Ozzie. He is almost as much magician as photographer, and he regularly applies his sleight of hand to his photos, whether they be of celebrities, wildlife, or athletes. He once shot a picture of Jimmy Durante with a Monarch butterfly poised on Jimmy's schnozzola. The butterfly is, of course, a specimen glued to Durante's nose, but the photo is so delightful that, hey, who cares?

Ozzie used to defy his outdoors magazine editors to tell him which of his deer were real and which were stuffed. (He keeps an ace taxidermist on call.) His biggest bag of tricks, though, was reserved for harder sports like baseball and football. He would create these elaborate, Rube Goldbergian setups to simulate, say, Jackie Robinson sliding into second base. In reality, Jackie would be propped up on a specially built stool while Ozzie's assistant threw ashes at the Dodger's feet to make it look like flying dirt. His favorite tool was fishing leader, which he used to suspend balls, bats, masks, whatever. He even kids that he suspended Maury Wills by fishing line in the picture on page 86. (Actually Ozzie was lying on the ground while Wills jumped in the air.) Sometimes his tricks were as simple as tilting his trusty, Mathew Brady-like View Camera.

And sometimes, there was no trick at all. That marvelous picture on pages 4–5 is really Mickey Mantle et al. on a fishing trip off St. Petersburg, and that's really Willie Mays in his actual robe with his actual wife in his actual home (page 61). They're all having a good time because just being with Ozzie is a good time. "I know I'm a Pollyanna," he says. "I just believe in making the most of every day, trying to be as happy as you can, and keeping everybody around you happy." Or, to put it another way, "I'm a great believer in harmony."

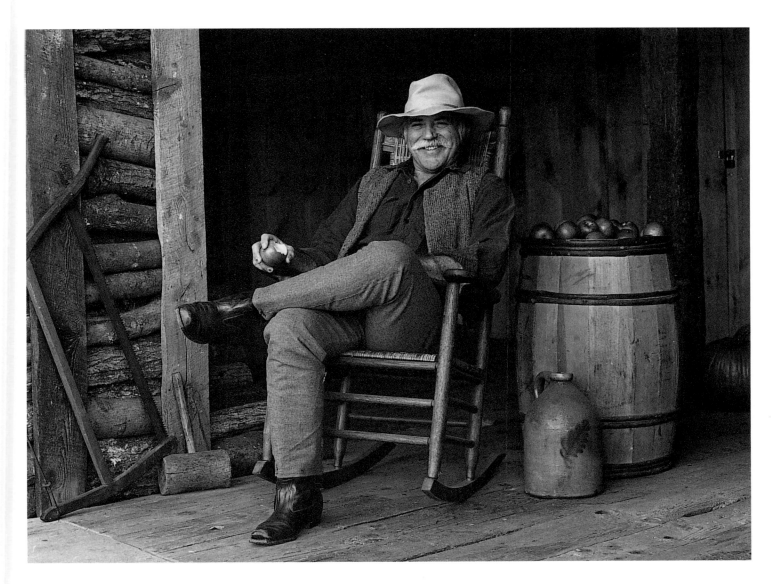

OPPOSITE: Ozzie and equipment 1954 (Photo by Nick Scutti)

ABOVE: Ozzie at home in New Hampshire, 1992, photographed by Diane Sweet

Which brings us back to the harmony of faces on my old bedroom wall. Somewhere along the line, and for some forgotten reason, I took the pictures down. It had been a great regret of mine that I didn't somehow preserve the wall, not only for myself, but for my children. Maybe it was the era, maybe it was Ozzie, but the stars sure seemed to shine brighter then.

That's the great thing about this book: Our walls of fame have been restored.

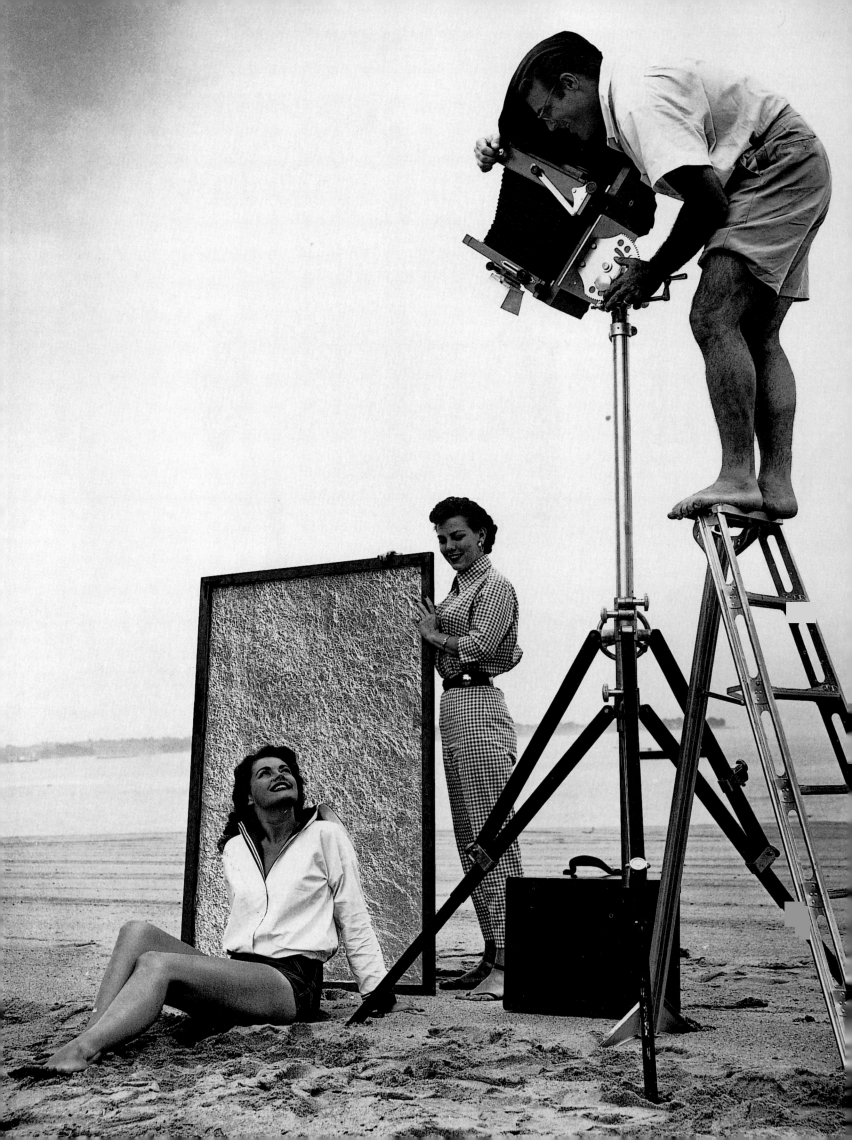

Ozzie Sweet

BY ED FITZGERALD

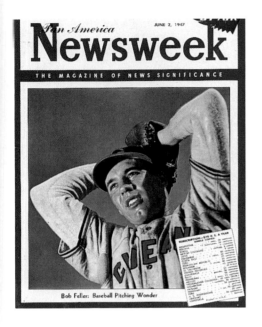

ABOVE: Bob Feller in 1947, Ozzie's first sports cover

OPPOSITE: Ozzie shoots actress Barbara Darrow for *True Story* magazine (Photo by Nick Scutti)

*W*hen you haven't seen somebody in over thirty years, it's natural to feel a little apprehensive when you're on your way to meet him. Ozzie Sweet had agreed to pick me up in the lobby of The Ritz-Carlton in Boston early on a fall morning in 1992, and when I walked out of the elevator coming down from my room I suddenly realized that it was going to be embarrassing if I walked right past him without recognizing him. We had been pretty close once. But the second I looked out into that beautiful lobby, I saw him. His hair was white and he weighed a few more pounds, but there was no doubt that the man standing at the front desk was Oscar Cowan Sweet. In his flannel shirt, jeans, and boots, he looked like one of the Ritz's guests who had just come back from a skiing trip to Vermont. The only thing different was that he didn't have a Hasselblad hanging over his shoulder.

Camera or no camera, this was the person who had taken hundreds of color cover pictures for me when I was editor-in-chief of *SPORT* Magazine in the 1940s and 1950s, who had supplied the photographs for hundreds of magazine covers overall, and who had seen a proud two dozen of his pictures blown up to a dominating 60 feet by 18 feet for the Eastman Kodak Colorama high over the main concourse of Grand Central Terminal in New York City. This was the Ozzie Sweet who had no peer as the portrait photographer of sports heroes.

My time with Ozzie began when I saw a stunning color portrait of Bob Feller on the cover of the June 2, 1947, issue of *Newsweek*. It was Feller to the life, half farmboy and half arrogant

big-leaguer. In those days, we were using mostly wire-service photographers for *SPORT*'s covers, and one of my ambitions was to persuade an established cover specialist to work for us. We wanted our new magazine to be the best looking as well as the best written periodical on the stands, and clearly Ozzie had the talent to help us achieve our goal. I called Ozzie to ask him if he had any time he could give us. He said that time was no problem. "But I don't know anything about sports," he told me in my first experience with the uncompromising Sweet candor. "That doesn't matter," I said, "you know how to take pictures of people, and that's what we want."

ABOVE: Thanks for this memorable shot of Bob Hope

I didn't know the half of it. When I sat down to lunch with Ozzie a couple of blocks from our 42nd Street offices and he showed me some of the pictures he had taken for *Newsweek*, I was satisfied I had made a great catch. *Newsweek* had hired him specifically to shoot covers after he had done some for them during the war when he was a photography officer in the Air Corps. He pulled out cover pictures of celebrities from Princess Grace and Arthur Godfrey to Ernest Hemingway and the Pope. He said he had done most of God-

BELOW: Arthur Godfrey amid the flora of Hawaii

frey's advertising and promotion photography; Godfrey was then king of morning television. Ozzie, I soon learned, could get along with anybody. What it came down to was that he liked people and people liked him. That's a priceless asset for a professional photographer who makes a living asking busy people to let him take pictures of them.

In those days, we were a small tight crew working on

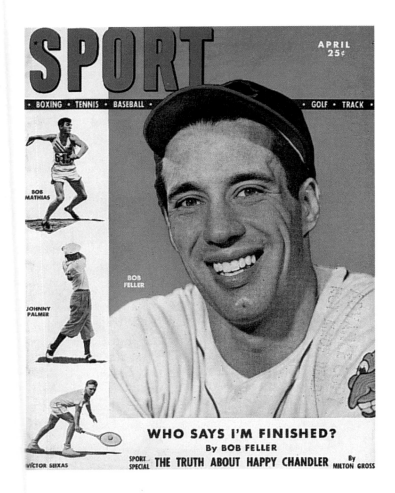

ABOVE: Bob Feller posed again for
Ozzie, this time for *SPORT*

SPORT Magazine, long before *Sports Illustrated.* Irv Goodman, who went on to become president of the Viking Press; Al Silverman, who became president of the Book-of-the-Month Club; and Jack Newcombe, who went on to become an editor at *Life*, each loved Ozzie as much as I did, and we were all grateful to him for helping us realize our dream of what our magazine ought to look like.

Ozzie produced dozens of covers for *SPORT*. Most of those photographs were shot with a cumbersome but incredibly effective View camera. Ozzie lugged his heavy equipment from Ebbets Field in Brooklyn to the Rose Bowl in Pasadena. Along the way, he charmed some of the most famous athletes into patiently posing for him over and over again. As soon as Ozzie was finished they would say, "Don't forget to send the picture," and Ozzie never forgot to send it.

Ozzie combined technical skill with creative virtuosity, but his true talent, the spark that fired his genius, was his buoyant personality. Like Will Rogers, Ozzie never met a man he didn't like, or a woman either, and he could charm the birds out of the trees. Even if you were a reluctant subject who began the session grumbling that you had a million better things to do than pose for another batch of pictures by another pushy photographer, you ended up being Ozzie's friend. That was why, when he walked into Mickey Mantle's restaurant in New York City not long after our reunion in Boston and asked Mickey to sign a set of prints for him, Mickey said, "Be glad to, Ozzie, as long as you sign a set for me." How many times does a Hall of Fame ballplayer ask a photographer for *his* autograph?

Ozzie went way back with Mickey. He had taken pictures of him from the time he first arrived in the Yankees' spring training

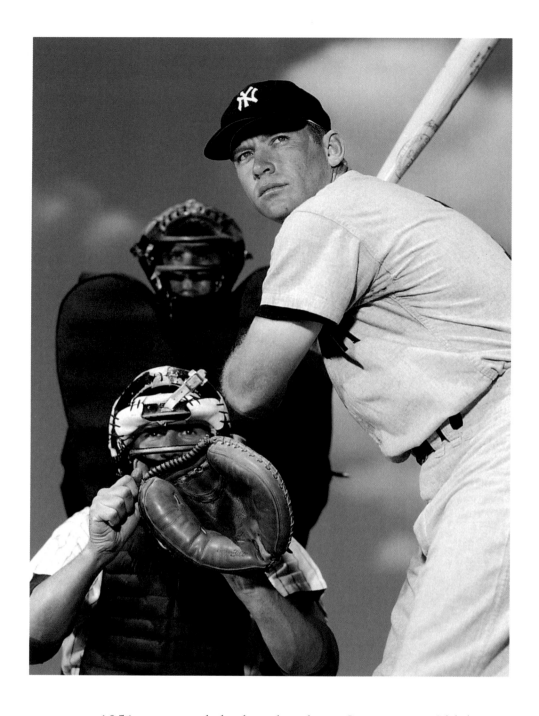

camp in 1951, an unpolished rookie from Commerce, Oklahoma, who had the God-given ability to run like the wind and smash the baseball out of sight. Ozzie knew that it was his job to put on film the wide-eyed innocence, the Huck Finn quality that made everybody like Mickey as much as they admired him. He took wonderful pictures of Mickey, as you'll see in the pages that follow.

It was a fact that you could tell an Ozzie Sweet portrait a mile away. The subject's eyes looked right at you, and they had expression. What you saw was not just the image, but the man inside, whether he was a pink-cheeked boy like the young Whitey Ford or a seamed

RIGHT: Frank Robinson warms up to Ozzie

veteran like Sal Maglie. There was never anything flat about one of Ozzie's pictures. They had the blood of life in them. He even got Frank Robinson, in his early years the sullen slugger of the Cincinnati Reds, to break out into a dazzling smile for the camera.

It's a measure of how much I thought of Ozzie that the first color portrait he shot for us was of Jackie Robinson. I suspended my editor's objectivity when it came to Jack. I admired him unreservedly, and I liked him even more. Jack Roosevelt Robinson, the first African American ever to play in the major leagues, was the heart and soul of the Brooklyn Dodgers in those years after World War II. I wasn't go-

ing to ask him to pose for any photographer I didn't have total confidence in. Ozzie came back with pictures of Jack, and you could feel the pulsing humanity in him, the sensitivity and awareness of the man. I wasn't surprised when, ten years later, while my wife, Liby, and I visited the Robinsons in their beautiful home in Connecticut, I saw that one of Ozzie's portraits of Jack was in their living room. It made me feel good.

Jackie Robinson was a part of my favorite Dodger picture. It appeared on the cover of *SPORT*'s October 1952 issue (opposite, above). I asked Ozzie to simulate a Reese-Robinson double play, and as usual, he talked the ballplayers into trying it. He set up shop at second base in Ebbets Field, and after some experimenting, they all decided that the best bet was to have Pee Wee Reese crouch down in the dirt as though he had just grabbed a ground ball and had tossed it to Robinson. Jackie gave an Academy Award performance phantom double play. Time after time Jack leaped up in the air and faked a strong throw to first while Pee Wee watched with appropriate tension. They were troopers. Everybody loved the picture, and almost everyone in the Brooklyn clubhouse—and the front office too—asked for a print of that one. I always felt a special glow of pleasure knowing that our Reese-Robinson double play picture was pinned to the walls of the bedrooms of small boys and grown men all over the borough of Brooklyn.

Brooklyn wasn't the only town where boys' rooms were decorated with Ozzie Sweet pictures. The magazine got letters by the thousand, sometimes with pictures of the room, thanking us for the precious photographs. It's anybody's guess how many of them were signed by good-natured stars badgered for their autographs by boys who waited hungrily for their idols by the players' entrance or the door to the team bus.

ABOVE: Jackie Robinson and his wife, Rachel, at home

OPPOSITE, ABOVE: Jackie and Pee Wee Reese at Ebbets Field

OPPOSITE, BELOW: Former dentist Casey Stengel bares his teeth

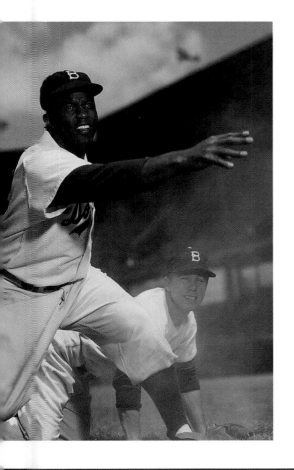

Looking at one of Ozzie's pictures of one of the headline performers of the 1950s, I'm reminded of the extravagant care he put into setting up his sittings. Most photographers were happy to pounce on their target whenever they got a chance, grab their pictures quickly and unobtrusively, and get out of there as fast as they could. Not Ozzie. His first visit wasn't for shooting; it was just for getting acquainted. He would ask one of the club officials, or a player he had already worked with, to introduce him to his man. Then he would talk to him in his earnest way about how they should go about making sure they got the best pictures they possibly could. He would enlist the star in a joint effort. The tougher the shot he was after, the more talking Ozzie did before he tried to shoot it. He never asked for any favors for himself, only for help in getting the picture. That's why a master promoter like Casey Stengel was always willing to help him out. "And if you can't get what you want from me," Casey told Ozzie

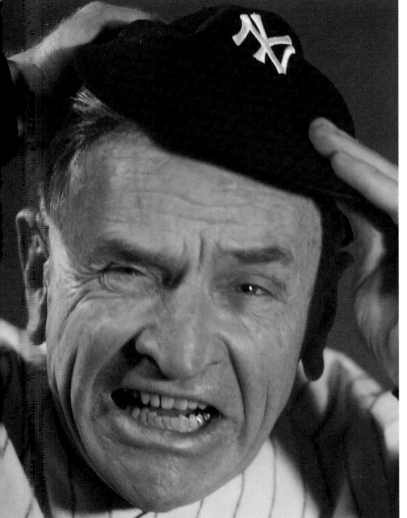

once, "you can always ask my assistant manager over there, which is Mister Berra." Ozzie always figured that what Casey meant was that if Ozzie couldn't find what he wanted in Casey's face, maybe he could find it in Yogi's.

After all that preparation, when he showed up at the ball park with his quaint camera that was so large it made him look like Cecil B. DeMille shooting *The Ten Commandments*, there was no question about taking too much time or asking for too many special effects. Ozzie was the original FX man. Whenever he couldn't think of an idea for a column, Red Smith would shrug his shoulders, squint his eyes, and say, "God will provide." But Ozzie didn't leave it to God. He made all of the arrangements himself, and he made them well in advance.

Sometimes I worked along with Ozz because I was writing a piece on the same athlete, and I saw

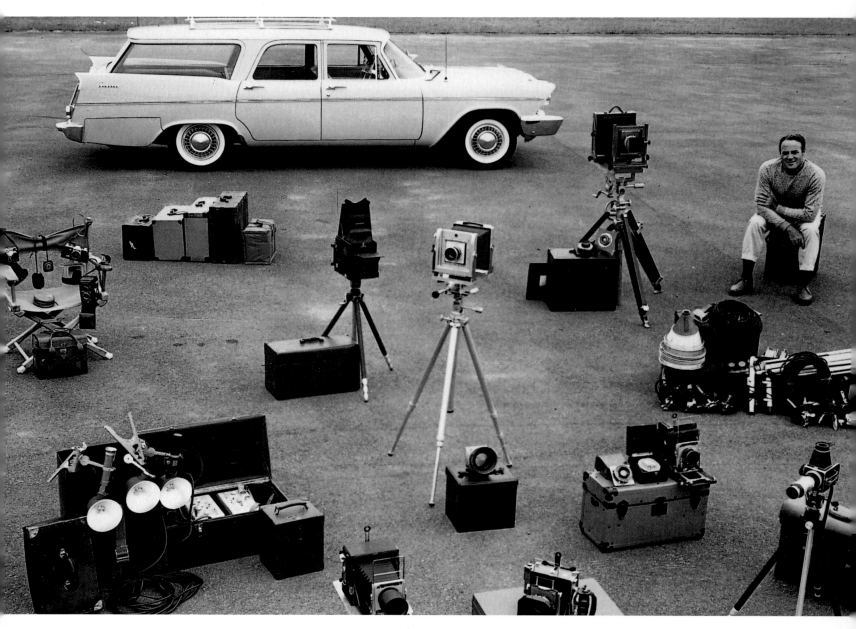

first-hand how smoothly Ozzie conquered the star's natural resistance. Inside of minutes he would be telling him how to get the most out of his own camera, what kind of film to use in different situations, and how to take good color pictures. We worked together on the first cover Ozzie shot for *SPORT*, the March 1949 issue. I was writing the cover story on Ralph Beard of the University of Kentucky. Beard followed Ozzie's directions faithfully and easily and answered my questions the same way. By the time we picked up Ralph's girlfriend and moved on to a college hangout for lunch, not only had Ozzie made many exposures but I was convinced that I had a better story than I ever would if Ozzie's participation hadn't helped encourage the young athlete to reveal himself freely.

Another sports legend we worked with together was Sid Luckman, who was near the end of his Hall of Fame career with the Chicago Bears when we met him and persuaded him to give us any time he could steal from George Halas's tight schedule. I thought Ozzie's exquisite care in setting up what turned out to be portraits of sudden impact had a lot to do with Sid's openness with us. It certainly helped my interview go like a reunion of brothers. Sid talked quietly but unhesitatingly about his love for Sister Mary William of St. Mary's Hospital at the Mayo Clinic, who took care of him when he had a thyroid operation that almost ended his career the year before. "She held my hand all through the operation," he said movingly while Ozzie asked him to put his head down a little. Sid told us about the despair he felt when his father was sent to prison for helping to supply transportation to the Murder, Inc. gang in Brooklyn. He provided me an unforgettable lesson in the importance of treating sports heroes like regular people, and I felt I owed it all to Ozzie.

We shared time with Phil Rizzuto once when the Yankee shortstop was making a personal appearance at a men's clothing store in Newark, N.J. Ozzie's contagious good humor got us through a chaotic scene of teenage girls mobbing Rizzuto while a loudspeaker blared in our ears. Talking steadily all the time, Ozzie got a portrait of Rizzuto looking as relaxed as though all he had to do was think about the lovely .324 batting average he had posted in the 1950 season.

That same year we joined up in Tampa, at the training camp of the Reds to meet the slugging first baseman Ted Kluszewski. While I talked to Klu about how he'd scored the winning touchdown for Indiana over Michigan in the Big Ten championship game, Ozzie got him to push back the short sleeves of his uniform shirt to give even

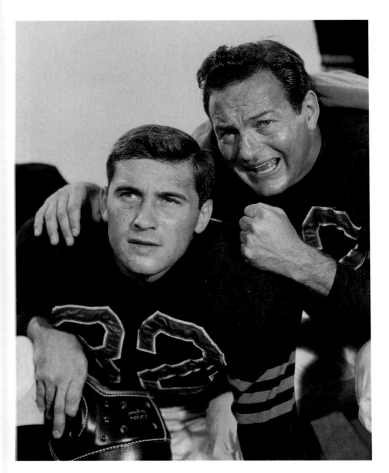

BELOW: Johnny Lujack and Sid Luckman of the Bears

more exposure to his massive biceps. "Nobody's going to have to put a caption on this picture," Ozzie said. "Everybody will know who it is." Klu talked football like an old soldier telling war stories, and Ozzie got his pictures. It turned into another sitting that produced so many good shots that we kept using them until Ted was traded to the Pirates two years later.

It shouldn't be a surprise that Ozzie got on very well with Yogi Berra. He once got Yogi to pose looking up at a face mask that Ozz had suspended with transparent fishing leader. He wanted Yogi to look as though he had just whipped the mask off and was searching the sky for a foul popup. Some of the other players began to laugh at the spectacle of Yogi crouched under the mysteriously floating mask, but Yogi shut them up. "Leave Ozzie alone," he said. "He knows what he's doing." Later, before the start of an all-star game, while most of the ballplayers spent every minute taking pictures of each other, I asked Yogi why he wasn't taking any pictures himself. "I don't need pictures," Yogi said. "I remember it." Thanks to Ozzie Sweet, the rest of us don't have to settle for our memories.

OPPOSITE: Ted Kluszewski, with his muscles and lumber

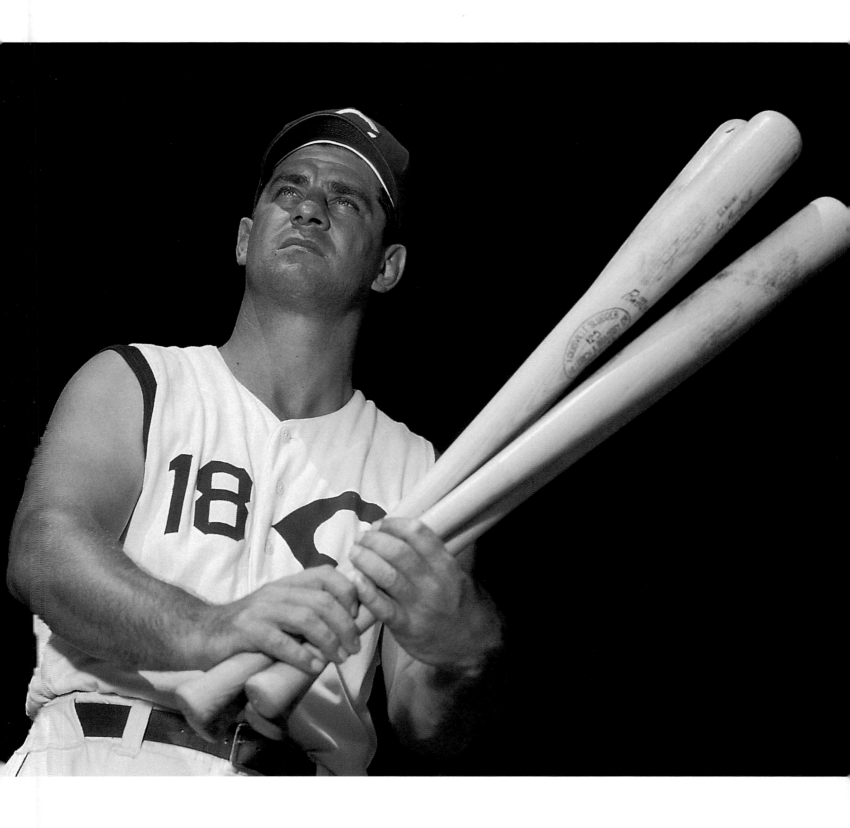

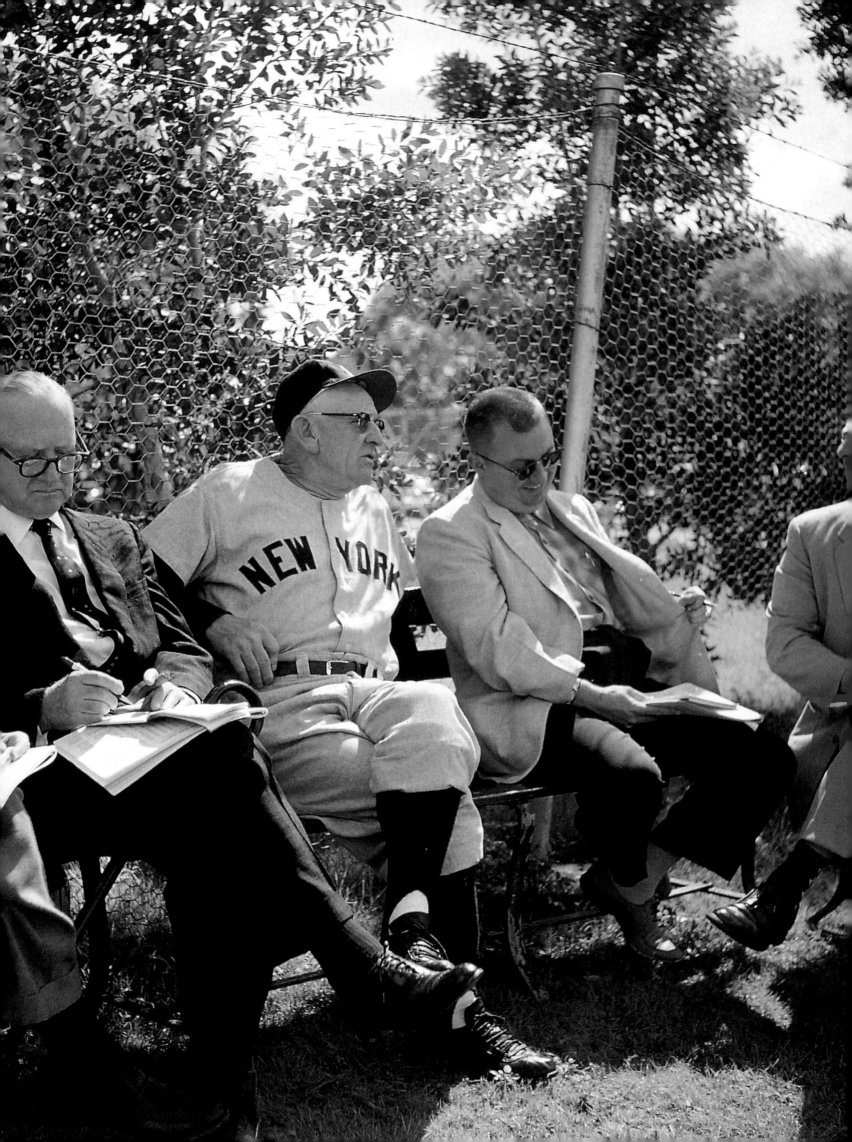

Spring Training

The happiest day of the year for many of us is not Christmas or New Year's or even the Fourth of July. It is that day in mid-February—the heart quickens just thinking about it—when pitchers and catchers report to their respective clubs for spring training. That day means, of course, that the baseball season is upon us.

Actually, there are three seasons to baseball—spring, summer, and fall—and they pay no mind to the calendar. (This is a sport that holds its so-called "winter meetings" in autumn and begins spring training in the winter.) Spring is for those games in Florida and Arizona, summer is for the epic regular season, and fall is for the postseason Classics. Each one naturally has its charms, but baseball people are inordinately fond of spring training. They often joke that it's a shame to have to go and ruin the game by starting the season.

There is a mystique about spring training that puts it in a class by itself. Football has its training camps, grueling two-a-day sessions in the heat of the summer. Basketball and hockey have their preseasons too, but for the most part, they are well-kept secrets. Baseball does it right. The players work, but not too hard, or at least not so hard that they can't go golfing or fishing in their off-hours. Faithful fans can sit in the sun and think that, yes, this might be their year. Sportswriters and photographers can hang around the cage, allegedly on the job, but really just working on their tans. For everyone, there is a wonderful sense of renewal.

The man we have to thank for spring training is Cap Anson, the Hall of Fame first baseman and manager who took his Chicago White Stockings south to Hot Springs, Arkansas, in 1886 to work out the kinks and sweat off the beer. Over the years, teams have

OPPOSITE: Casey Stengel entertains the scribes in St. Pete

trained in such diverse places as Catalina Island, California, and Cape May, New Jersey, but by the late 1920s, most of the teams were migrating to Florida. The Yankees moved to St. Petersburg in 1925, in large part because they found New Orleans to be too tempting for Babe Ruth.

Ozzie Sweet wasn't around for that spring training. But he has seen and photographed many of them, and this section is devoted to his pictures from springs past. The most evocative of the photos are the ones Ozzie took on a fishing boat he chartered for some of his New York Yankee friends. As Ozzie recalls, "I had spent a lot of time with the Yankees in St. Pete, and toward the end of

BELOW: A spring-training lineup

spring training in '56, I invited Billy Martin, Mickey Mantle, Whitey Ford, and Bob Grim to go fishing with me. It was more of a social occasion than a photo assignment, though luckily I did have my camera. We stocked the boat with plenty of beer, soda, and fried chicken, and shoved off from John's Pass on the Gulf.

"Well, we all had a great time. Billy was sort of the master of ceremonies, keeping the conversation and laughter going. I remember that Whitey, who had very fair skin, had to wear this ladies' straw hat because it was the only one we could find on short notice. We had a lot of action—I think everyone got a marlin—but the nicest thing about the day was the camaraderie. We talked about the trip for years afterward. And later that year, *SPORT* ran the pictures."

In 1947, the Cleveland Indians and New York Giants established a new frontier for spring training in Arizona. Trying to decide between Florida and Arizona was not unlike trying to decide between the American League and the National League. Some baseball people are stuck on the Cactus League, others will squeeze the Grapefruit League dry. But both are to be appreciated—nay, cherished.

Arizona not only has dry air and Indian jewelry, but it also has the Pink Pony. For the six weeks of spring training, this restaurant in Scottsdale is something like the center of the baseball universe. Teams in Arizona are more closely clustered than in Florida, so you're liable to see, on any given spring evening, Reggie Jackson and Bill Rigney, Willie Mays and Whitey Herzog. My own personal highlight came the night I heard the hostess say, "Paging Chuck Estrada. Paging Chuck Estrada."

Florida has beaches, seafood, and Dodgertown, where all the streets are named after great Dodgers. One day I was walking along Sandy Koufax Way when the door of one of the motel rooms

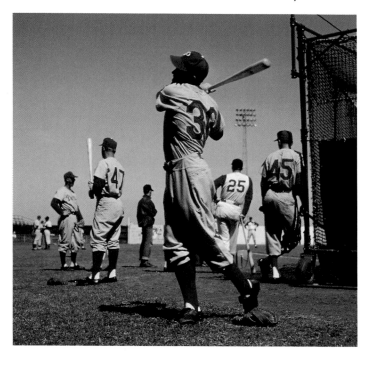

ABOVE: The Phillies and Reds get in the swing

opened and out stepped . . . Sandy Koufax. I turned the corner at Walter Alston Avenue and, lo and behold, ran right into Walter Alston. As if that weren't enough, I took a right on Roy Campanella Drive, and along came a golf cart carrying Roy Campanella. True story.

Another joy of spring training, be it Arizona or Florida, is that early glimpse of greatness. Watching Roger Clemens throw for the first time or spotting an odd-looking rookie named Kirby Puckett, you feel as though you are in on something, as though you were E. L. Schanberger. If that name doesn't ring a bell, you should know that Schanberger was a Baltimore sportswriter who filed this dispatch from spring training in 1914: "A youngster named Frank Ruth . . . has shown [Jack] Dunn so much that the manager makes the bold statement that he will stick with the team this season, both on account of his hitting and his portside flinging." So what if E. L. got the first name wrong.

The most charming spring training stadium is McKechnie Field in Bradentown, Florida, where the Pittsburgh Pirates play. It's rickety and somewhat lacking in amenities, but you can look out onto the field and imagine Roberto Clemente or Ralph Kiner or

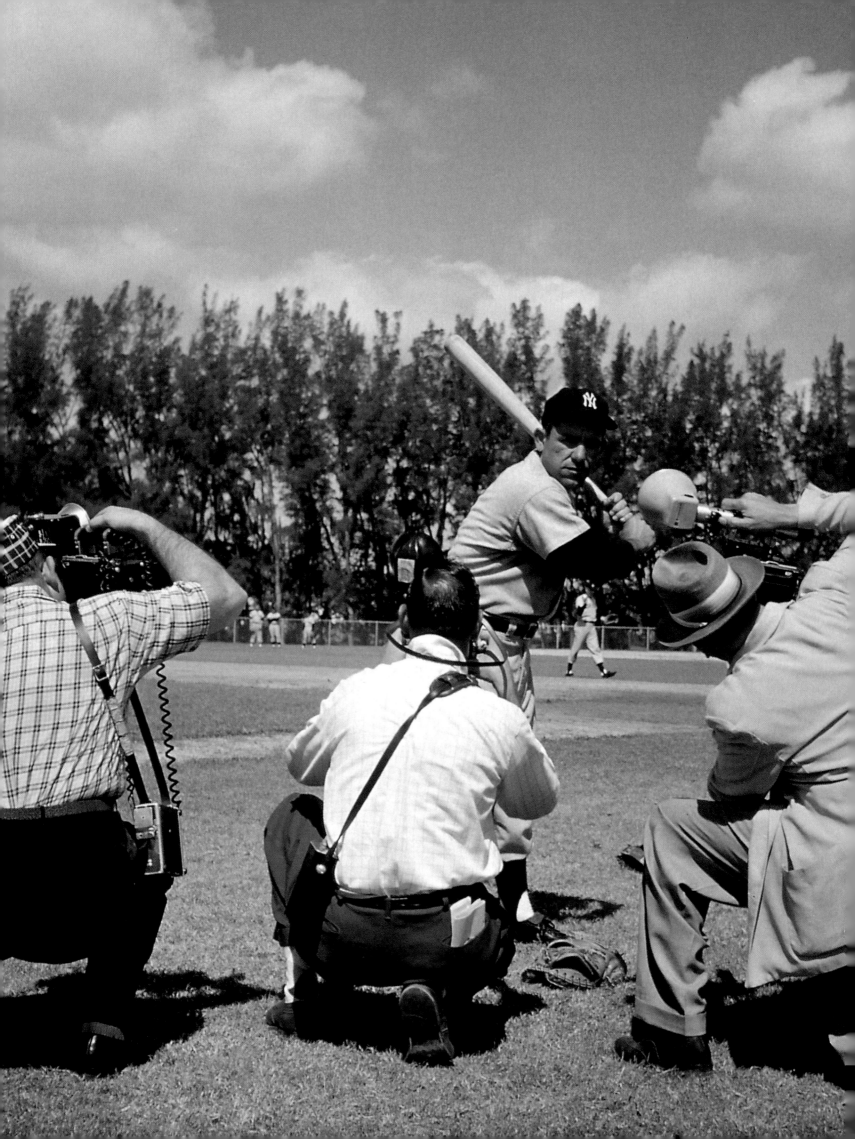

Paul Waner out there. Actually, you would be surprised the people you run into during spring training. Several years ago, an ancient man sat in a corner of the lunchroom at McKechnie Field, and word spread quickly among the scouts and writers that they were in the presence of Edd Roush, the great Hall of Fame centerfielder for the Reds and Giants. We tossed him some names from the past. What was Grover Alexander like? "Good pitcher," said Edd. How about Rogers Hornsby? "Good hitter," said Edd. John McGraw? "Managed the Giants," said Edd.

We hid our disappointment as best we could. Then Edd's eyes lit up, and he said, "Do you know a really good player?" We gathered closer. "Ruth," said Edd. "Babe Ruth. Left-handed hitter. Lot of home runs. Started out as a pitcher, you know."

Alas, we lost Edd a few years ago. And we may be losing spring training as we knew it. Many teams have spanking-new, colorless stadiums. Players aren't quite as congenial as they used to be. The spring is big business now, and exhibition games are often sellouts. As Yogi Berra once said of a certain restaurant, "Nobody goes there anymore—it's too crowded."

But if you want to know what spring training is really like, just turn the page.

OPPOSITE: Yogi goes to bat for the photographers

RIGHT: Whitey Ford enjoys a day at the beach with his family

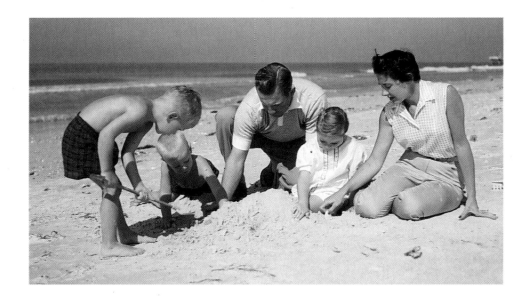

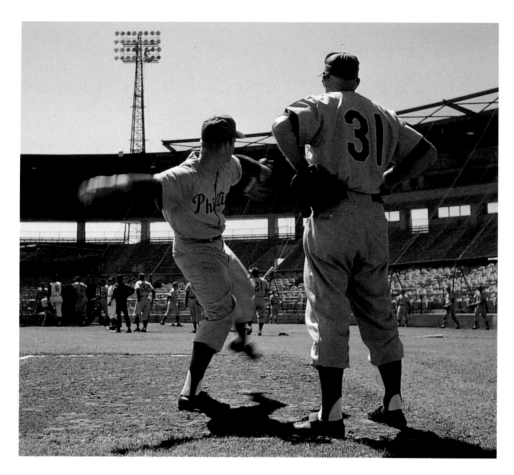

LEFT: A Phillies pitcher loosens up

BELOW: Reds manager Birdie Tebbetts à la cart

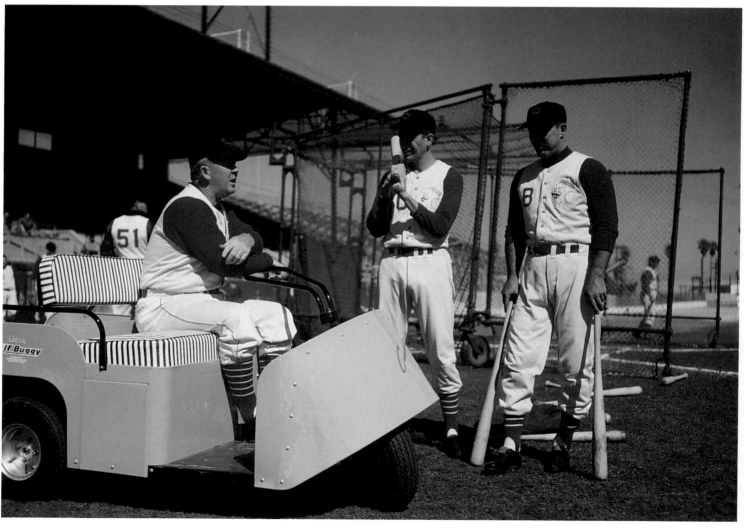

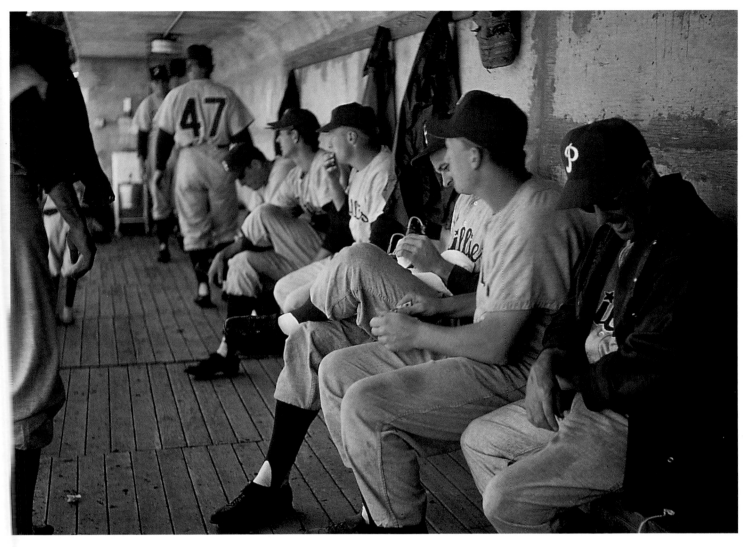

ABOVE: The Phillies in their dugout in Clearwater

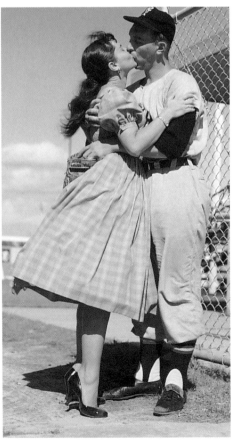

FOLLOWING PAGES 42–43: Putting the ball in play

LEFT: The kiss of springtime

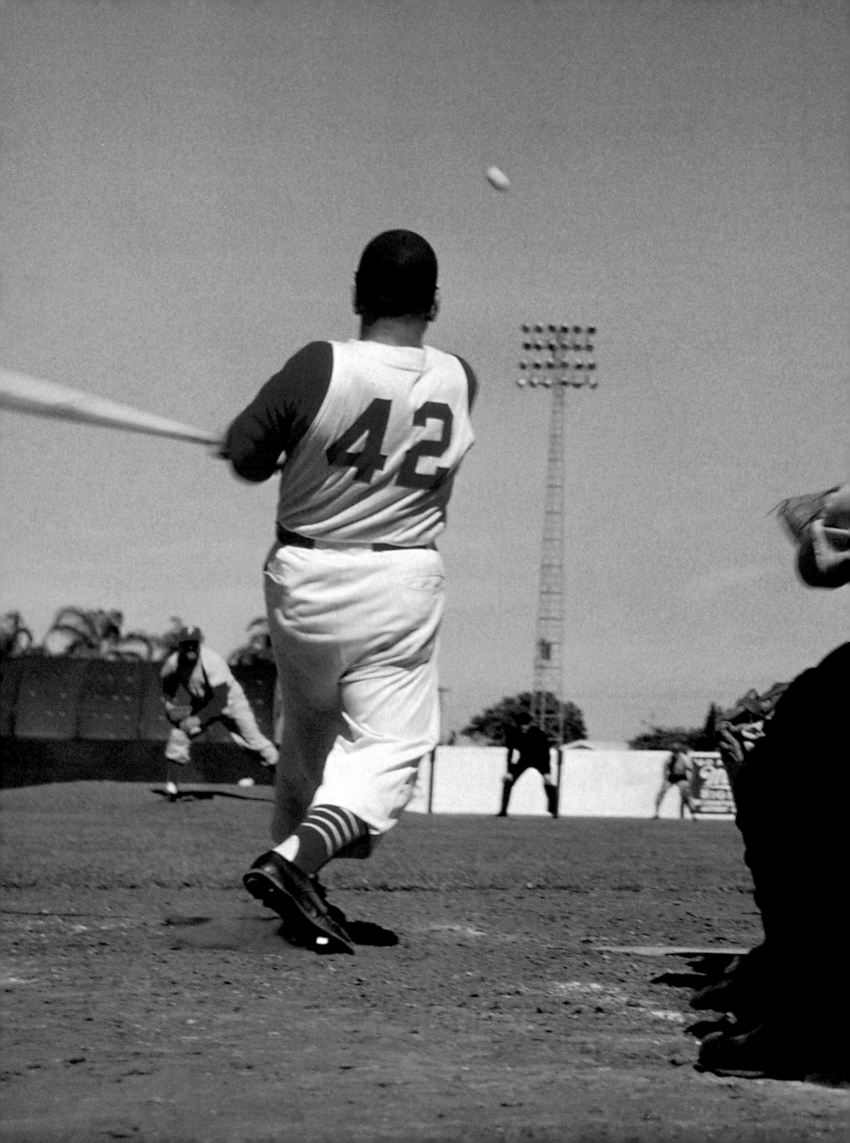

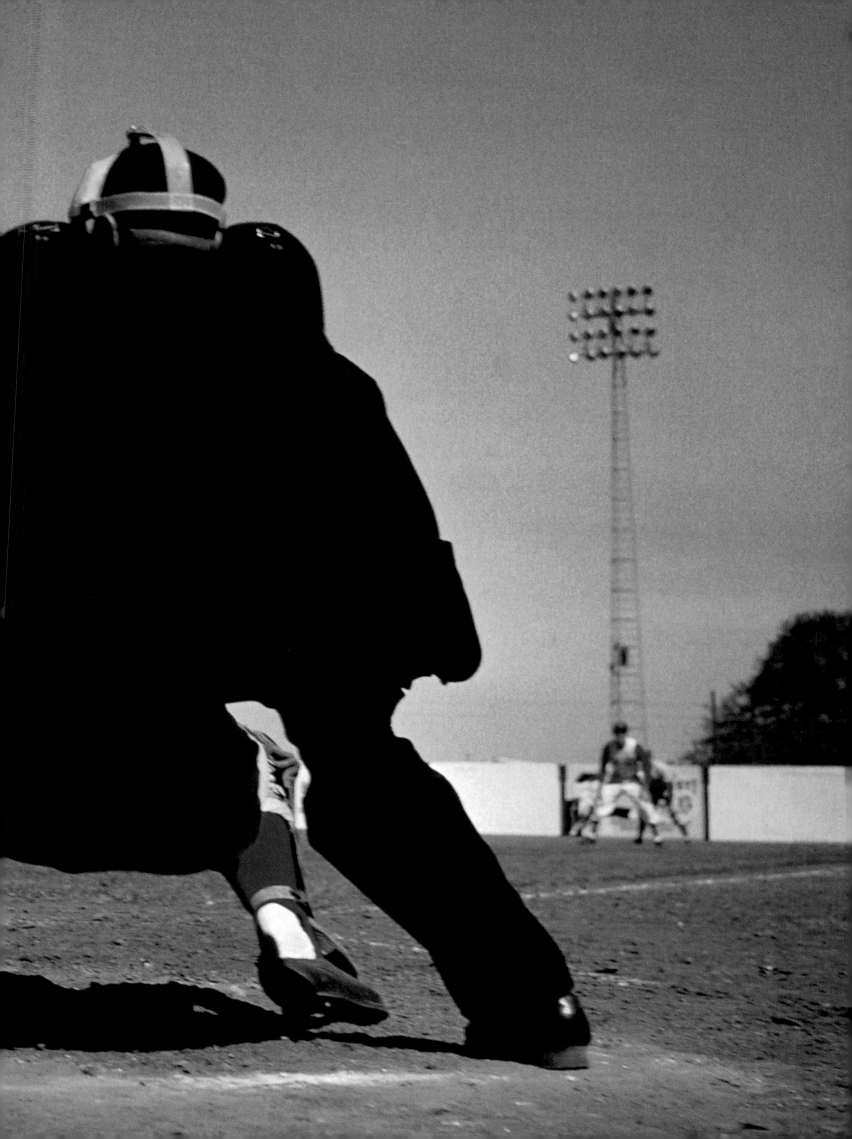

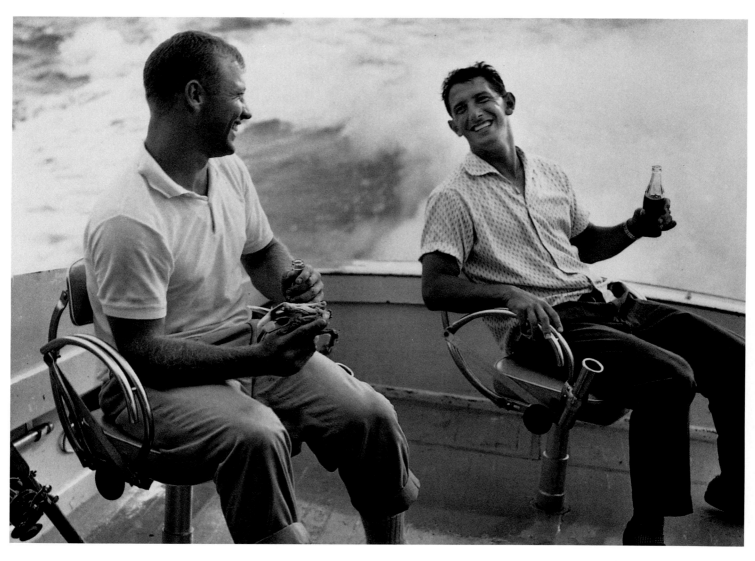

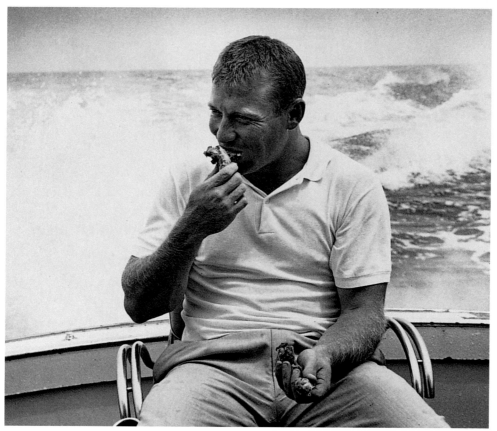

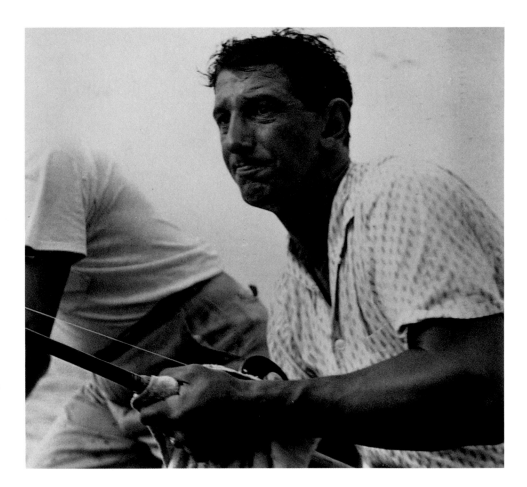

OPPOSITE, ABOVE: Mantle and Martin enjoy their surroundings

OPPOSITE, BELOW: Mickey has some chicken with his fish

ABOVE, RIGHT: Billy gets set to land one

BELOW, RIGHT: The Captain and Whitey show off their chapeaux

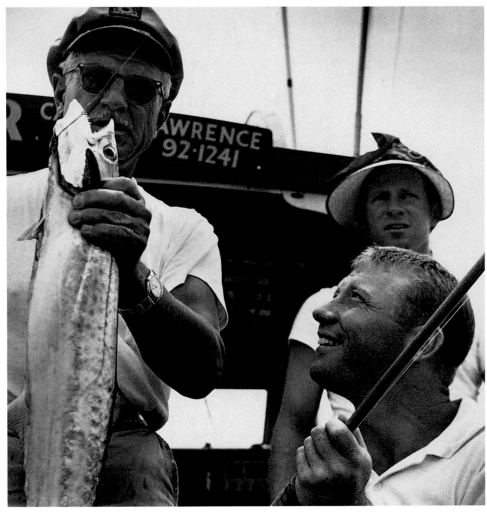

LEFT: The crowd at Dodgertown soaks up the sun

BELOW: Steve Garvey limbering up

OPPOSITE: Garvey was always a hit with the scouts.

Perhaps the most evocative of spring-training camps is Dodgertown in Vero Beach. Here the players and fans freely mingle, and the streets are named for great Dodgers past.

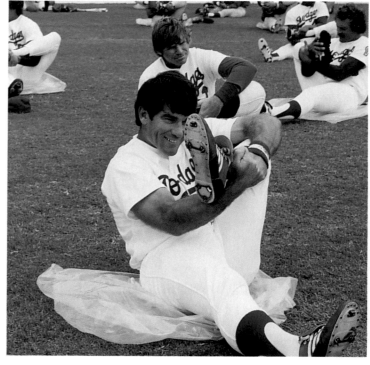

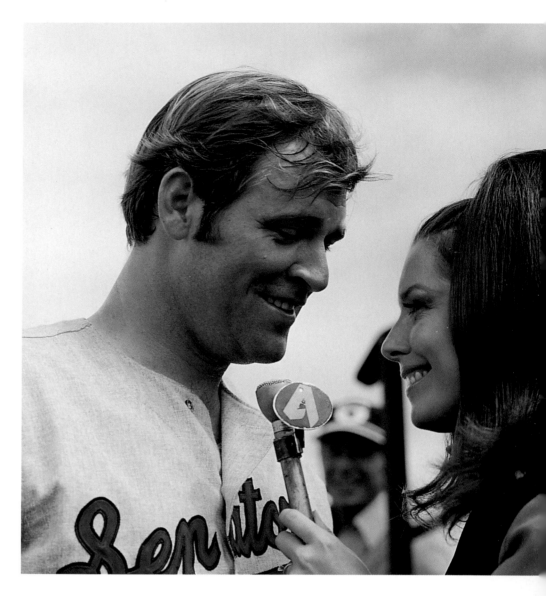

RIGHT: Denny McLain, past his prime time, grants an interview

BELOW: Young fans go into the stretch for a Yankee autograph

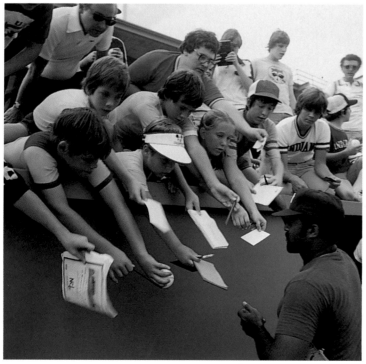

The true magic of spring training is that all of its participants—players, writers, fans—feel young again.

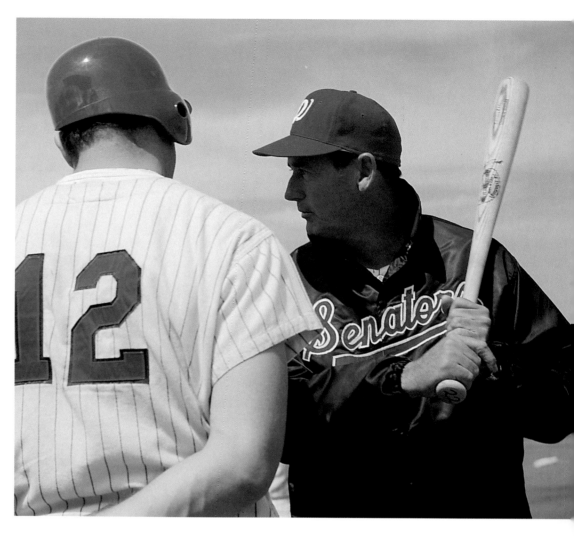

RIGHT: Ted Williams gives batting instructions to a young Senator

BELOW: Senior Senators: Curt Flood, McLain, and manager Williams

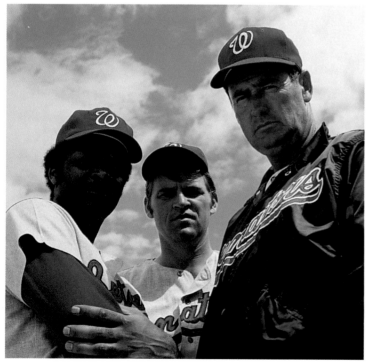

\mathcal{B}aseball people often kid that it's a shame to ruin the sport by heading north to start the season.

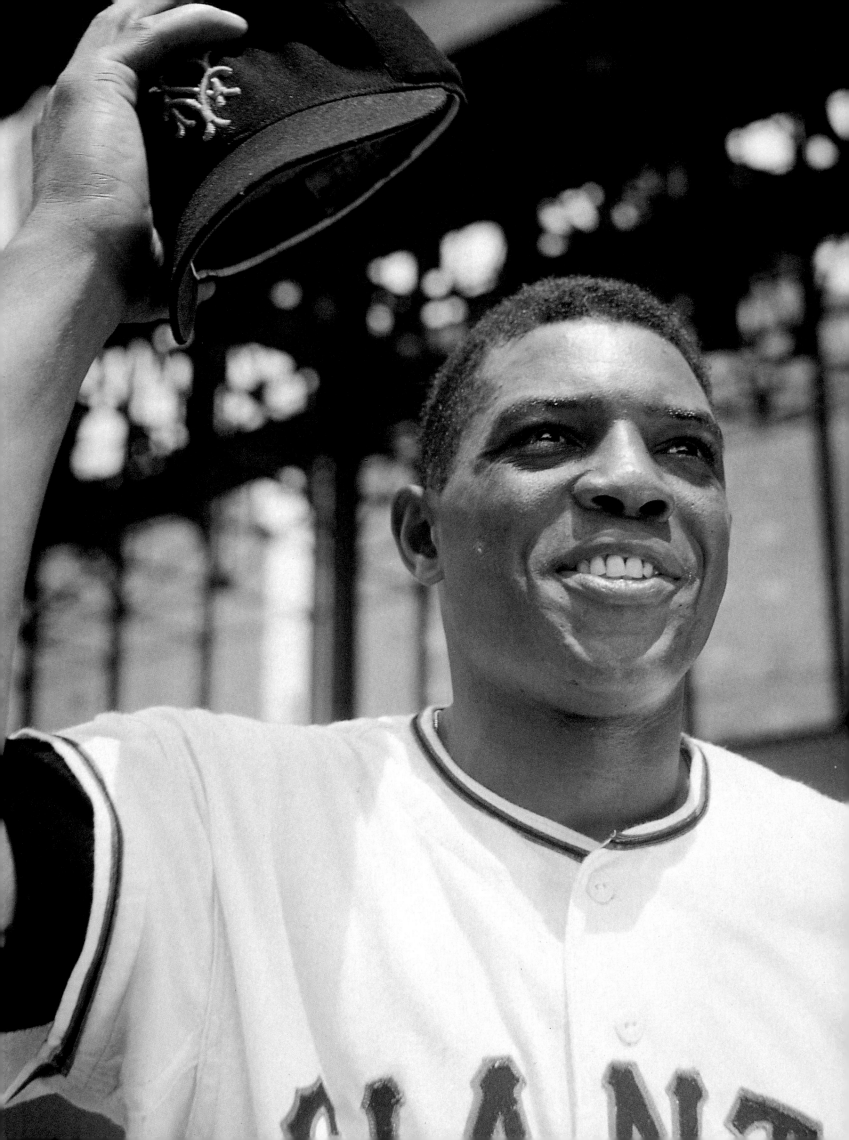

Baseball

\mathcal{Y}ou are about to go to a day game at Ebbets Field.

That's a pretty heady promise to make, but I can assure you that the Sweet photographs in this section are so vivid and so evocative that you will soon find yourself traveling back in time. Perhaps you'll be going back to your own childhood, perhaps even to a time before you were born, but go you will. One of these pictures is bound to be your transportation—your DeLorean, to use a modern cinematic reference. It might be the photo of Warren Spahn with the twinkle in his eye, or the one of Jackie Robinson and Pee Wee Reese turning a double play, or the one of Roger Maris "tossing" his bats in the air. But before too long, you will be sitting along the first-base line at the Polo Grounds or in the bleachers of Comiskey Park or in the upper deck of Connie Mack Stadium, or wherever it is you want to be sitting forever. You will look at the picture of Joe DiMaggio on page 183—God, what great hair—and pretty soon the music of the Tommy Dorsey Orchestra will be playing in your ear.

OPPOSITE: Say hey, it's Willie Mays

RIGHT: Young Al Kaline of the Tigers

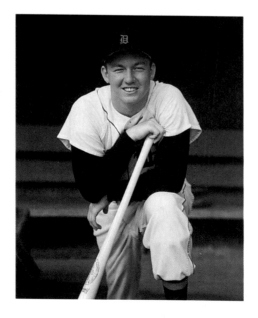

That is the essential magic of these pictures and indeed of baseball. The game has its unique ability to cross the space-time continuum. Baseball is almost 150 years old, but it really is just one long, continuous, and ongoing season. Most basketball aficionados would probably agree that Bob Cousy couldn't hold a candle to Magic Johnson,

and football diehards no doubt realize that Jerry Rice is several steps up on the evolutionary scale from Don Hutson, but baseball fans can argue endlessly over who was the best shortstop ever, Honus Wagner, Ernie Banks, or Cal Ripken (to name a few candidates). You can watch Roger Clemens pawing the mound and imagine him pitching to DiMaggio, or you can see Toronto Blue Jays centerfielder Devon White running down a fly ball alongside Willie Mays.

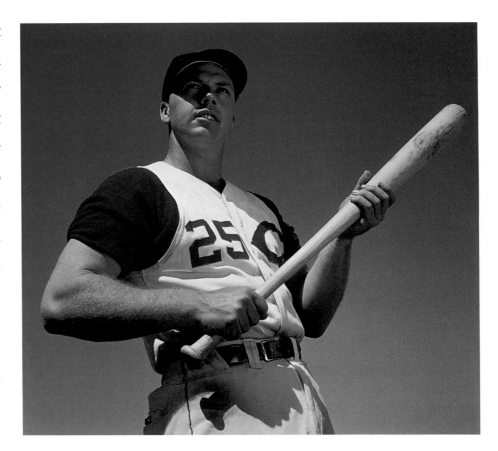

ABOVE: Outfielder Gus Bell of the Reds

That timelessness also permits us to see baseball as it should be—a nice, short, two-hour game on grass in the sunshine at your favorite park—rather than what it has become: a three-and-a-half-hour game under the lights, often in an impersonal stadium with carpeting. But there's no sense in carping about the modern entrapments of baseball; it is still basically the same game we grew up with, the same game we cherish.

I am fond of all the pictures in this section of *Legends of the Field*, but the ones that really bring me back are on pages 128–133, the Phillies trio of Jim Bunning, Johnny Callison, and Richie (pre–Dick) Allen.

Growing up in upstate New York, I had adopted the Phillies as my team because, in 1962, I knew they needed help. I was overjoyed in 1963 when they finished a surprising fourth. In the spring and summer of '64, I was in ecstasy as they rose to the top. Bunning, the father of a dozen kids, pitched a perfect game in Shea Stadium on Father's Day. Callison, our right fielder, hit a dramatic two-run homer

in the bottom of the ninth to beat the American League in the All-Star Game. Allen, our third baseman, was on his way to the Rookie of the Year. And we were on our way to the pennant. My friends wanted to congratulate me on my astute choice of team, but even then, I knew enough to hold them off until we had clinched.

With ten games to go, we were six and a half games up. But at that point the Phillies couldn't buy a win, and the Cardinals and Reds couldn't seem to lose. Manager Gene Mauch pushed the panic button and reduced his starting rotation to two: Bunning and Chris Short. Callison came down with the flu.

Another picture in this book, that of Cardinals first baseman (and current National League president) Bill White on page 115, brings back a poignant memory. Callison couldn't start in a game against St. Louis that last week because of his illness, but in the late innings, Mauch asked him if he could pinch-hit. Somehow, racked

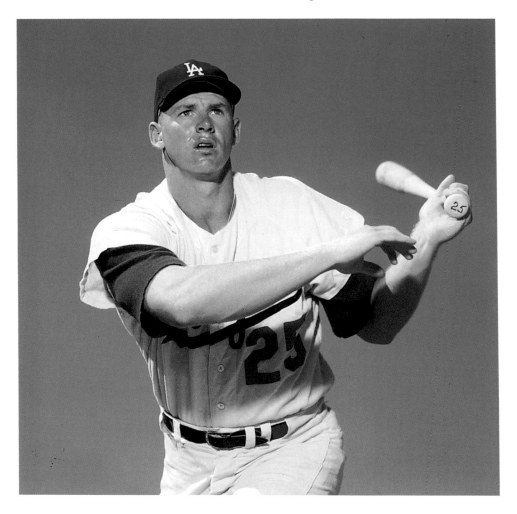

BELOW: Slugger Frank Howard of the Dodgers

with fever, Johnny found his way to the plate and singled. Shaking with the chills on a balmy summer night, he called to the dugout for a jacket. But his fingers were so useless to him that White, playing first base, had to help him zip up the jacket.

Unfortunately, the Cardinals offered no other help to the Phillies. On the last day of the season, the Phils still had a chance, if they won and the Cardinals lost. Philadelphia did win, but so did St. Louis. I got the news while I risked draining

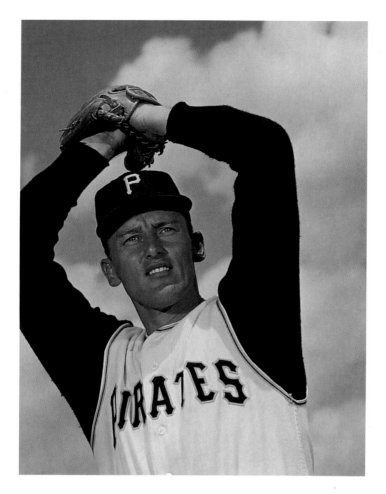

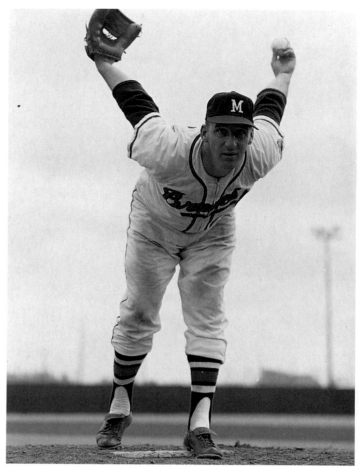

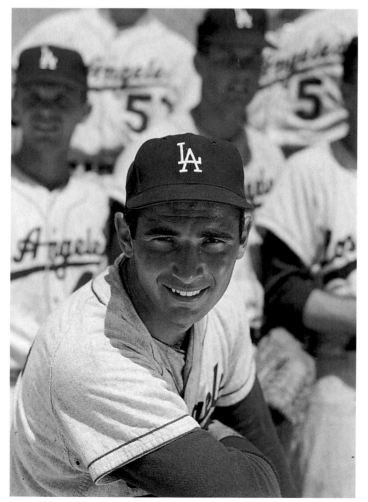

If you were a National League hitter in the early 1960s, the faces on this page were three you didn't want to see.

ABOVE, LEFT: Pirate hurler Vern Law

ABOVE, RIGHT: Braves southpaw Warren Spahn

BELOW, LEFT: Lefty Sandy Koufax of the Dodgers

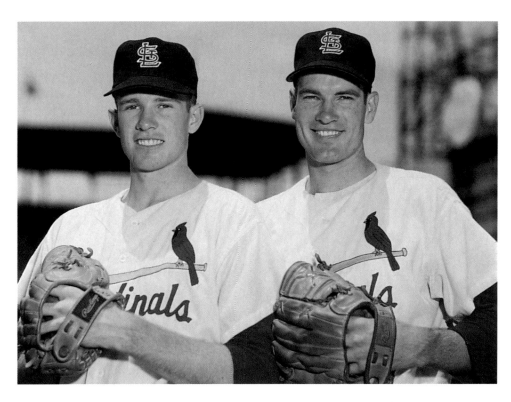

the battery of my father's car at a hunting preserve where we worked our dogs every Sunday. (His hunting took precedence over my baseball.) Upon hearing that the Cardinals had won, I went to a nearby field and sat there, hugging our Brittany Spaniel. At times like these, only a dog will do.

Baseball does occasionally break your spirit. For the most part, though, it puts a smile on your face, a spring in your step, a song in your heart . . . I'm getting carried away here. I'll let these pictures speak for the game. You'll see the power of Ted Kluszewski. The majesty of Sandy Koufax. The whip of Ewell Blackwell. The softer side of Frank Robinson. The mystery of the young Steve Carlton. The genius of Casey Stengel. The sadness of Billy Martin. The wonderment of Yogi Berra. You'll see all of that, and more.

You can find out, for instance, what it is like to be greeted at home plate after a homer. Of course, Tommy Davis didn't really hit a homer on page 88, and Frank Howard and Willie Davis aren't really congratulating him, because after all, no team is going to let Ozzie dig a ditch in the middle of the field during a game and let him take pictures. Nonetheless, the feeling of joy that you get from the photograph is totally sincere.

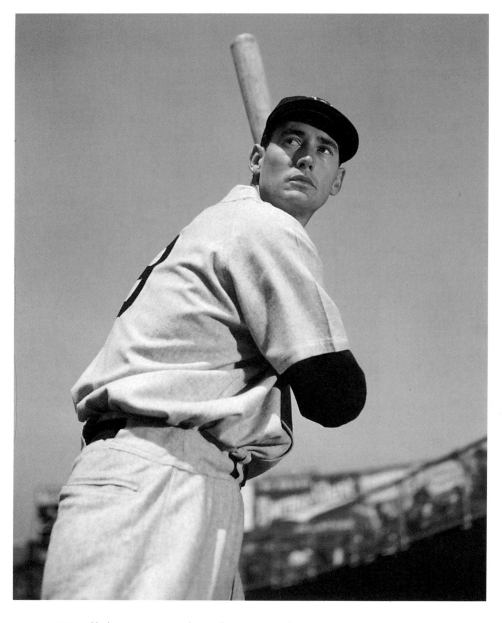

You'll be surprised at how much some of the players have aged—Bob Lemon and Willie Stargell, for example—and how little—Hank Aaron, Al Rosen, Don Drysdale. And some, like Mickey Mantle, will age before your eyes. But you'll grow younger just looking at them. At the risk of giving any more away, I want to point out one more photograph. It's the shot of Tony Conigliaro on page 177, so full of promise and possibilities. Tony C.'s career came to a grinding halt after a beaning, and his life was all too short. But in this book he lives again.

So sit back and relax, as the public-address announcer in Forbes Field heralds the arrival at the plate of Dick Stuart . . . or wherever and whoever you want.

You may not care if you ever get back.

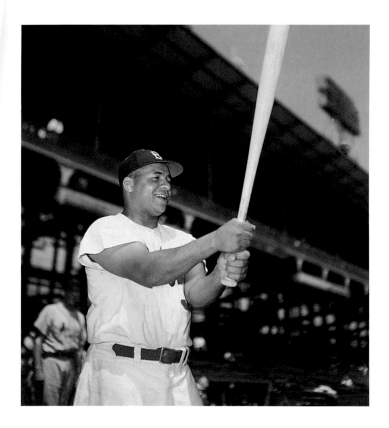

These three sluggers not only did their part to help out their teams but also their racial and ethnic communities. Doby was the first black player in the American League; while Capanella was a black pioneer in the National League. Al Rosen was an inspiration to Jewish Americans.

ABOVE, LEFT: Roy Campanella checks his wood

ABOVE, RIGHT: Al Rosen joins an Indian pow-wow

BELOW, RIGHT: Larry Doby shows off his trophies

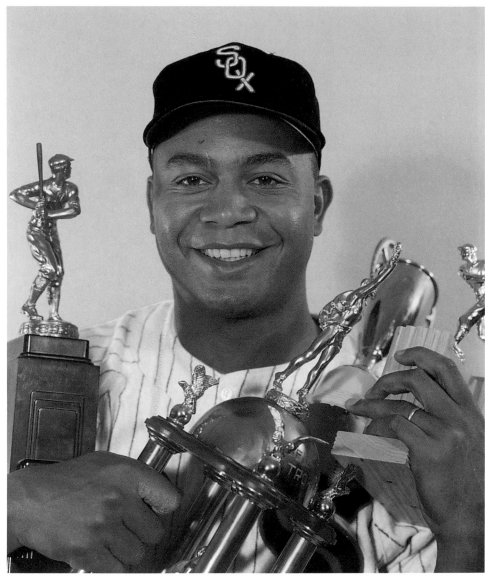

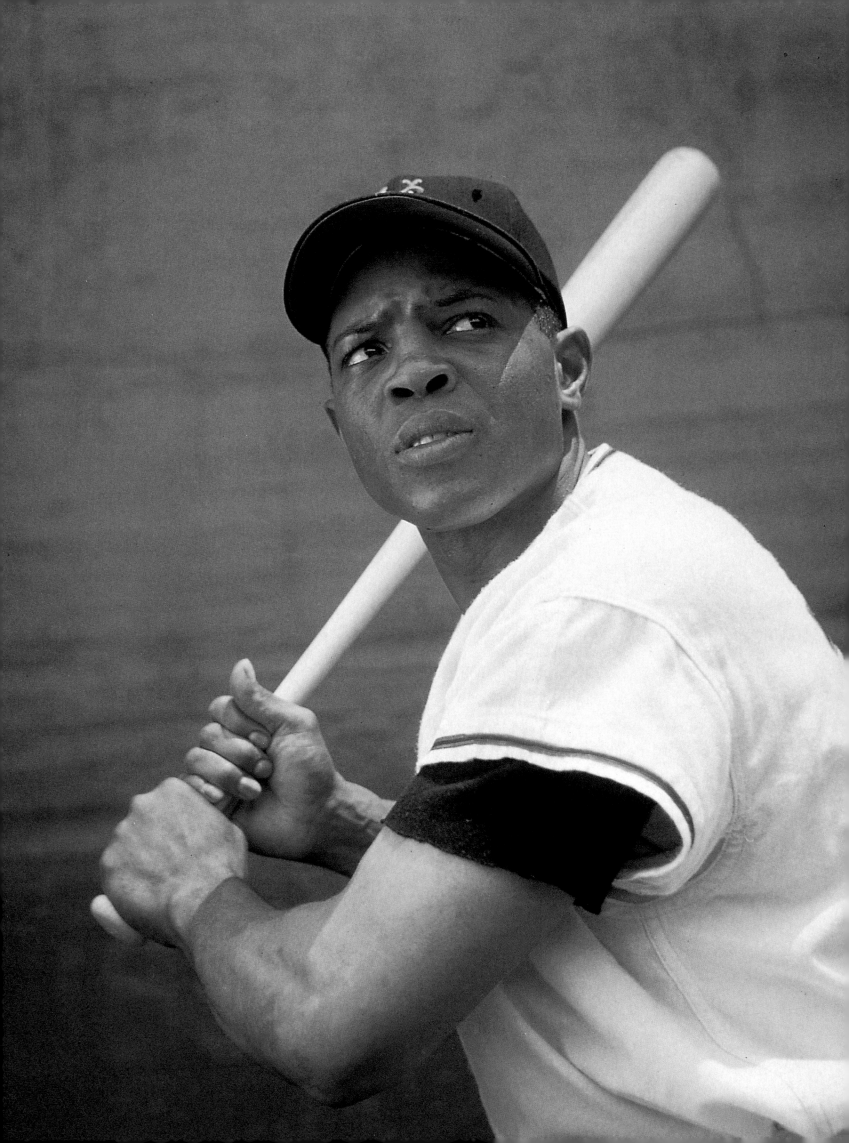

Willie Mays

- ◆ BORN: 1931
- ◆ OUTFIELDER 1951–73 Giants, Mets
- ◆ 1951 Rookie of the Year
- ◆ MVP 1954, 1965
- ◆ All-Star 1954–73
- ◆ 660 career home runs
- ◆ .302 career batting average
- ◆ Elected to Hall of Fame 1979

As great a hitter as Mays was, it was his defense that set him apart from mere mortals. In the first game of the 1954 World Series against the Cleveland Indians, the Say Hey Kid made what has to be called simply The Catch, running down a long drive by Vic Wertz and whirling to fire the ball back to the infield. The Catch not only turned back an Indian uprising, but it set the stage for the Giants' stunning sweep.

BELOW: The Kid and a family friend at breakfast

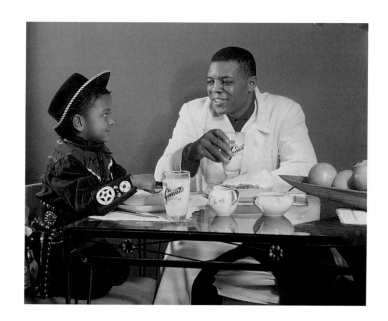

OPPOSITE: Willie lounges around with his wife, Marghuerite

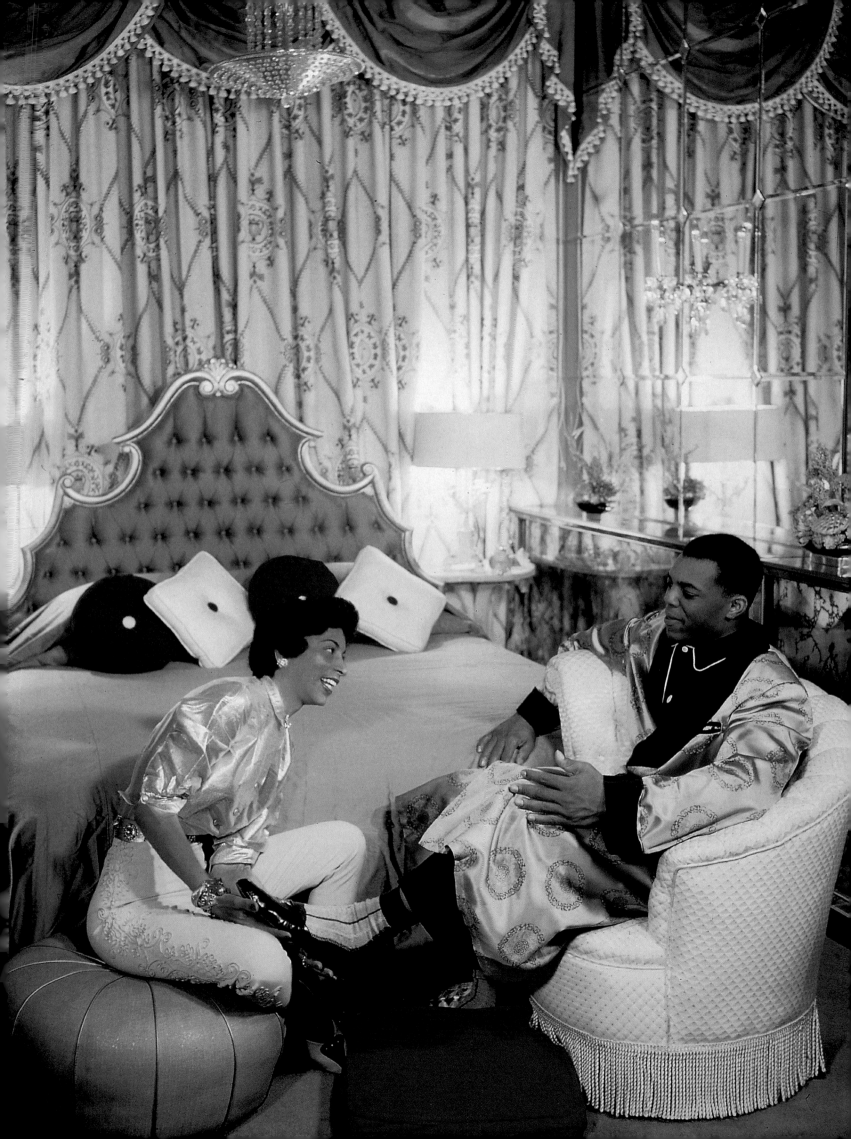

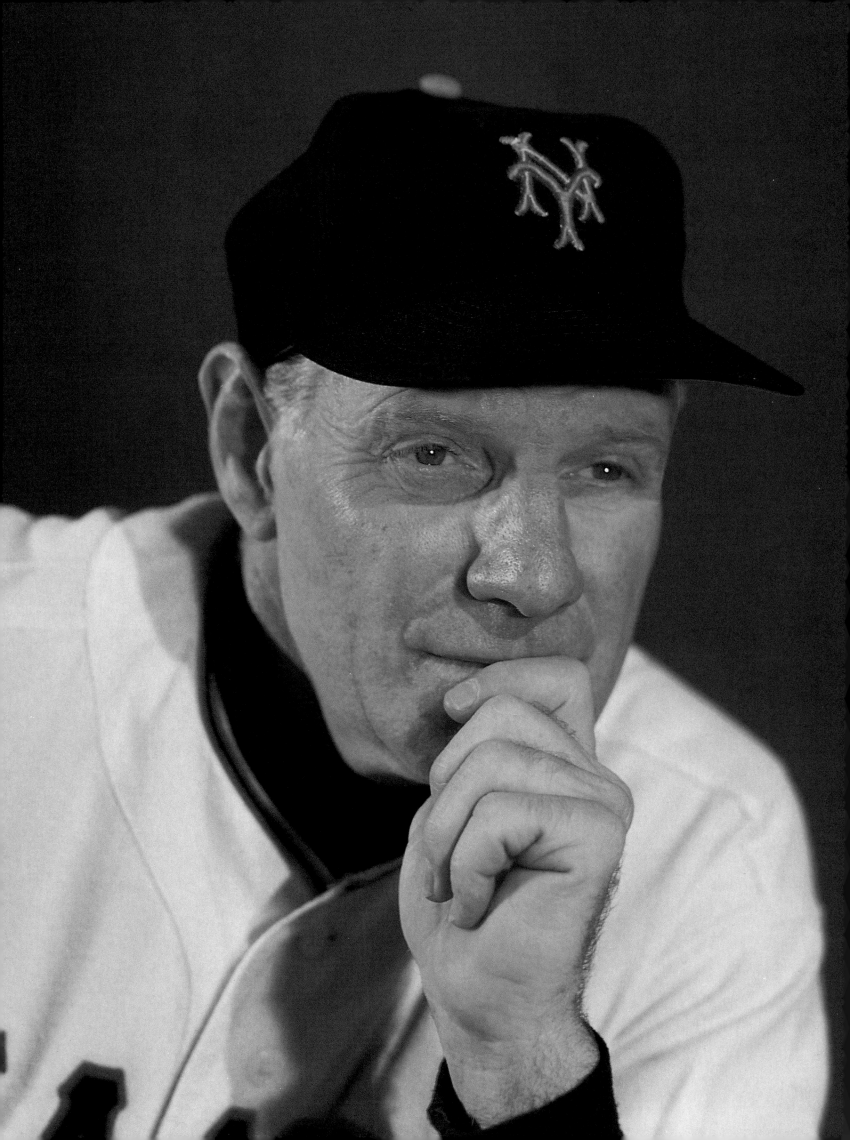

Leo Durocher

- ◆ BORN: 1905 DIED: 1991

- ◆ SHORTSTOP 1925–45 Yankees, Reds, Cardinals, Dodgers

- ◆ MANAGER Dodgers (1939–46), Giants (1948–55), Cubs (1966–70), Astros (1971–73)

- ◆ All-Star 1936, '38, '40

- ◆ Led NL in fielding in '36 and '38

- ◆ Managed three pennant winners and one world champion ('54 Giants)

Though Leo the Lip later became popular as a manager, he was not exactly beloved when he took the field in his playing days. Once, when Durocher was almost beaned by Cubs pitcher Hi Bithorn, John Lardner wrote that the pitcher "missed by a millimeter, to the profound regret of uncounted millions."

Frankie Frisch

- BORN: 1898 DIED: 1973

- INFIELDER 1919–37 Giants, Cardinals

- MANAGER Cardinals (1933–38), Pirates (1940–46), Cubs (1949–51)

- MVP 1931

- All-Star 1933–35

- .316 career batting average

- Struck out only 272 times in 9,112 at-bats

- Played in 8 World Series

- Led 1934 Gas House Gang to World Championship

- Elected to the Hall of Fame 1947

The Fordham Flash was one of the game's great second basemen, but as a manager, he was thought by his players to be far too demanding. When asked in 1971 what advice he would give to young managers, Frisch said, "Stay away from firearms and don't room higher than the second floor."

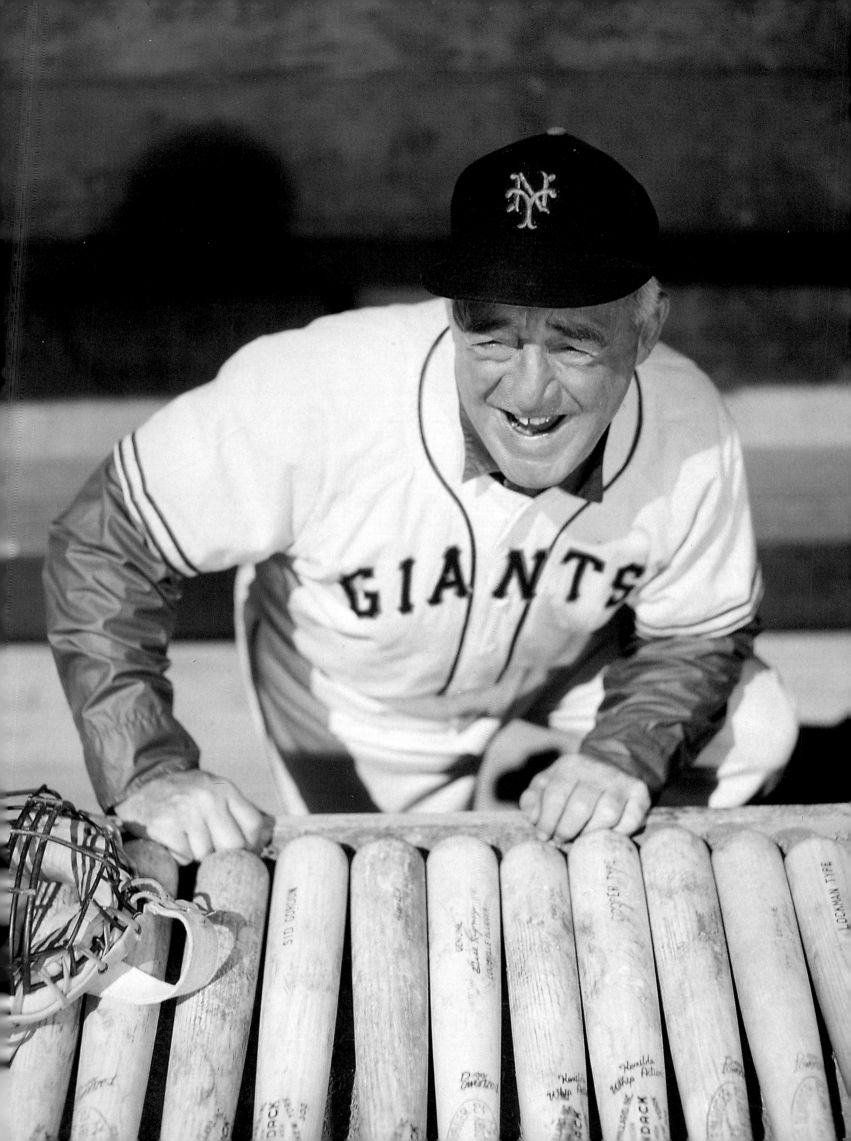

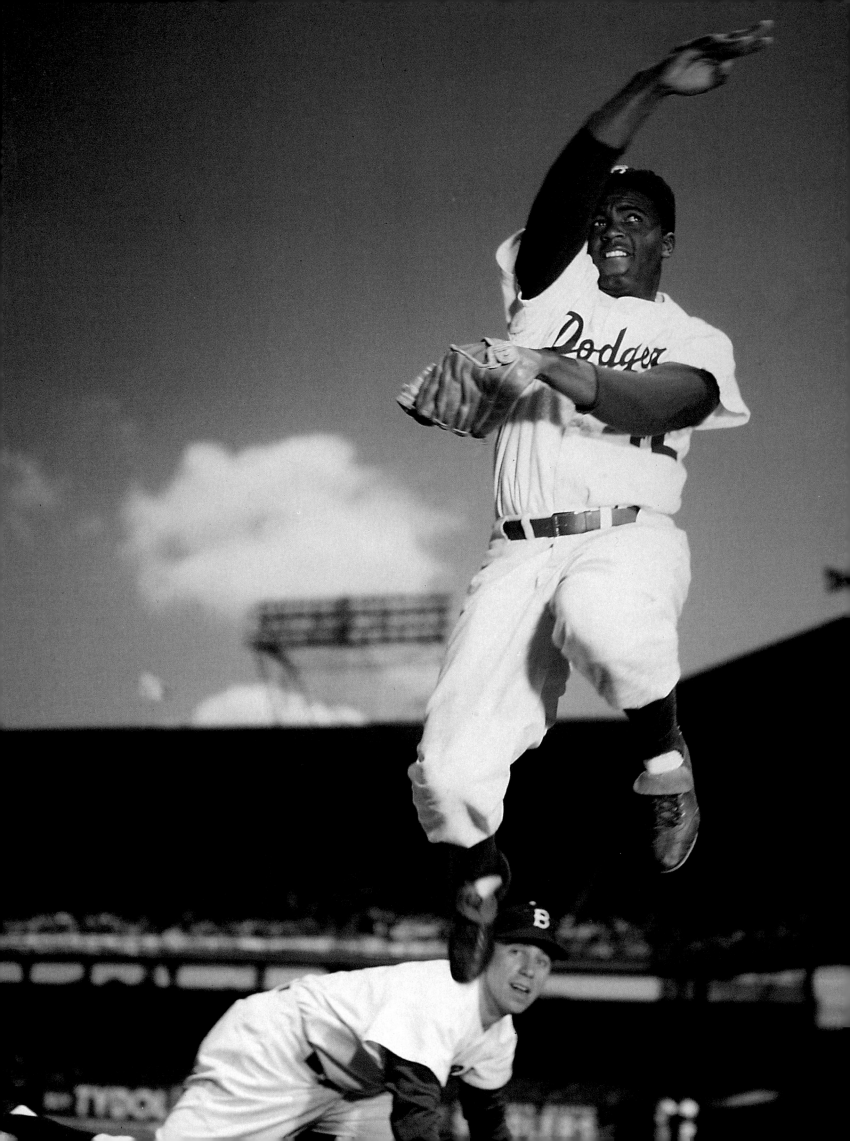

Jackie Robinson

- BORN: 1919 DIED: 1972

- INFIELDER 1947–56 Dodgers

- First African-American player in 20th-century major leagues

- Rookie of the Year 1947

- MVP 1949

- .311 career batting average

- Stole home 19 times, the post–WWI record

- All-Star 1949–54

- Played in 6 World Series

In breaking the color line, Robinson withstood constant verbal, social, and physical abuse. But once he had proven that he belonged, it was his competitive nature that most defined his character. After Bobby Thomson hit the Shot Heard 'Round the World in 1951 to send the Giants to the World Series, Robinson's Dodger teammates ran for the safety of the clubhouse. But Robinson stayed at his position, watching Thomson to make certain that he touched every base.

Pee Wee Reese

◆ BORN: 1918

◆ SHORTSTOP 1940–58 Dodgers

◆ All-Star 1942, '47–54

◆ Elected to the Hall of Fame 1984

◆ Played in 7 World Series

Orignally Red Sox property, Reese's contract was bought by Brooklyn from the Kentucky Colonels in 1939 for $75,000. Later Reese recalled, "One of the Louisville writers told me that I had been sold to Brooklyn. I said something like, 'Gee, Christmas, that's the last place in the world I'd want to go.' Which was kind of a stupid thing for me to say. It didn't go over too well in Brooklyn." Nonetheless, Reese became one of the most popular Dodgers.

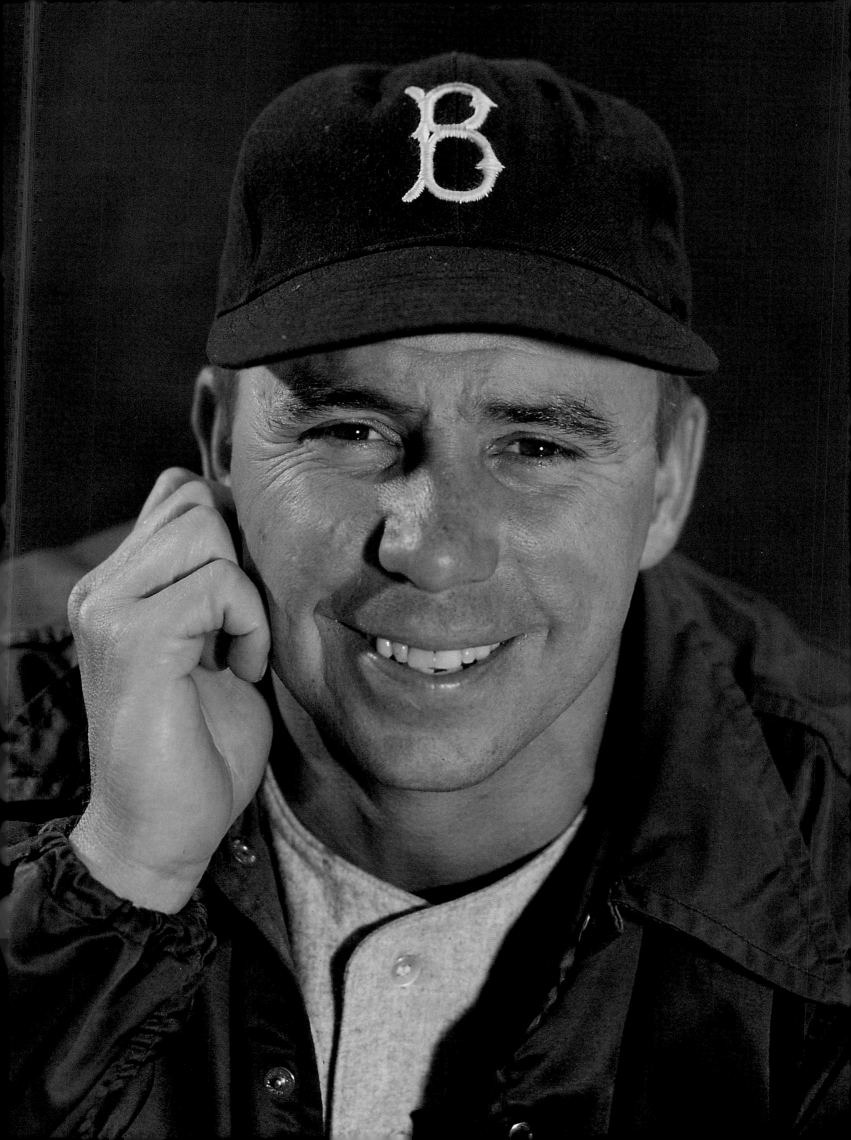

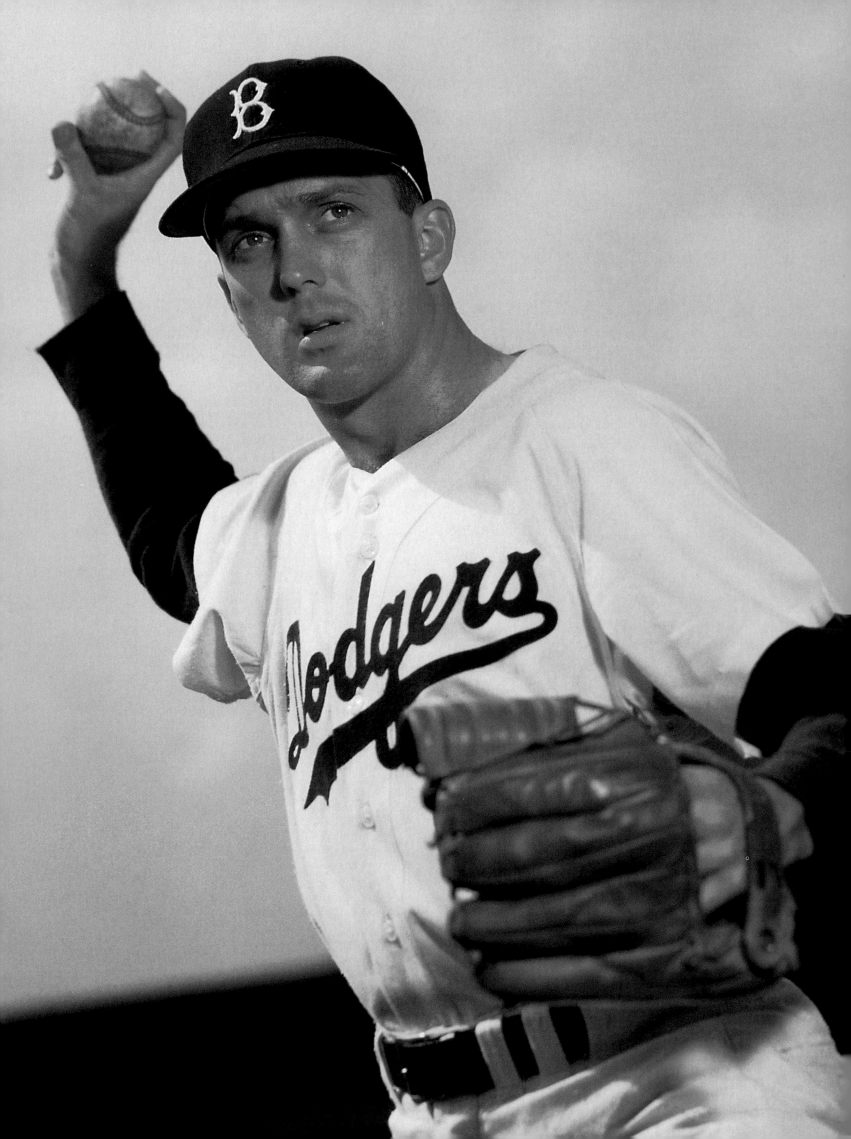

Carl Erskine

- ◆ BORN: 1926
- ◆ PITCHER 1948–59 Dodgers
- ◆ 122–78 career won–lost record
- ◆ All-Star 1954
- ◆ Pitched two no-hitters
- ◆ 20–6 in 1953

"*Oisk,*" *as he was called by Brooklynites, was almost the pitcher brought in to face Bobby Thomson in the playoff game to decide the 1951 NL pennant. Erskine was warming up alongside Ralph Branca when he bounced a pitch in the dirt. So Branca got the call, and the rest was history. Of Thomson's homer, Erskine said, "That's the first time I've seen a big fat wallet go flying into the seats."*

These are some of the Brooklyn Dodgers of 1955, the so-called "Boys of Summer" who captured not only the World Series that year but also the heart of America.

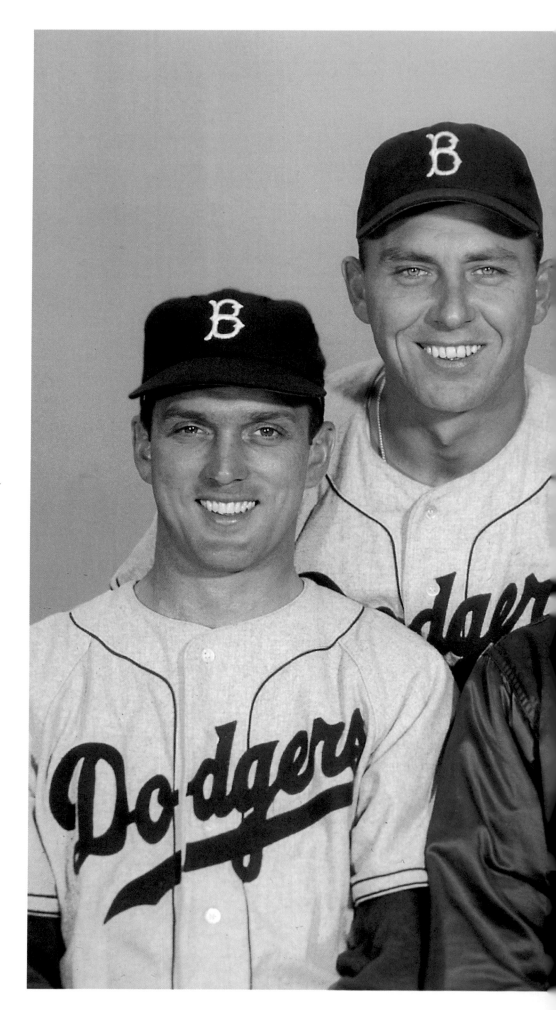

RIGHT: (From left) Carl Erskine, Gil Hodges, Pee Wee Reese, Jackie Robinson, and Duke Snider

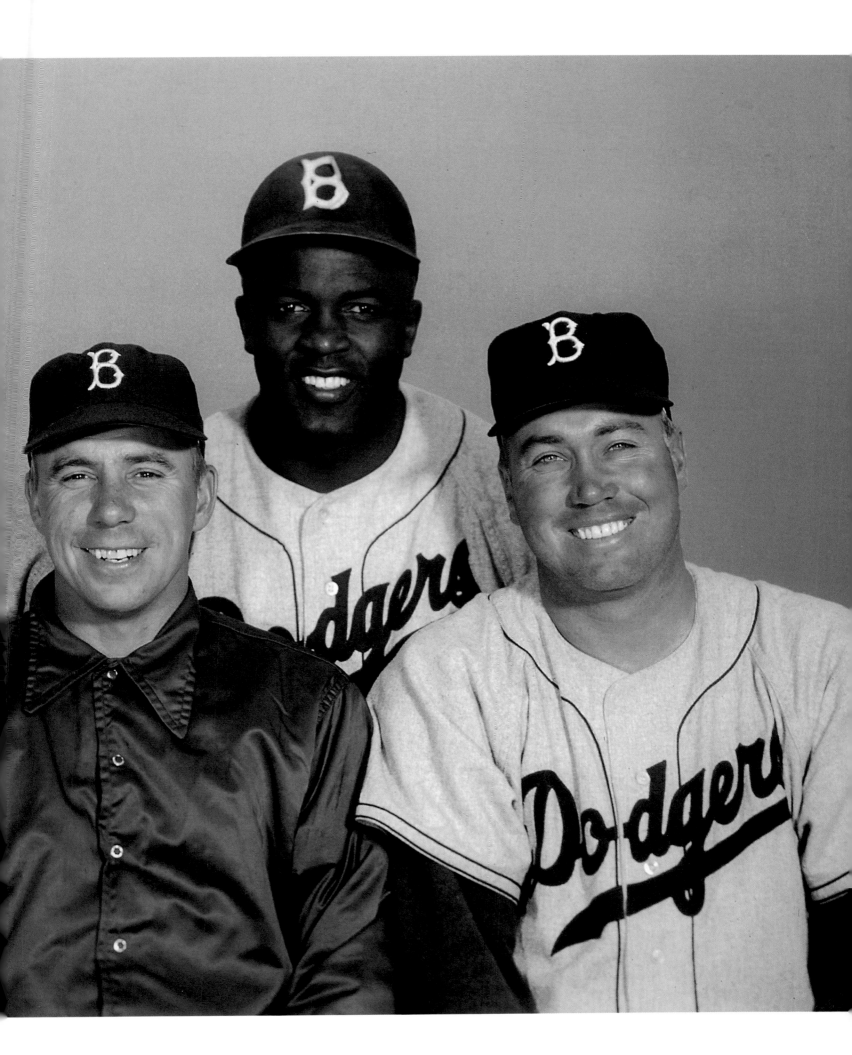

Duke Snider

◆ BORN: 1926

◆ OUTFIELDER 1947–64 Dodgers,
Mets, Giants

◆ .295 career batting average

◆ 407 career home runs

◆ All-Star 1950–56

◆ 11 World Series home runs

◆ Elected to the Hall of Fame 1980

*Duke had the bad luck of playing center
field in a town that already had Willie Mays and
Mickey Mantle. He also had bad luck in general.
He used to car-pool with Reese and Erskine,
and one day while Reese was driving, a policeman
pulled them over. Snider said to Reese, "Well,
Captain, let's see what you're going to do about this."
Reese said, "Geez, Officer, I'm awfully sorry. I'm
Pee Wee Reese of the Brooklyn Dodgers and this is
Duke Snider and Carl Erskine." The officer let Reese
go with a warning. The next day it was Snider's turn
to drive, and sure enough, at about the same spot,
the car was waved over. Reese said, "Well, it's your
turn, Duke." When the cop got to the car, Snider
said, "Say, Officer, I'm Duke Snider of the Dodgers."
Without looking up from Snider's license, the officer
said, "I hate baseball."*

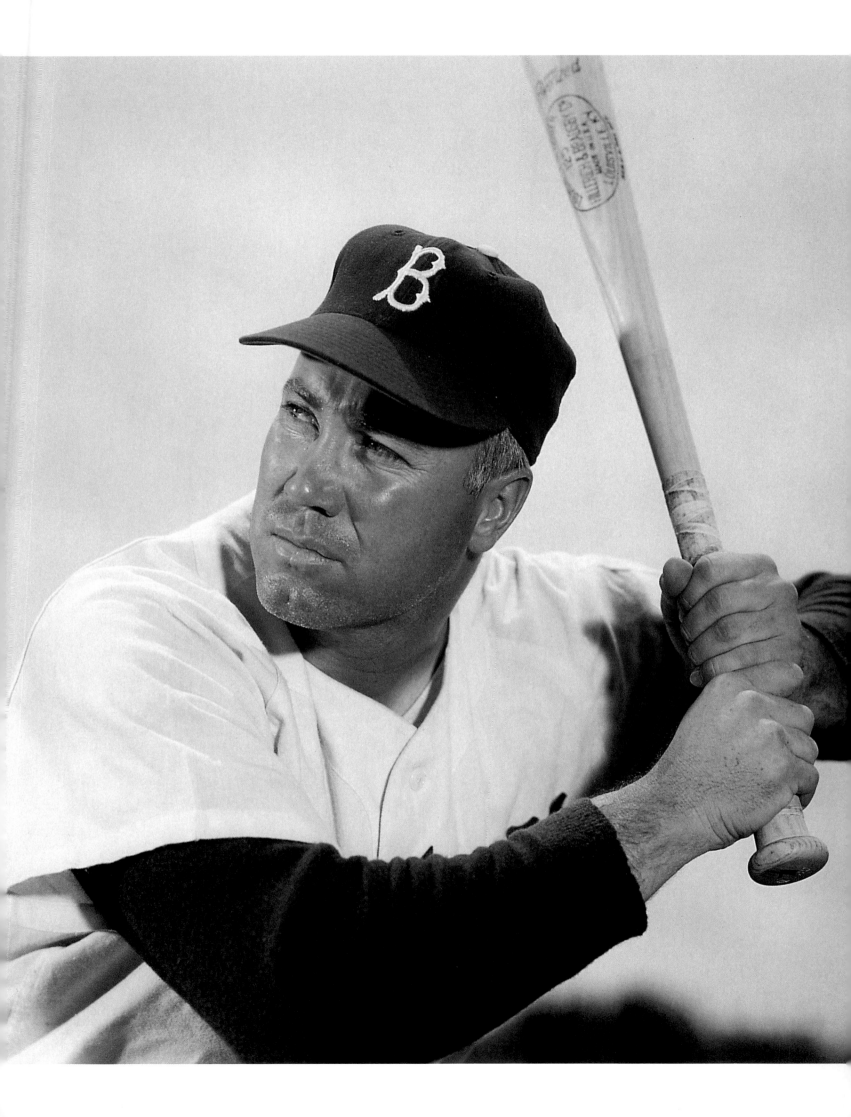

ABOVE: The Duke of Flatbush

OPPOSITE: Snider shows how to (Ebbets) field

Don Newcombe

- ◆ BORN: 1926

- ◆ PITCHER 1949–60 Dodgers, Reds, Indians

- ◆ 149–90 career won–lost record

- ◆ Rookie of the Year 1949

- ◆ MVP and Cy Young Award 1956

- ◆ All-Star 1949–51, '55

- ◆ Hit .358 with 7 home runs in 1957

Newcombe was the first out-standing African-American pitcher. In 1950 Dodger manager Burt Shotton agreed to let him start both games of a doubleheader. Teammate Carl Erskine recalled that Newcombe dispatched the Phillies in the first game. "He would have won the second game easy," said Erskine. "Except we couldn't get him any runs."

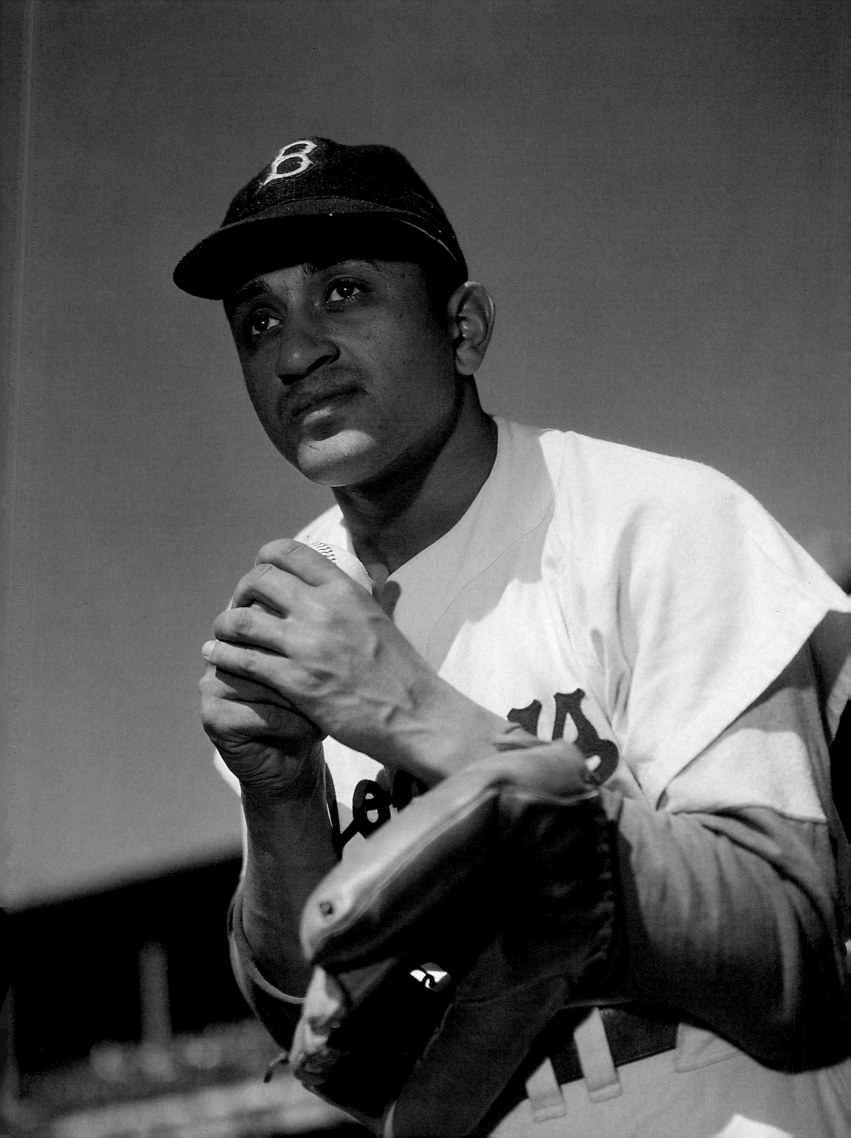

Sandy Koufax

- ◆ BORN: 1935

- ◆ PITCHER 1955–66 Dodgers

- ◆ 165–87 career won–lost record

- ◆ 2.76 career ERA

- ◆ 2,396 career strikeouts

- ◆ 20-game winner 1963, '65, '66

- ◆ 0.95 World Series ERA

- ◆ MVP 1963

- ◆ Cy Young Award 1963, '65, '66

- ◆ All-Star 1961–66

- ◆ In 1972 became youngest ever to be elected to the Hall of Fame

Koufax won a league-leading 26 games in 1965, but he did not get the World Series opening-game assignment against the Twins because he would not pitch on Yom Kippur. Don Drysdale got the start instead and lasted less than three innings. After the 8–2 loss, old Yankee pitcher Lefty Gomez came into the clubhouse and shouted to Dodger manager Walt Alston, "Hey, I bet you wish Drysdale was Jewish, too."

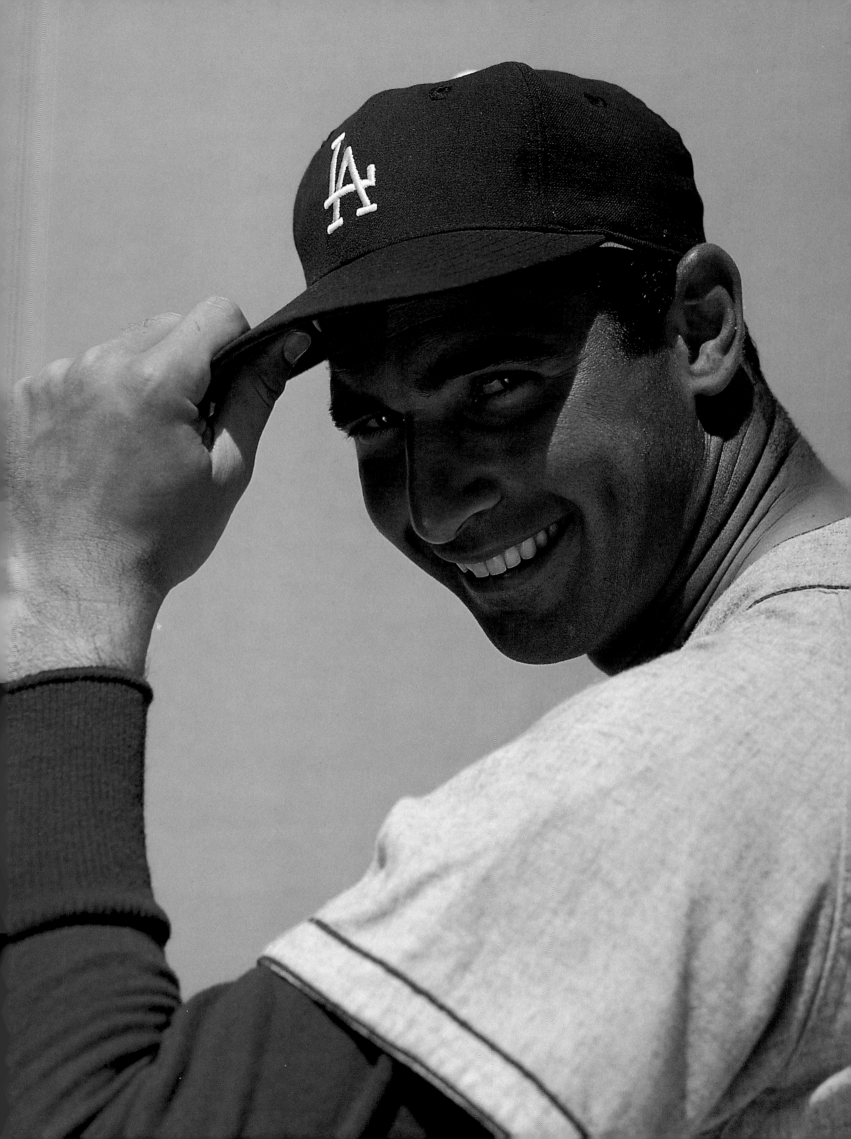

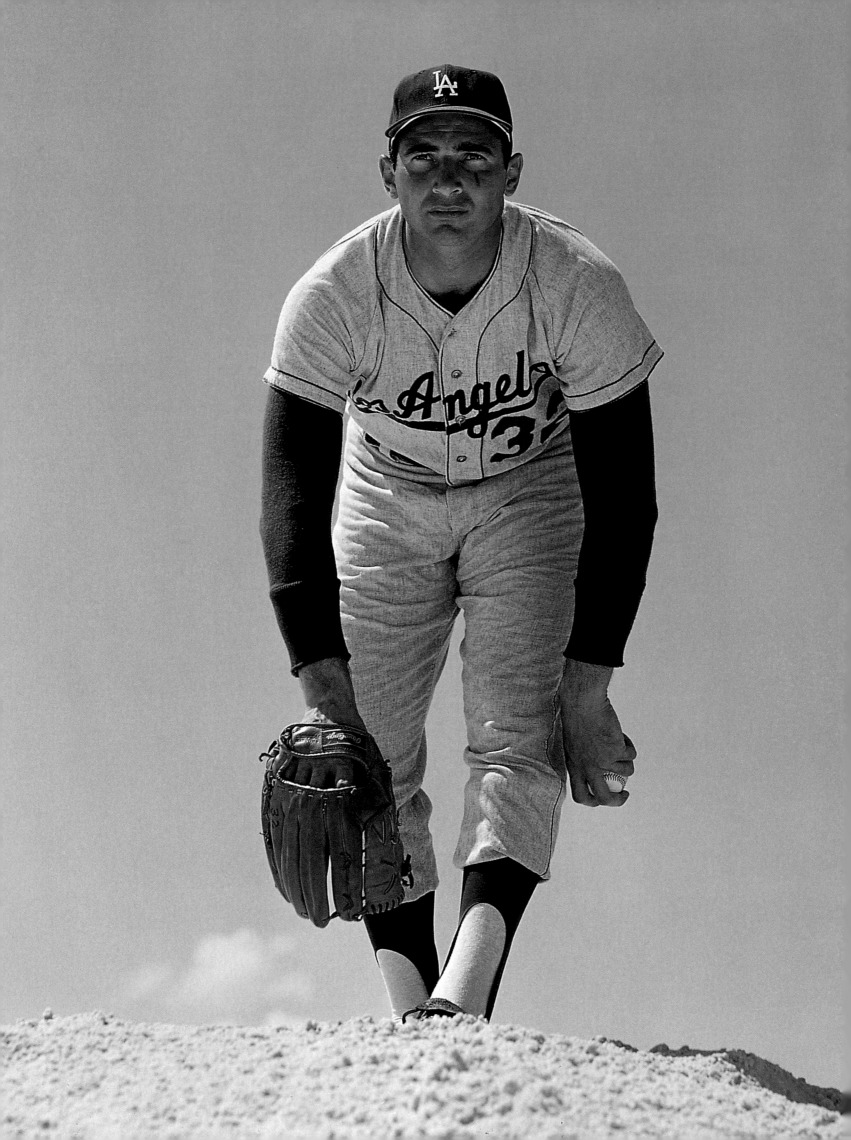

*P*hillies manager Gene Mauch was once asked if Sandy Koufax was the best lefthander he had ever seen. "Best righthander, too," said Mauch. Baseball fans, and especially Dodger fans, went into a state of shock when Koufax retired after his brilliant 1966 season, 27–9, with a 1.73 ERA. But, he said, "There are a lot more things in life I want to do, and I don't want to do them as a sore-armed person."

OPPOSITE: Koufax gets set to deal

Don Drysdale

◆ BORN: 1936 DIED: 1993

◆ PITCHER 1956–68 Dodgers

◆ 209–166 career won–lost record

◆ 2.95 career ERA

◆ 2,486 career strikeouts

◆ 20-game winner 1962, '65

◆ Cy Young Award 1962

◆ All-Star 1959, '61–65, '67, '68

◆ Elected to the Hall of Fame 1984

Despite a Hollywood smile, Drysdale was a mean sonofagun on the mound. He holds the NL career record for hit batsmen with 154. In a game against the Braves one year he hit Hank Aaron in the back. The next day, during batting practice, Drysdale told Aaron, "Sorry I hit you in the back yesterday. I meant to hit you in the neck."

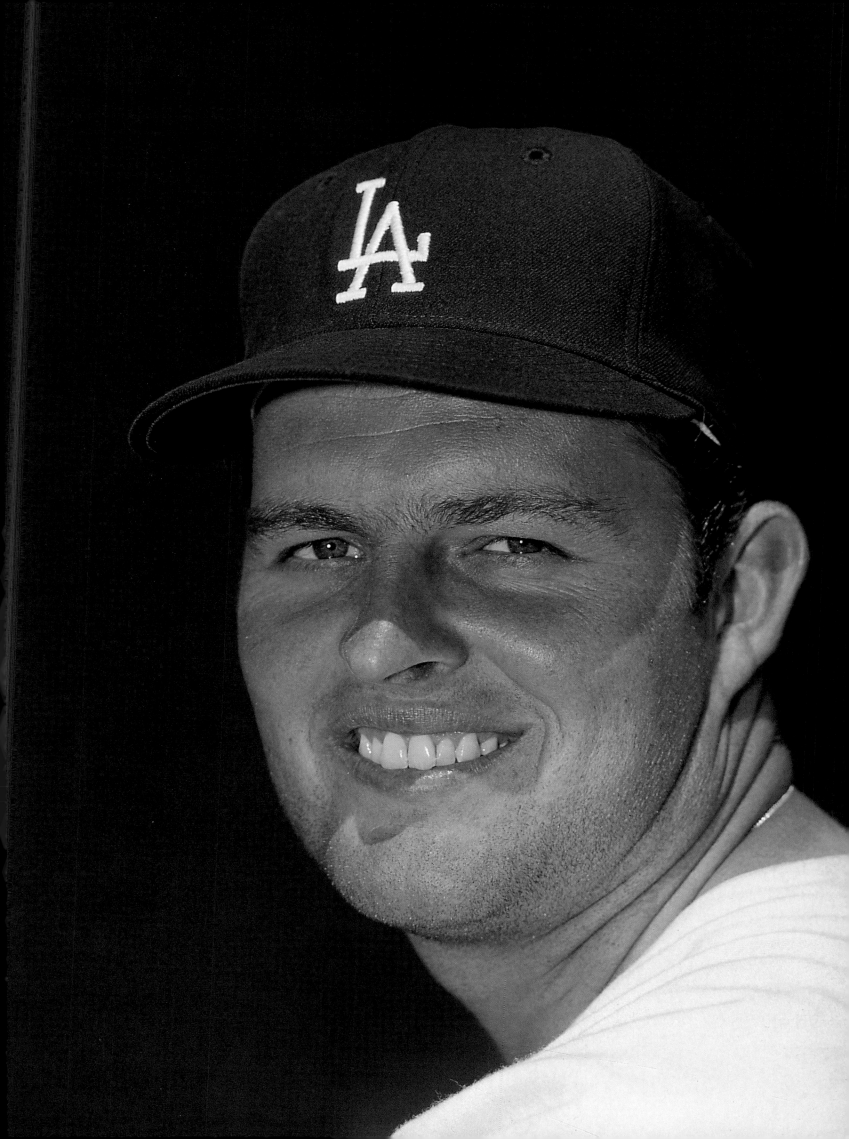

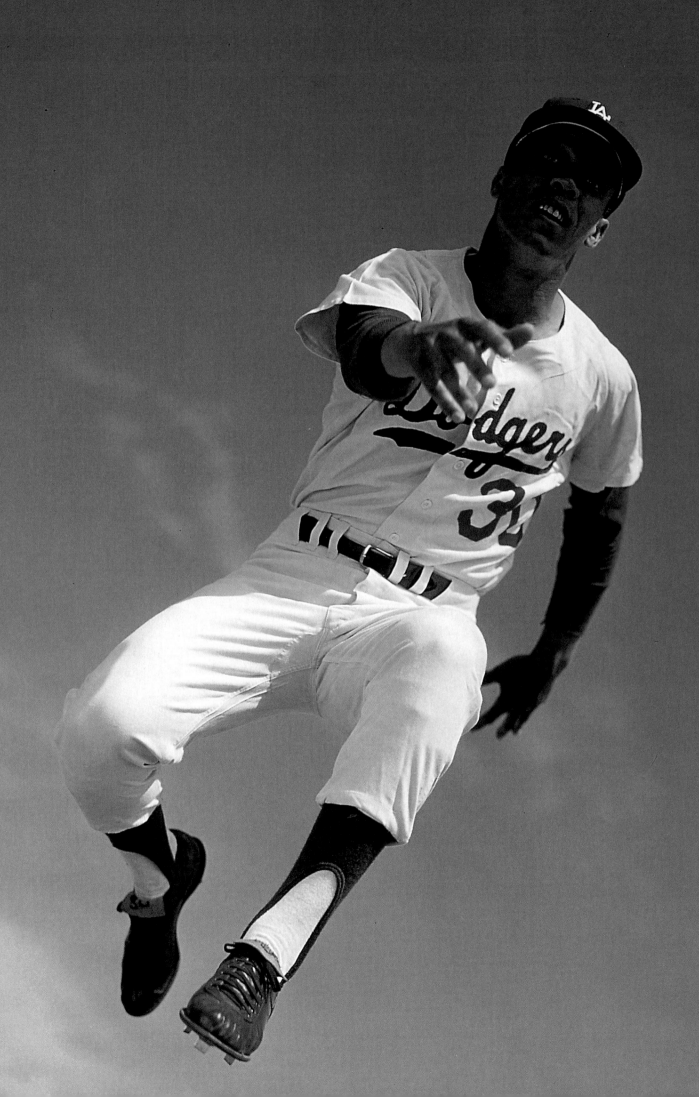

Maury Wills

- ◆ BORN: 1932

- ◆ INFIELDER 1959–72 Dodgers, Pirates, Expos

- ◆ MANAGER 1980–81 Mariners

- ◆ .281 career batting average

- ◆ 586 career stolen bases

- ◆ MVP 1962

- ◆ All-Star 1961–63, '65, '66

As good a player as Wills was, he was at least that bad as a manager. At the press conference announcing his hiring, Wills was asked who his centerfielder would be. "I wouldn't be a bit surprised if it was Leon Roberts," said Wills, who was surprised to find out that Roberts had been traded five weeks earlier.

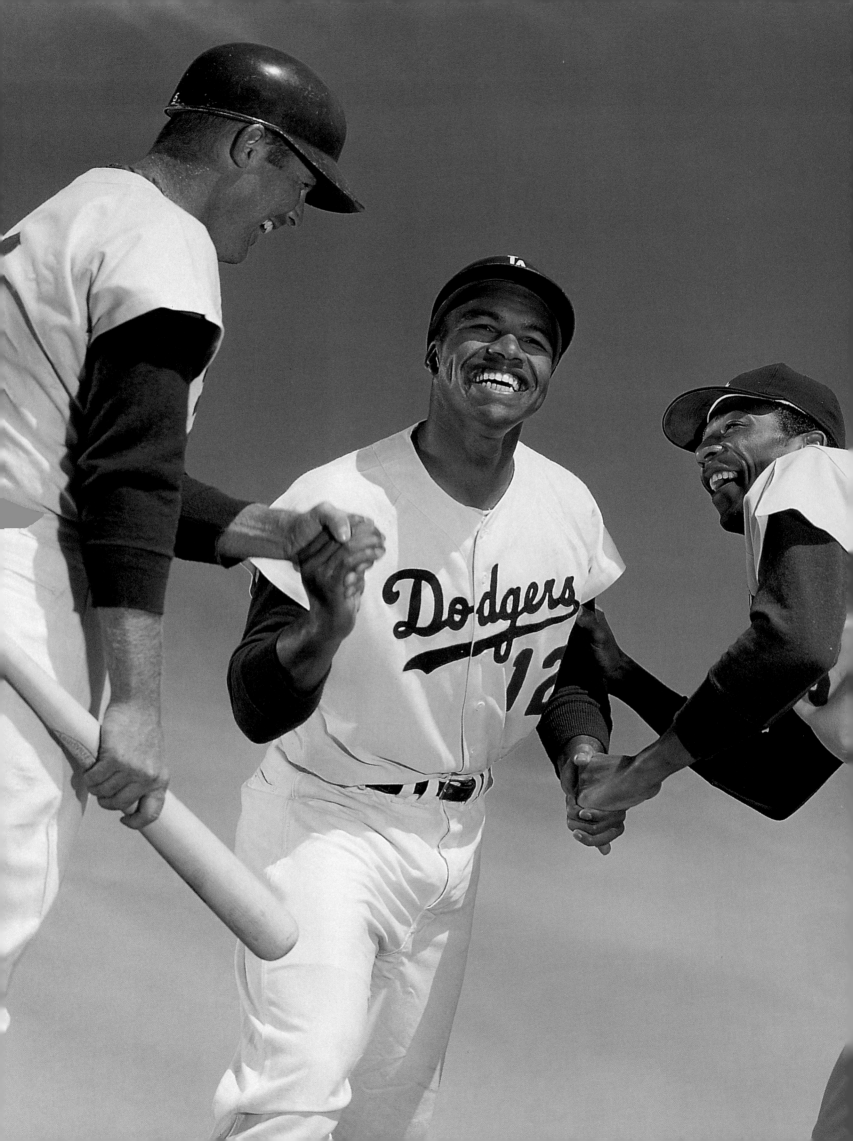

Tommy Davis

- ◆ BORN: 1939

- ◆ OUTFIELDER 1959–76 Dodgers,
 Mets, White Sox, Pilots, Astros,
 A's, Cubs, Orioles, Angels, Royals

- ◆ .294 career batting average

- ◆ 1,052 career RBIs

- ◆ .320 career pinch-hitting average

- ◆ All-Star 1962, '63

Davis was a high-school basketball star in Brooklyn, where he played alongside future NBA great Lenny Wilkins. But the hometown Dodgers signed him in 1956, thanks to Jackie Robinson, who personally recruited him. Davis was often labeled as lazy, but as he later said, "The lazier I felt, the better I hit."

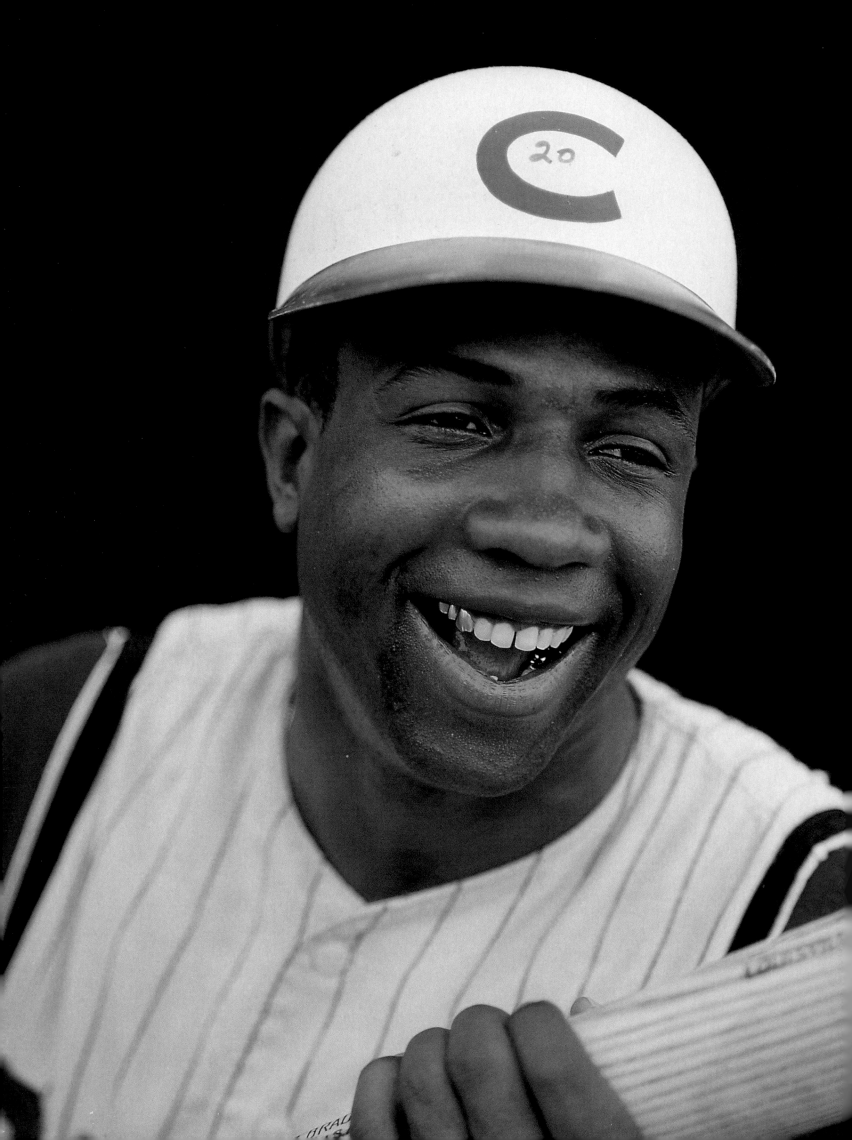

Frank Robinson

- BORN: 1935

- OUTFIELDER 1956–76 Reds, Orioles, Dodgers, Angels, Indians

- MANAGER 1975–77, '81–84, '88 Indians, Giants, Orioles

- .294 career batting average

- 586 career home runs

- 1,812 career RBIs

- 1966 Triple Crown (.317 BA, 49 HRs, 122 RBIs)

- Rookie of the Year 1956

- MVP 1961, '66

- All-Star 1956, '57, '59, '61, '62, '65, '66, '69–71, '74

- First African-American major league manager

- Elected to the Hall of Fame 1982

In the '50s, Gabe Paul, then the Reds general manager, went to see his old mentor Branch Rickey, then the GM of the Pirates, about a trade. They agreed on the principals of the deal, but Rickey had one more small request. "What about that minor league outfielder of yours with the bad knee? I think his name is Frankie Robinson." Paul said, "No deal," to which Rickey said, "I'm proud of you, Gabe."

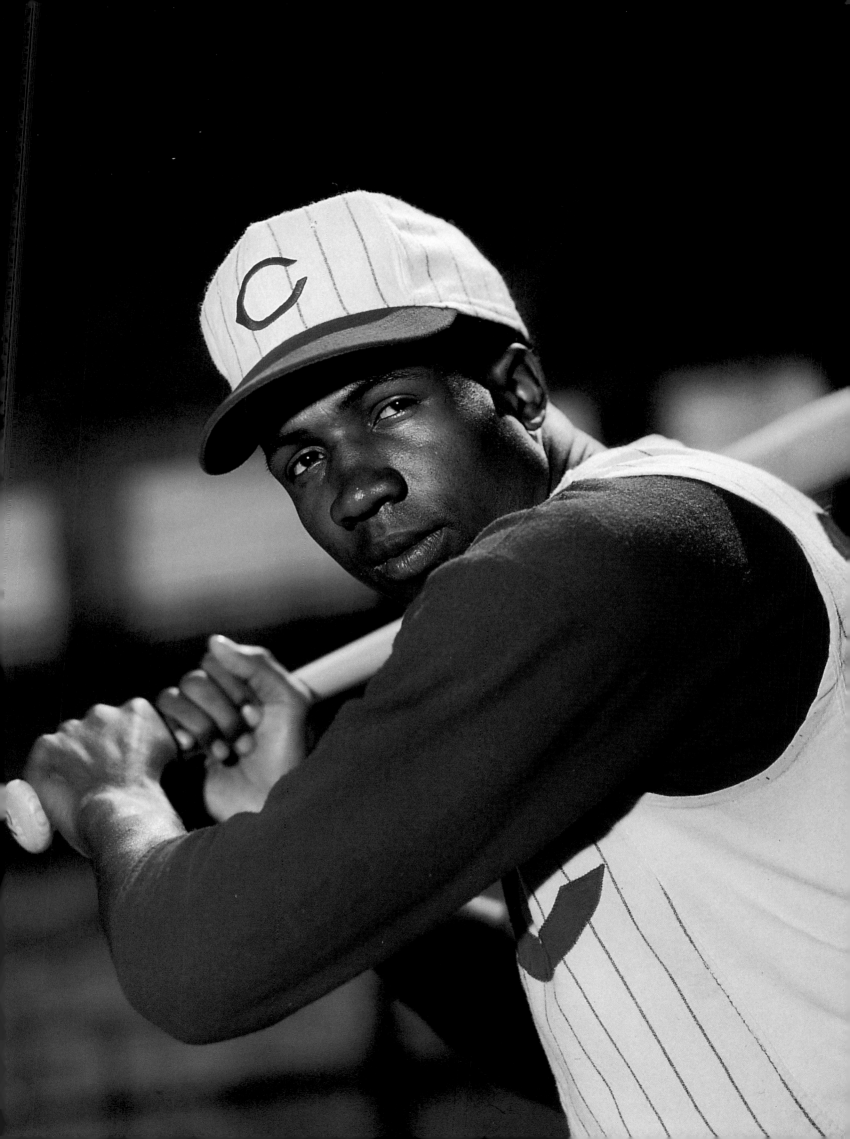

\mathcal{F}rank Robinson had a reputation
as a hard-nosed player, but Ozzie was
able to capture his softer side, signing a
ball for a kid. Robby maintained his
remarkable cool on the trip from
Cincinnati to Baltimore.

PRECEDING PAGE 92: Robinson signs
his autograph

PRECEDING PAGE 93: Robinson at bat
for the Reds

OPPOSITE: Robby became an even
bigger star as an Oriole

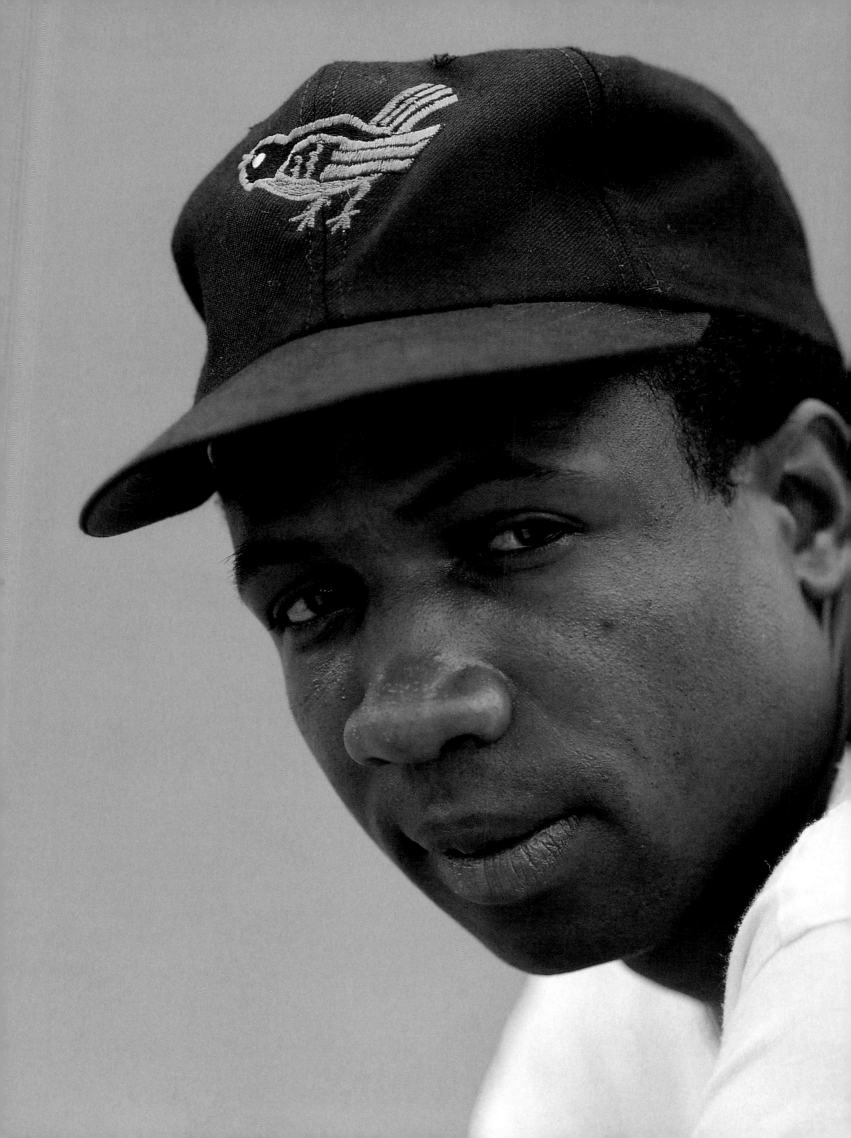

Ted Kluszewski

- ◆ BORN: 1924 DIED: 1988

- ◆ FIRST BASEMAN 1947–61 Reds, Pirates, White Sox, Angels

- ◆ .298 career batting average

- ◆ 279 career home runs

- ◆ 1,028 career RBIs

- ◆ All-Star 1953–56

- ◆ Led NL first basemen in fielding 1951–55

When Leo Durocher once suggested that Gil Hodges was the strongest man in the National League, he was asked, "What about Kluszewski?" Durocher replied, "Kluszewski? Hell, I thought we were talking about human beings."

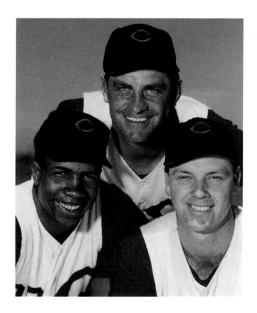

ABOVE: Robby, Klu, and Gus Bell

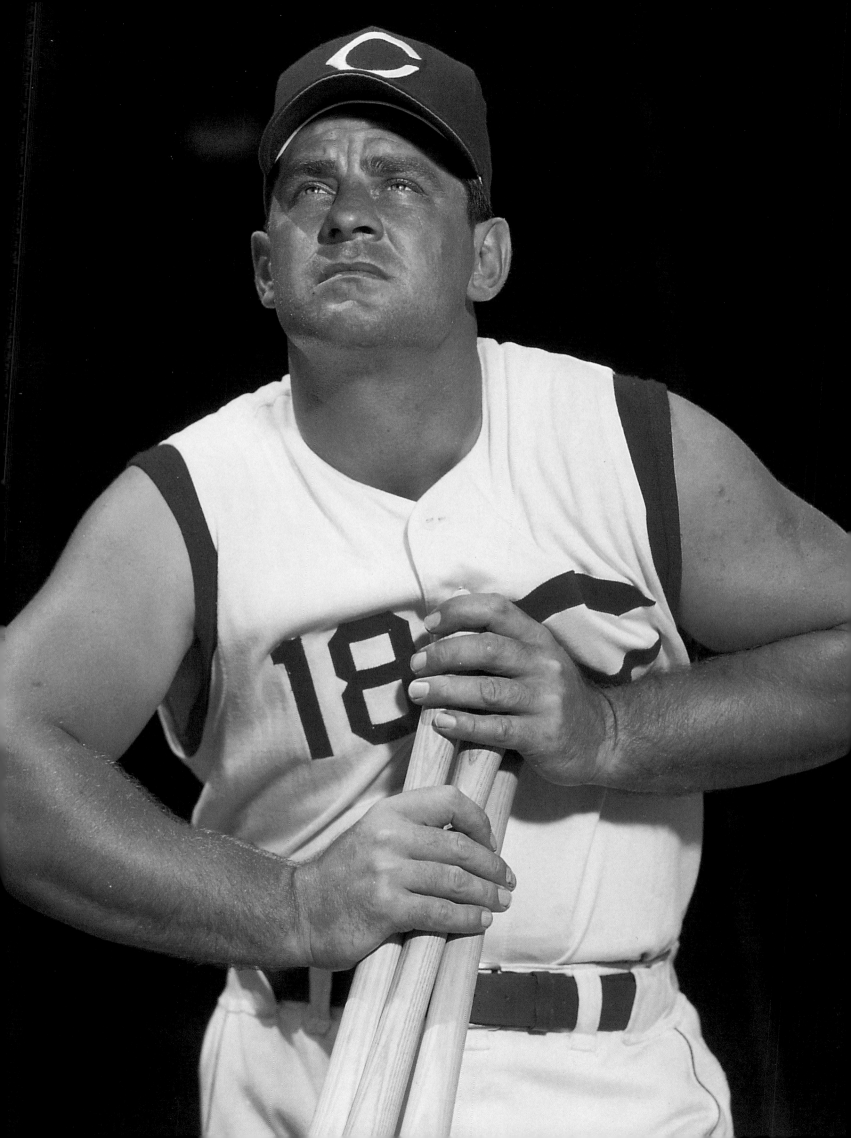

Ewell Blackwell

- BORN: 1922
- PITCHER 1942–55 Reds, Yankees, A's
- 82–78 career won–lost record
- All-Star 1946–51

*K*nown as The Whip for his sidearm delivery, Blackwell seemed to be pitching from third base. In 1947 he came very close to pitching back-to-back no-hitters for the Reds; in the start after his no-hitter against the Braves, he held the Dodgers hitless until Eddie Stanky singled with one out in the ninth. His unorthodox delivery, however, led to arm problems, and The Whip soon lost its sting.

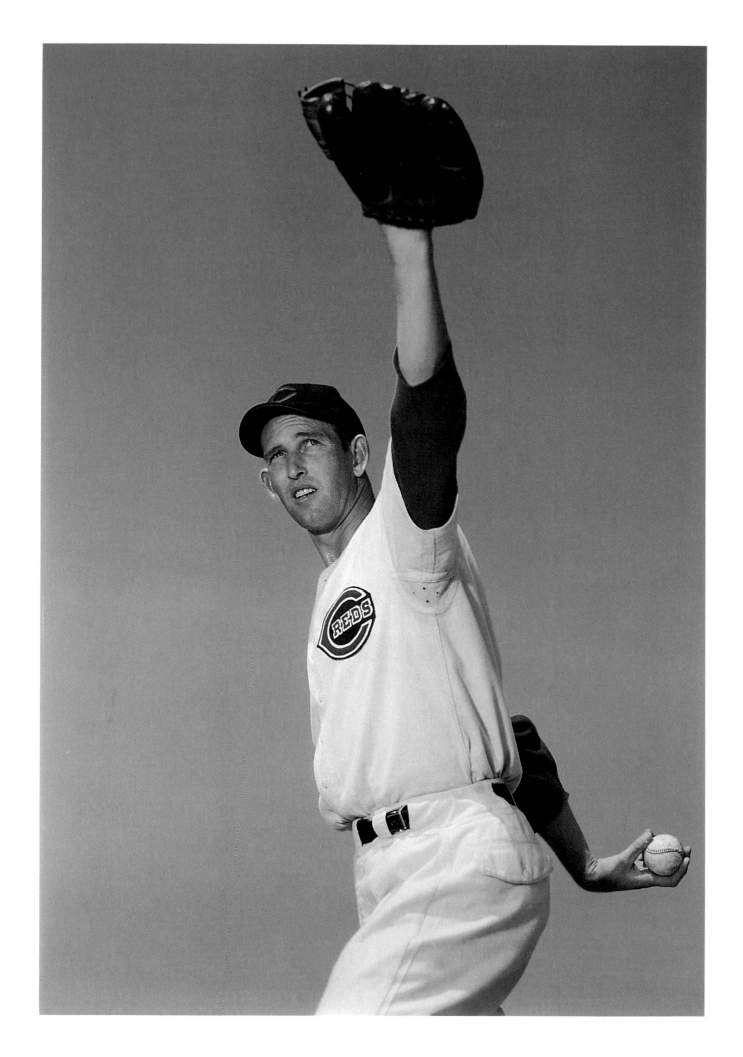

Johnny Bench

- ◆ BORN: 1947

- ◆ CATCHER 1967–83 Reds

- ◆ .267 career batting average

- ◆ 389 career home runs

- ◆ 1,376 career RBIs

- ◆ Rookie of the Year 1968

- ◆ MVP 1970, '72

- ◆ All-Star 1968–77, '80, '83

- ◆ Elected to the Hall of Fame 1989

In one game during Bench's rookie season, he was catching a journeyman named Jerry Arrigo. "He thought he had a fastball," Bench recalled. "I called for a curve and he shook it off, a curve again and he shook it off, a curve one more time and he shook it off. He finally threw a fastball outside." Bench displayed his disdain by reaching out and catching the ball barehanded.

Pete Rose

- ◆ BORN: 1941

- ◆ INFIELDER-OUTFIELDER 1963–86
 Reds, Phillies, Expos

- ◆ MANAGER 1984–89 Reds

- ◆ .303 career batting average

- ◆ Rookie of the Year 1963

- ◆ All-Star 1965, '67–71, '73–82, '85

- ◆ Career leader in hits (4,256),
 singles (3,215), at-bats (14,053),
 and games played (3,562)

- ◆ Suspended indefinitely from
 baseball 1989

After "Charlie Hustle" broke Ty Cobb's record for the most hits in a career, an interviewer asked him if he thought Cobb might be watching him from above. Rose replied, "From what I know about Ty Cobb, he's not watching from up there." Because of his own gambling activities, Rose has had to watch baseball from Purgatory.

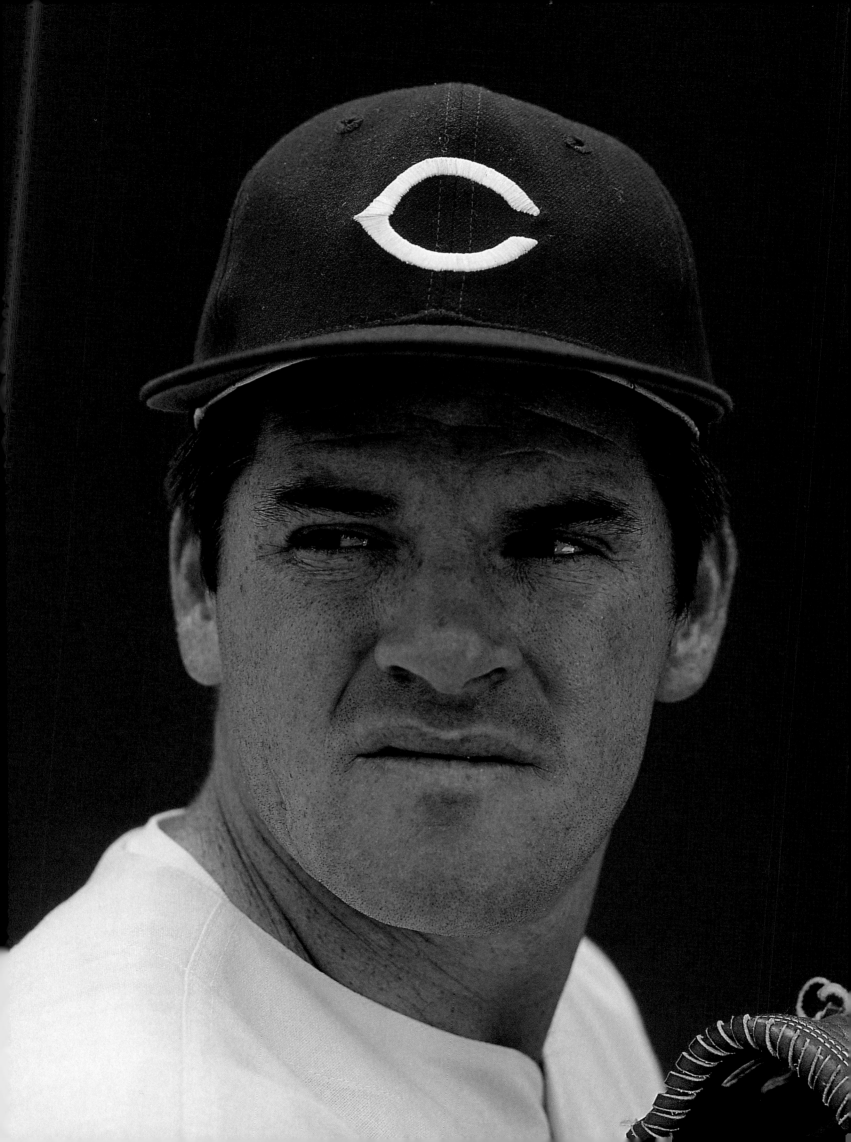

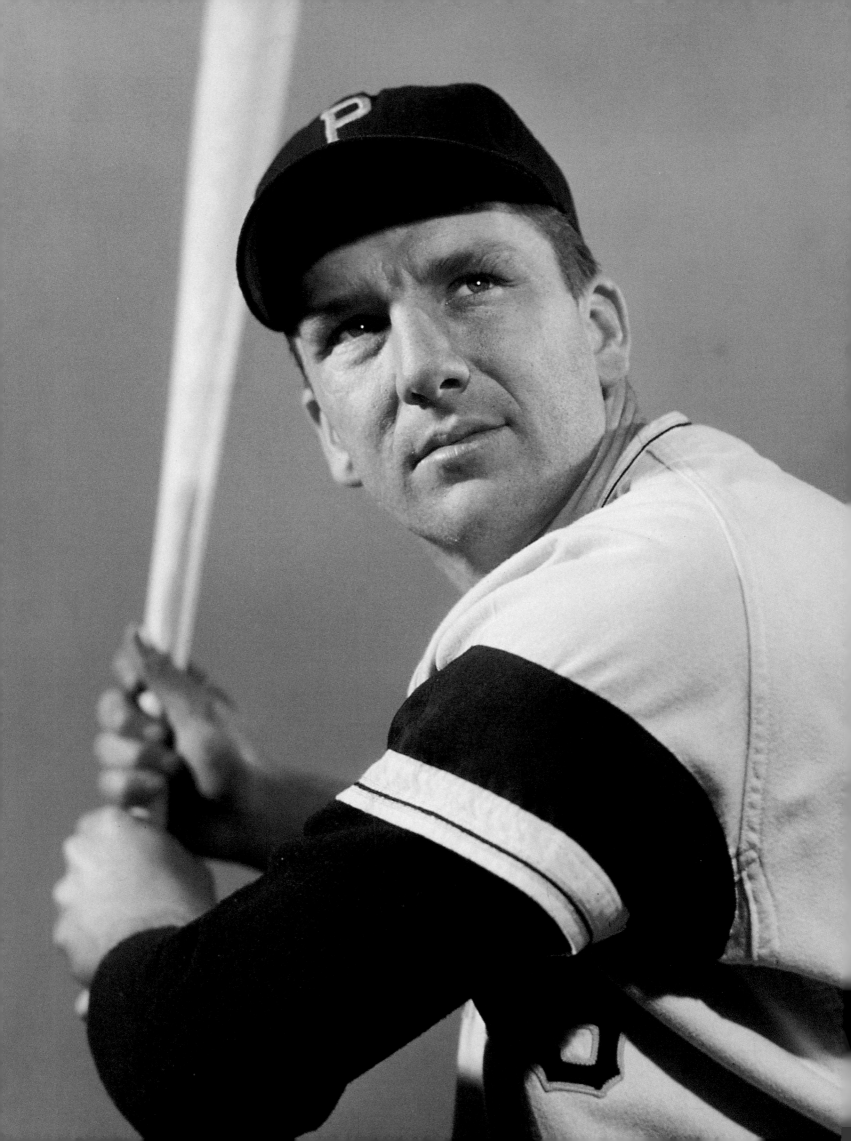

Ralph Kiner

- ◆ BORN: 1922

- ◆ OUTFIELDER 1946–55 Pirates, Cubs, Indians

- ◆ .279 career batting average

- ◆ 369 career home runs

- ◆ 1,015 career RBIs

- ◆ All-Star 1948–53

- ◆ Elected to the Hall of Fame 1975

- ◆ Mets Broadcaster 1962–present

Kiner was the most prodigious home run hitter in baseball in the years after World War II. When asked why he didn't choke up on the bat in order to improve his average, Kiner said, "Cadillacs are down at the end of the bat."

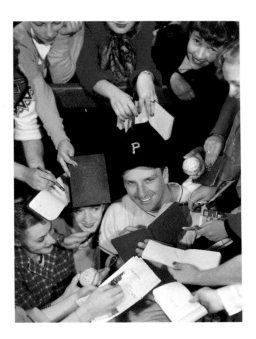

ABOVE: Ozzie actually asked Berra to do this shot, but Yogi didn't want to get into trouble with his wife

Roberto Clemente

- BORN: 1934 DIED: 1972

- OUTFIELDER 1955–72 Pirates

- National League MVP 1966

- Four-time NL batting champ with
 a career batting average of .317
 and 3,000 hits

- Winner of 12 Gold Gloves

- 1971 World Series MVP

- First Hispanic player elected to the
 Hall of Fame (1973)

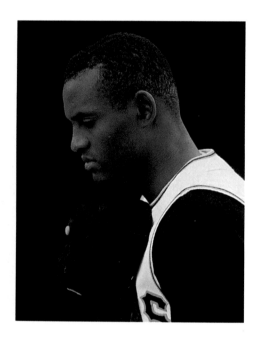

ABOVE: Clemente in a quiet moment

This picture was taken a few months before Clemente's plane, heading to Nicaragua on a mission of mercy, crashed into the ocean on New Year's Eve, 1972. In Pittsburgh the fans shouted "Arriba!" whenever he came to bat with men on base, and in Puerto Rico, there are those who still think this great man will literally arise.

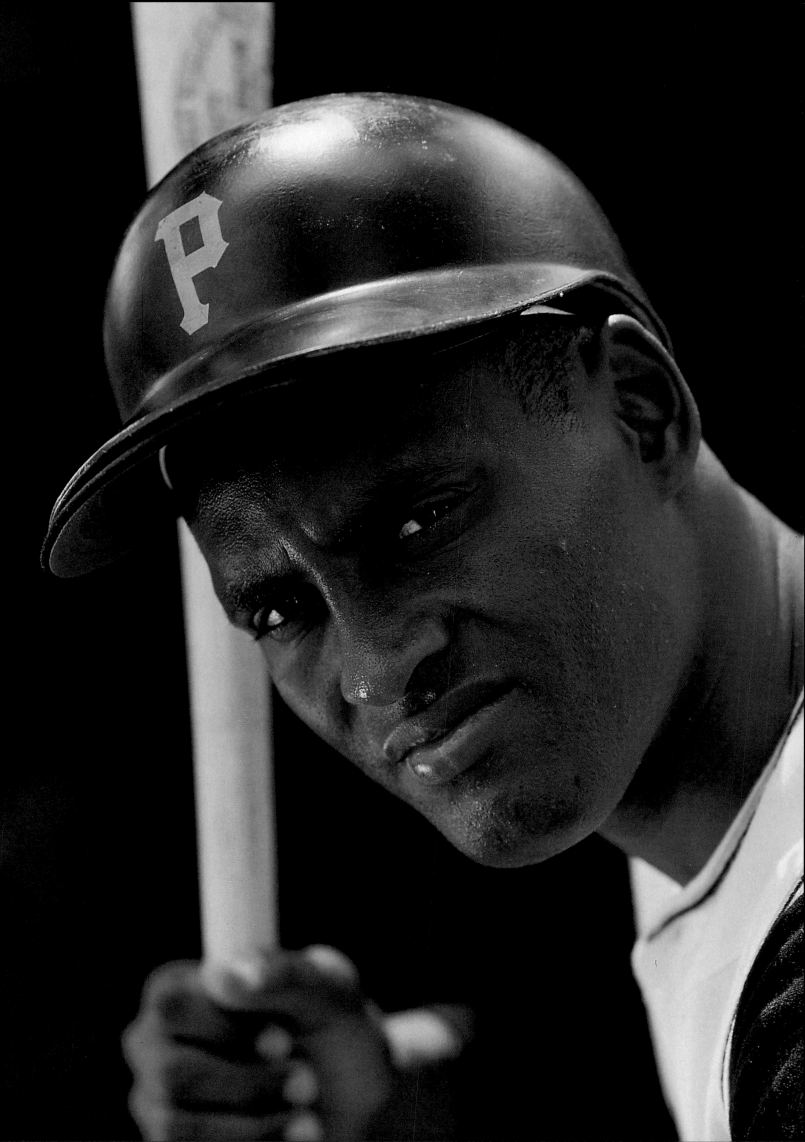

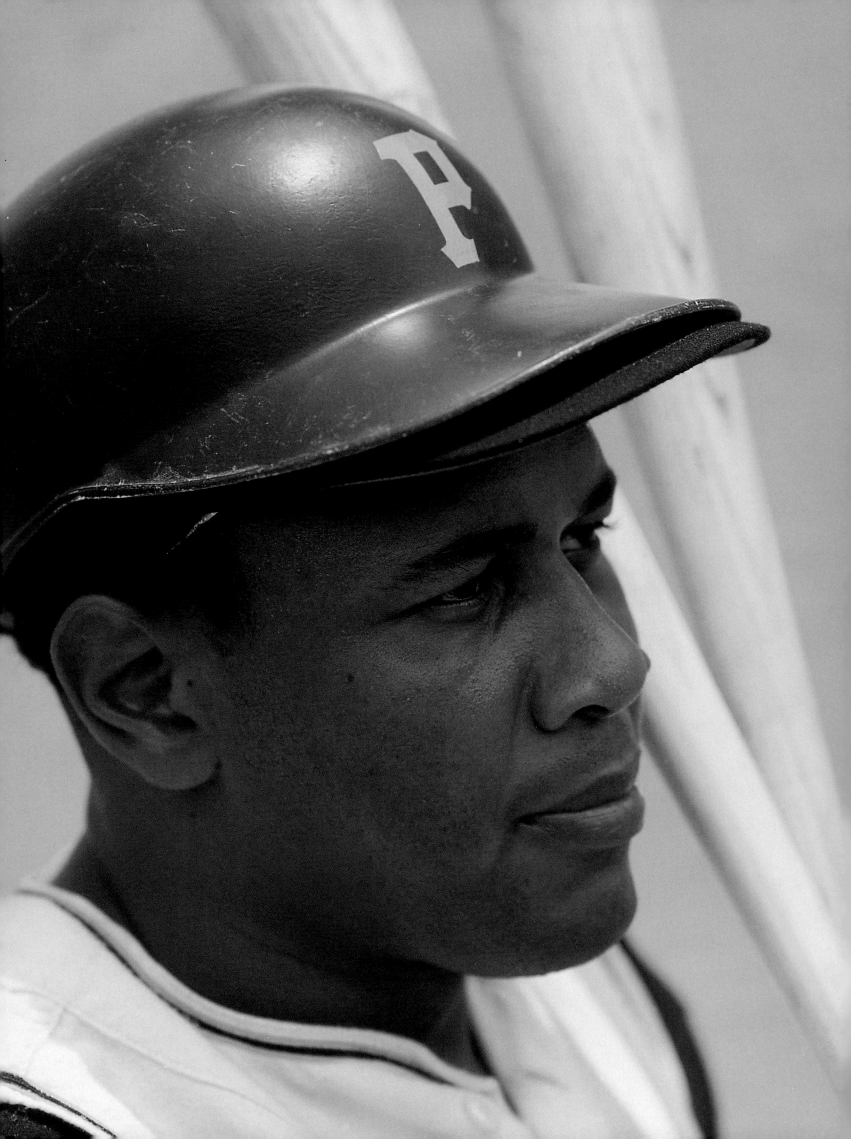

Willie Stargell

- BORN: 1940

- OUTFIELDER, FIRST BASEMAN
 1962–82 Pirates

- .282 career batting average

- 475 career home runs

- 1,540 career RBIs

- MVP 1979

- All-Star 1964–66, '71–73, '78

- Elected to the Hall of Fame 1988

Stargell, who became known as "Pops" toward the end of his career, was a spiritual leader of the Pirates, as well as a great power hitter. Asked to explain his upbeat attitude, Stargell once said, "The umpires always say 'Play ball.' They don't say 'Work ball.'"

Dick Stuart

- ◆ BORN: 1932

- ◆ FIRST BASEMAN 1958–69 Pirates,
 Red Sox, Phillies, Mets, Dodgers,
 Angels

- ◆ .264 career batting average

- ◆ 228 career home runs

- ◆ All-Star 1961

*Something of a fashion plate,
Stuart once said, "I add twenty points
to my average if I know I look bitchin'
out there." He did not look particular-
ly good in the field, however. Stuart
was such a bad first baseman that he
was dubbed "Dr. Strangeglove."*

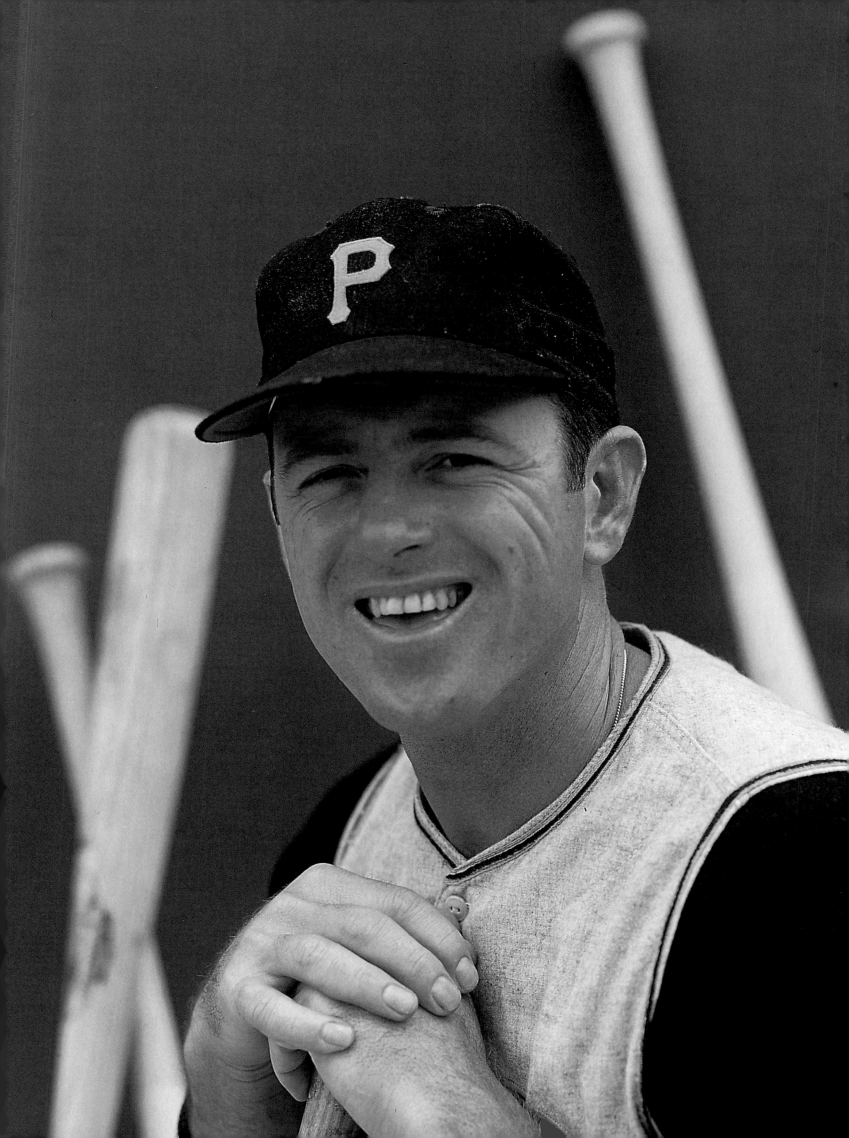

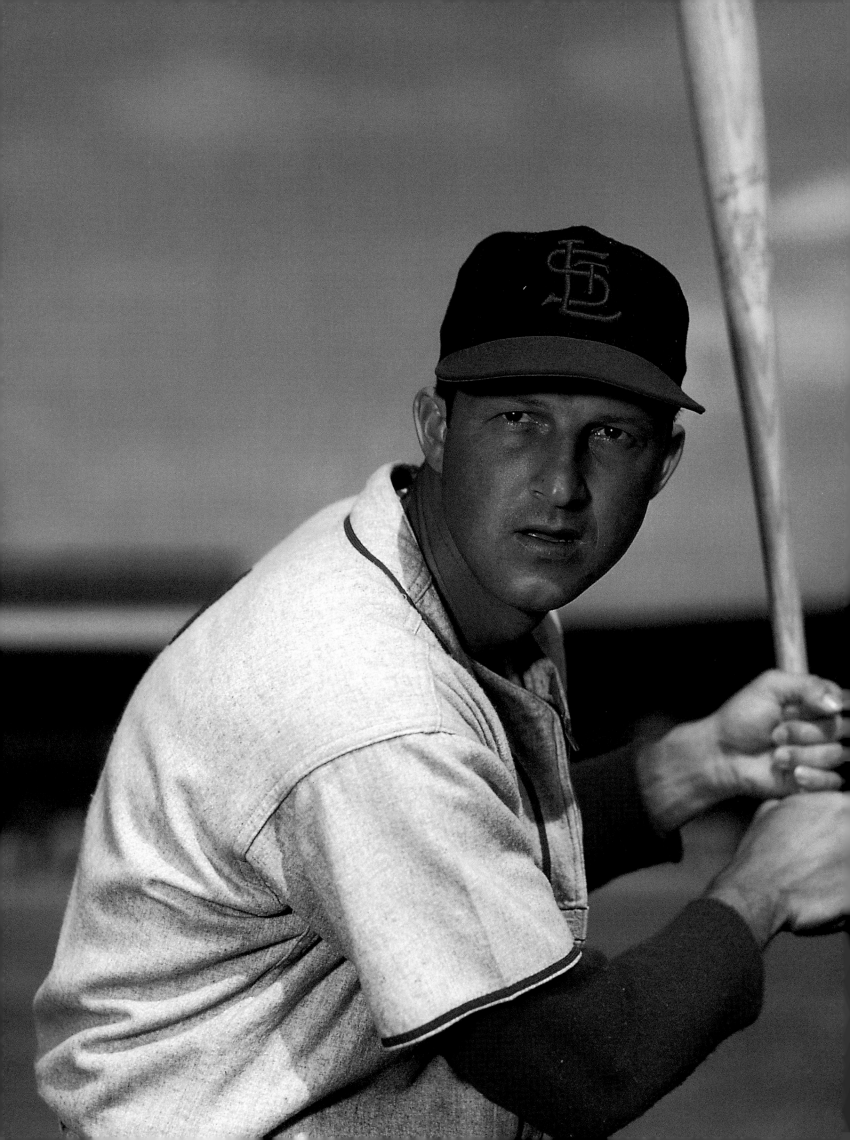

Stan Musial

- BORN: 1920

- OUTFIELDER, FIRST BASEMAN
 1941–63 Cardinals

- .331 career batting average

- 475 career home runs

- 1,951 career RBIs

- MVP 1943, '46, '48

- All-Star 1943, '44, '46–63

- Elected to the Hall of Fame 1969

Before the 1951 All-Star Game, Ed Lopat of the Yankees told Brooklyn's Preacher Roe that he had figured out a way to pitch to Stan The Man. In the fourth inning, Musial lined Lopat's first pitch into the right-field seats. Roe shouted to Lopat, "I see what you mean, but I found that way to pitch to him a long time ago, all by myself."

Bill White

- BORN: 1934

- FIRST BASEMAN, OUTFIELDER
 1956–69 Giants, Cardinals, Phillies

- .286 career batting average

- 202 career home runs

- All-Star 1959–61, '63, '64

- Homered in first major league at-bat

- Won 7 consecutive Gold Gloves
 1960–66

- New York Yankees broadcaster
 1971–87

- NL President 1988–present

Even as a player, White was a thoughtful man. In a 1964 interview in SPORT he told a story about the first day of integration at a school. A black woman came through the angry mob to drop her daughter off. She was followed by a white woman who, after taking her daughter inside, joined the protestors. After school, the white woman asked her daughter, "What happened? What happened with you and the colored girl?" And the little girl said, "We were both so scared, we sat and held hands all day."

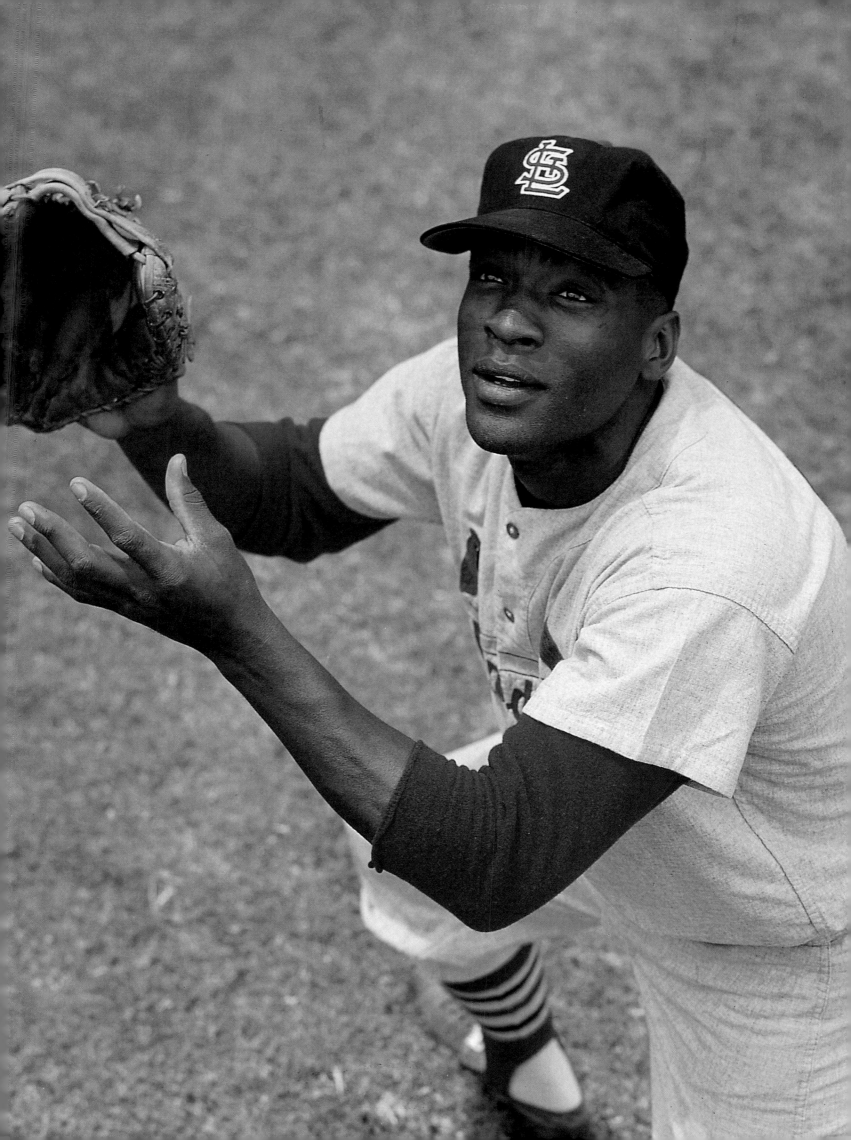

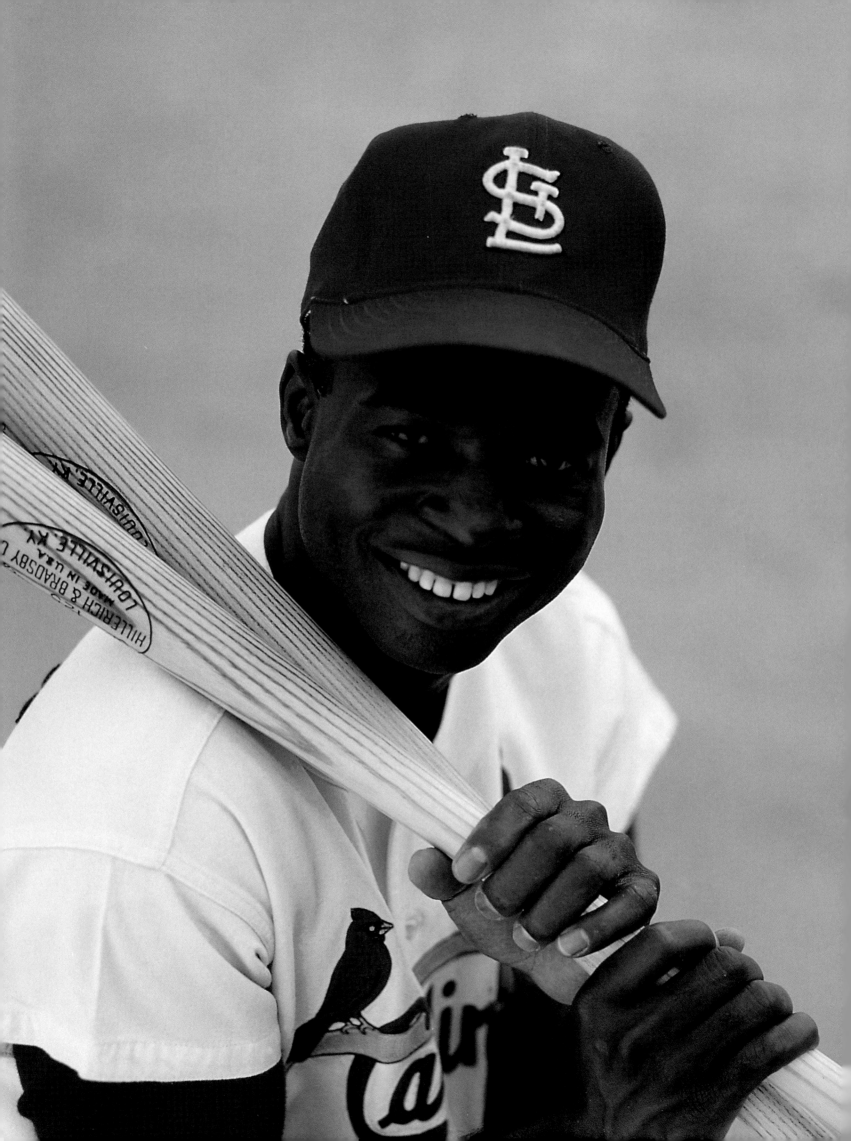

Lou Brock

- ◆ BORN: 1939
- ◆ OUTFIELDER 1961–79 Cardinals
- ◆ .293 career batting average
- ◆ 149 career home runs
- ◆ 938 career stolen bases
- ◆ Elected to the Hall of Fame 1985

After his first semester at Southern University, Brock lost his academic scholarship and the part-time jobs that went along with it. So when he tried out for baseball, he hadn't been eating very well. The coach didn't notice Brock until, while shagging flies under a sweltering sun, Brock collapsed. After he was revived, the coach, perhaps out of pity, allowed Brock to hit. On four of his first five swings, Brock knocked the ball out of the park, and a star was born.

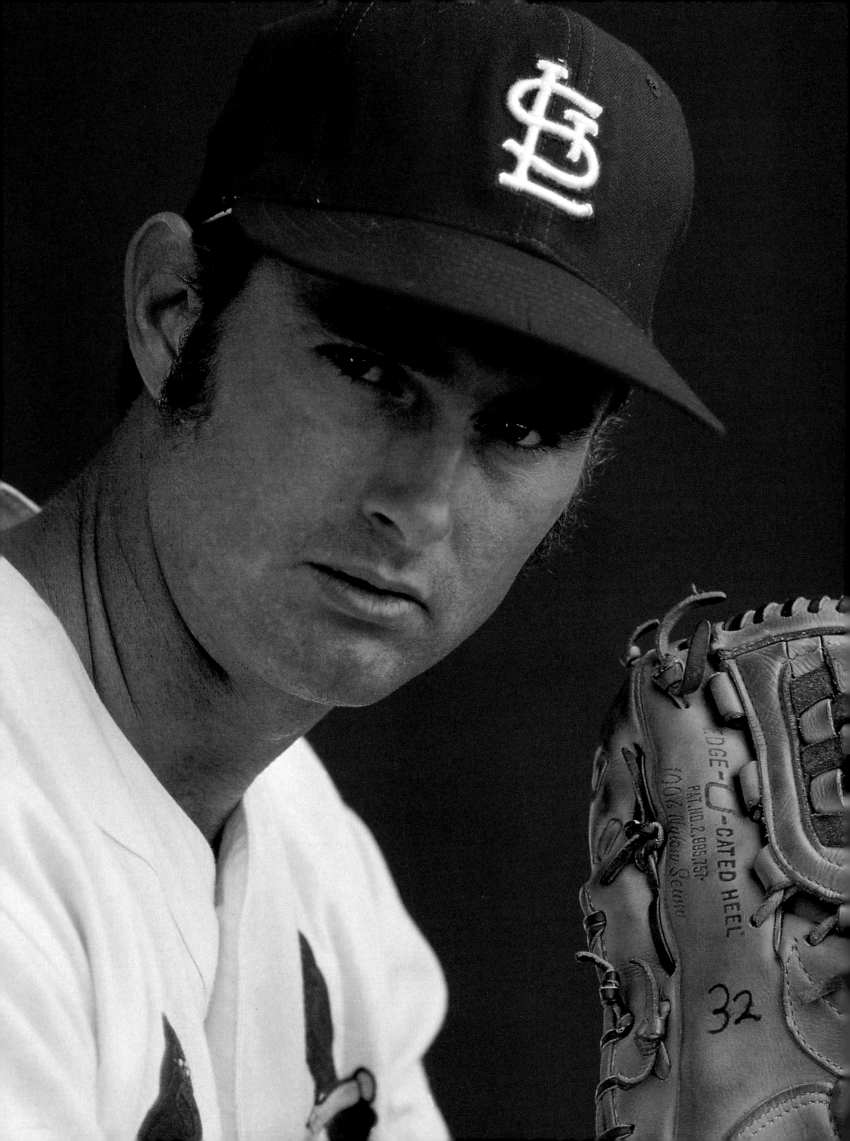

Steve Carlton

- ◆ BORN: 1944
- ◆ PITCHER 1965–88 Cardinals, Phillies, Giants, White Sox, Indians, Twins
- ◆ 329–244 career won–lost record
- ◆ 3.22 career ERA
- ◆ 4,136 career strikeouts
- ◆ Cy Young Award 1972, '77, '80, '82
- ◆ All-Star 1968, '69, '71, '72, '74, '77, '79–82

He didn't talk to the press for most of his career, and he left batters talking to themselves. In 1975 Willie Stargell said of Carlton, "Sometimes I hit him like I used to hit Koufax, and that's like drinking coffee with a fork! Did you ever try that?"

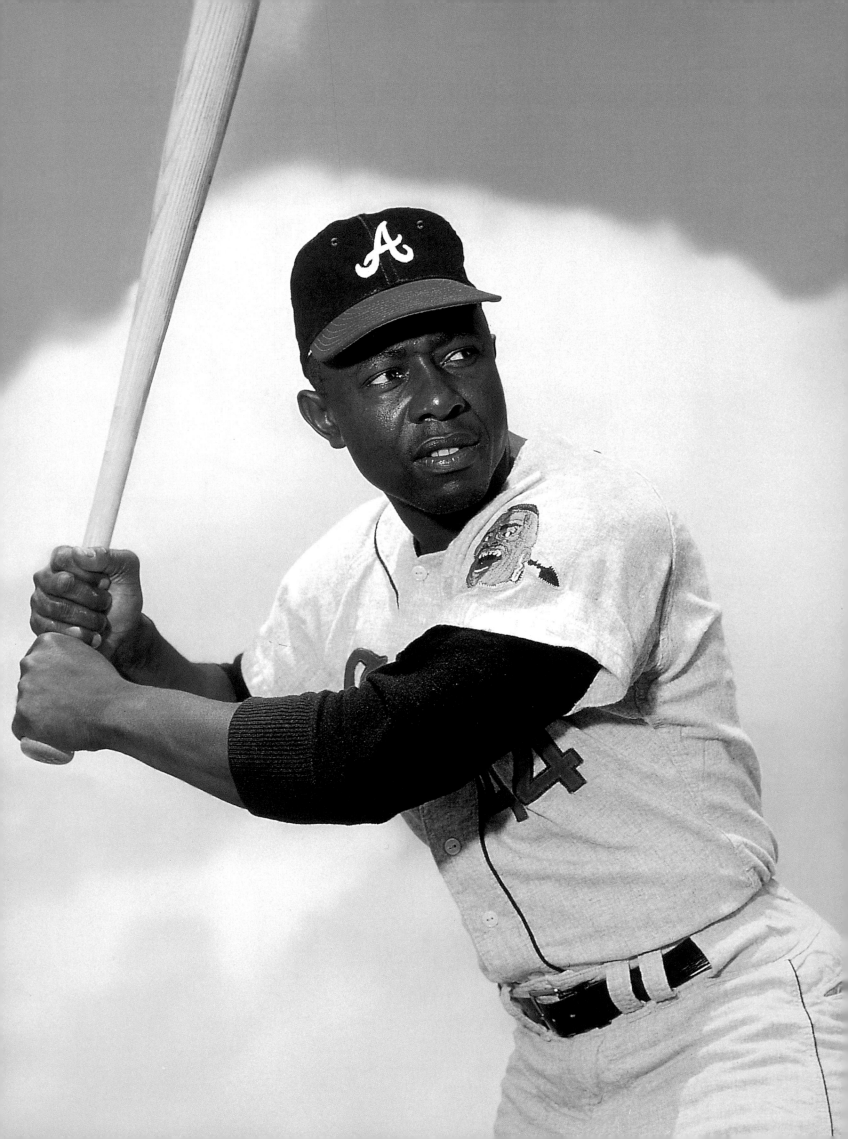

Hank Aaron

◆ BORN: 1934

◆ OUTFIELDER 1954–76 Braves, Brewers

◆ .305 career batting average

◆ 755 career home runs

◆ 2,297 career RBIs

◆ MVP 1957

◆ All-Star 1954-76

◆ Elected to the Hall of Fame 1982

In a way, Aaron was born to greatness. To this day he is first alphabetically—not to mention homerically—of anyone who has played major league baseball. His father, Herbert Aaron, recalled seeing Hank early in his career in Montgomery, Alabama: "When Henry came up, I heard the fans yell, 'Hit that nigger. Hit that nigger.' " Henry hit the ball up against the clock. The next time he came up, they said, 'Walk him. Walk him.'"

Eddie Mathews

- ◆ BORN: 1931

- ◆ THIRD BASEMAN 1952–68 Braves, Astros, Tigers

- ◆ MANAGER 1972–74 Braves

- ◆ .271 career batting average

- ◆ 512 career home runs

- ◆ 1,453 career RBIs

- ◆ All-Star 1953, '55–62

- ◆ Elected to the Hall of Fame 1978

Ty Cobb once said of Mathews, "I've only known three or four perfect swings in my time. This lad has one of them." Mathews was also as tough as they come. After Frank Robinson complained about a hard tag applied by the Braves' third baseman, Mathews socked Robinson and said, "How about that tag?"

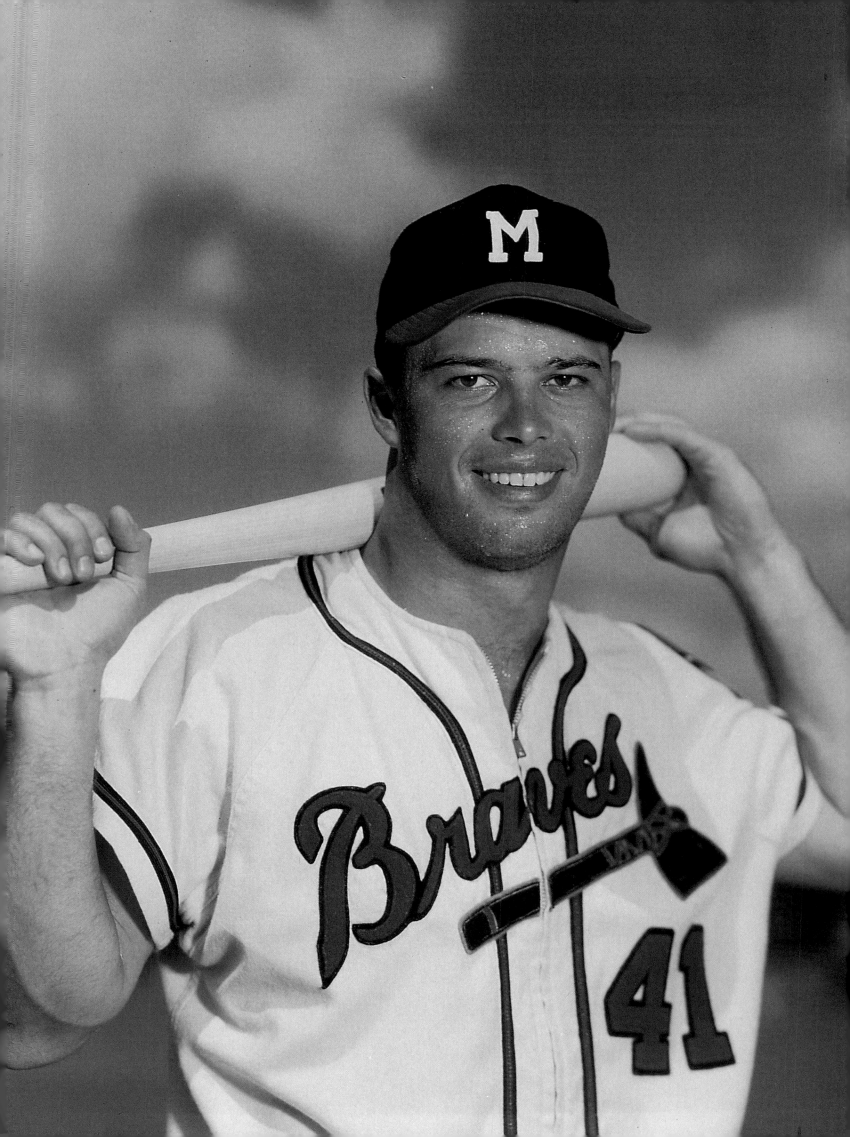

Warren Spahn

- BORN: 1921

- PITCHER 1942–65 Braves, Mets, Giants

- 363–245 career won–lost record

- 3.09 career ERA

- 2,583 career strikeouts

- 2 career no-hitters

- 35 career home runs (NL record for pitchers)

- Cy Young Award 1957

- All-Star 1949–51, '53, '54, '56–61, '63

- Elected to the Hall of Fame 1973

Spahn has the singular distinction of being a teammate of both Paul Waner and Ron Swoboda. As Stan Musial said of the crafty lefthander, "I don't think Warren Spahn will ever get into the Hall of Fame. He'll never stop pitching." Indeed, Spahn didn't hang up his spikes as a pitcher until he was 56.

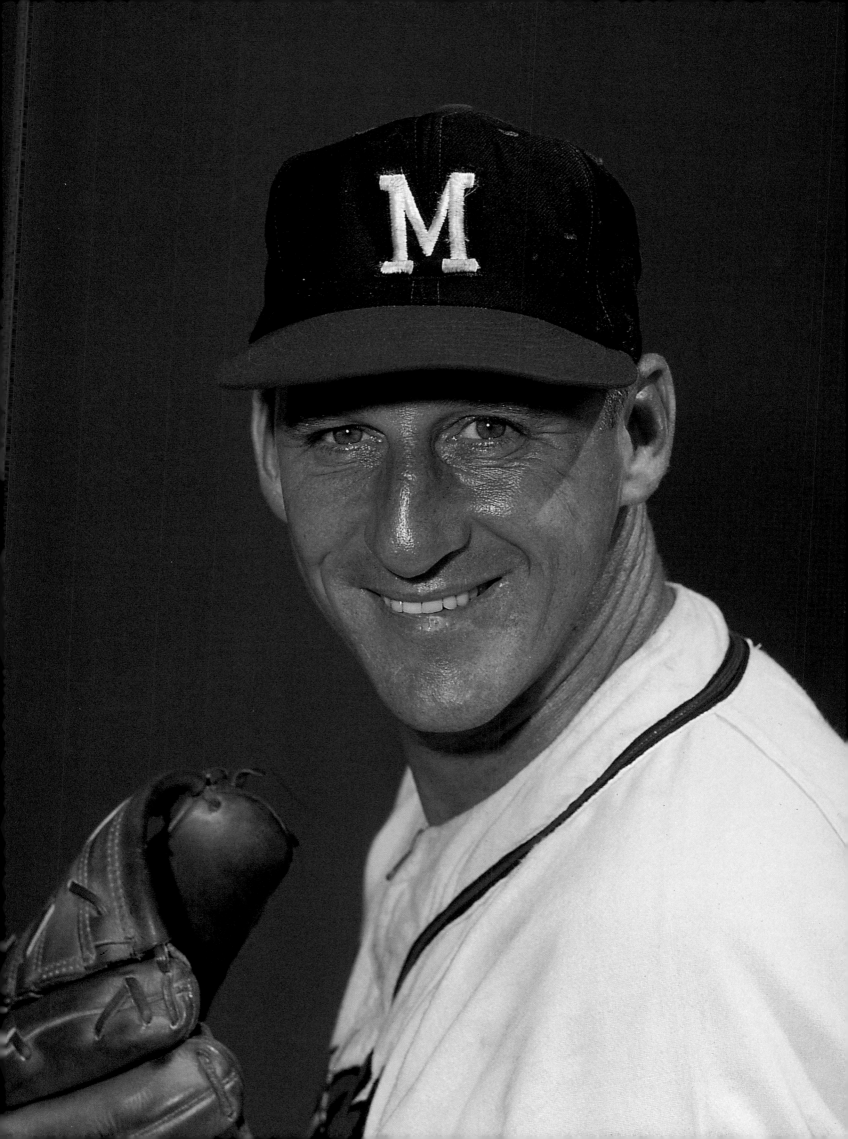

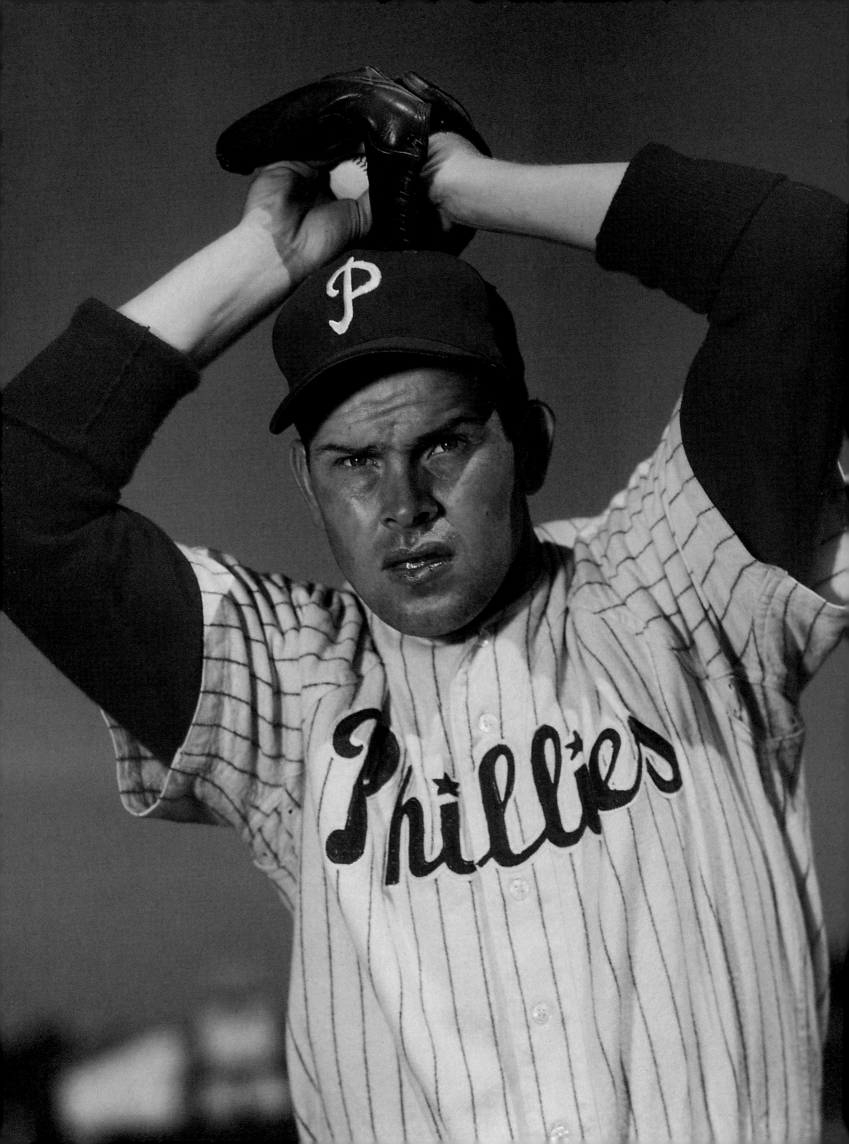

Robin Roberts

◆ BORN: 1926

◆ PITCHER 1948–66 Phillies, Orioles, Astros, Cubs

◆ 286–245 career won–lost record

◆ 3.41 career ERA

◆ All-Star 1950–56

◆ Elected to the Hall of Fame 1976

He won 20 games or more in six straight seasons, and he once pitched 28 straight complete games, but Roberts may have made his most lasting impact on baseball off the field. Active in the Players Association, Roberts was part of the group that interviewed and hired Marvin Miller.

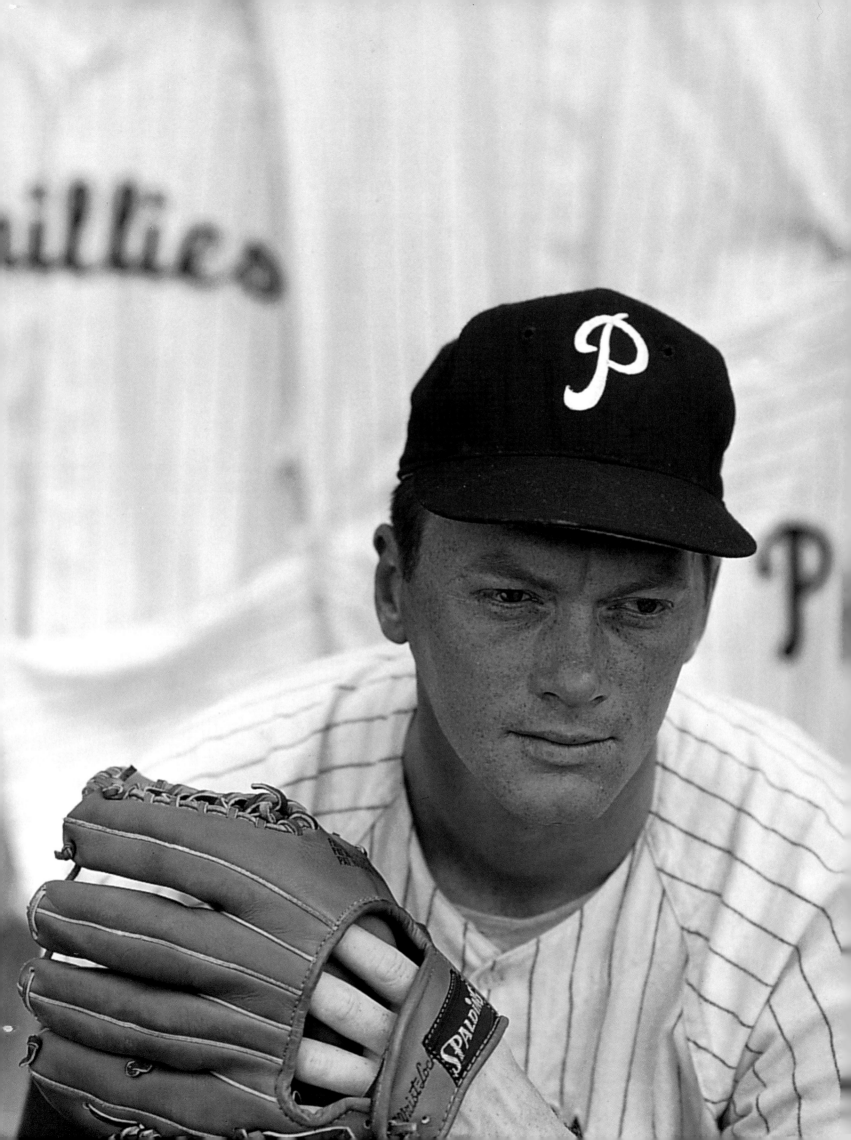

Jim Bunning

- BORN: 1931

- PITCHER 1955–71 Tigers, Phillies, Pirates, Dodgers

- 224–184 career won–lost record

- 3.27 career ERA

- 2,855 career strikeouts

- First pitcher to win no-hitters in both leagues

- Elected to the U.S. House of Representatives 1986

A father of 12, Bunning enjoyed his greatest moment when he pitched a perfect game against the New York Mets on June 21, 1964—Fathers' Day. While Bunning has not yet been elected to the Hall of Fame, he has been elected to Congress, serving as a Republican representative from Kentucky.

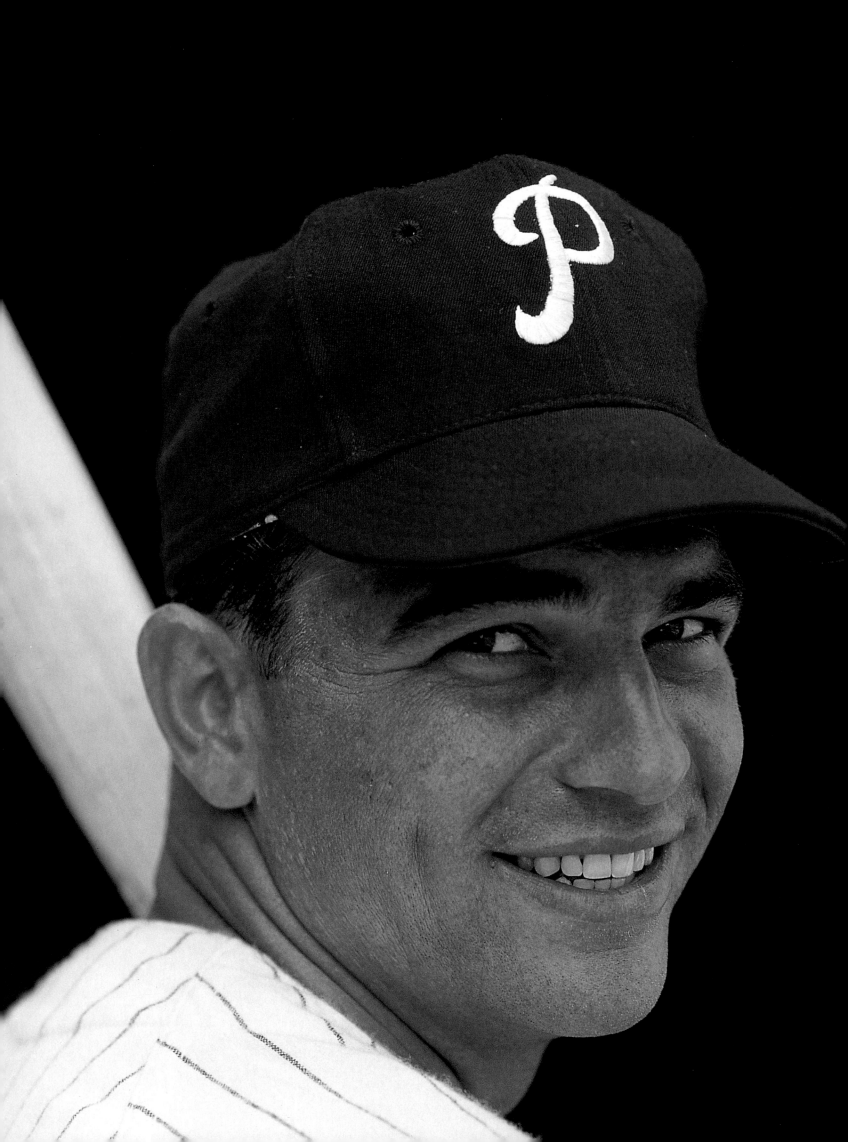

Johnny Callison

- BORN: 1939
- OUTFIELDER 1958–73 White Sox, Phillies, Cubs, Yankees
- .264 career batting average
- 226 career home runs
- All-Star 1962, '64, '65

*P*hillies manager Gene Mauch said of Callison, "There's nothing he can't do well on a ball field." He did it best in '64, when he nearly led the Phillies to the pennant (they finished second to the Cardinals) and almost won the MVP award (he lost out to Ken Boyer of the Cards). He did give the NL victory in the All-Star Game that year, hitting a dramatic ninth-inning homer off Dick Radatz.

Dick Allen

- ◆ BORN: 1942

- ◆ INFIELDER, OUTFIELDER 1963–77
 Phillies, Cardinals, Dodgers,
 White Sox, A's

- ◆ .292 career batting average

- ◆ 351 career home runs

- ◆ 1,119 career RBIs

- ◆ Rookie of the Year 1964

- ◆ AL MVP 1972

A gifted but troubled player, Allen took to writing messages in the dirt around first base during his first stint with the Phillies. When Commissioner Bowie Kuhn told the team to make him stop, Allen responded by writing three more messages: NO, WHY, and MOM. When asked, "Why Mom?" Allen answered, "To say she tells me what to do, not the man up there."

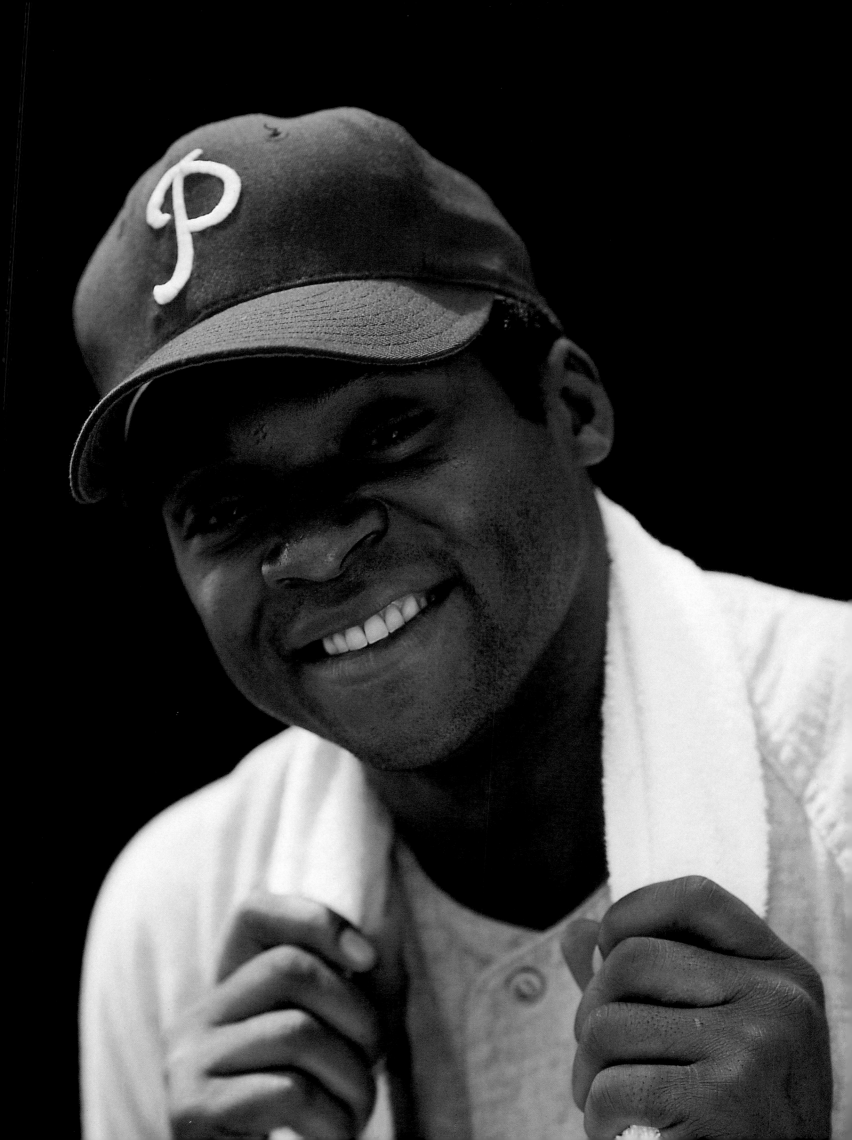

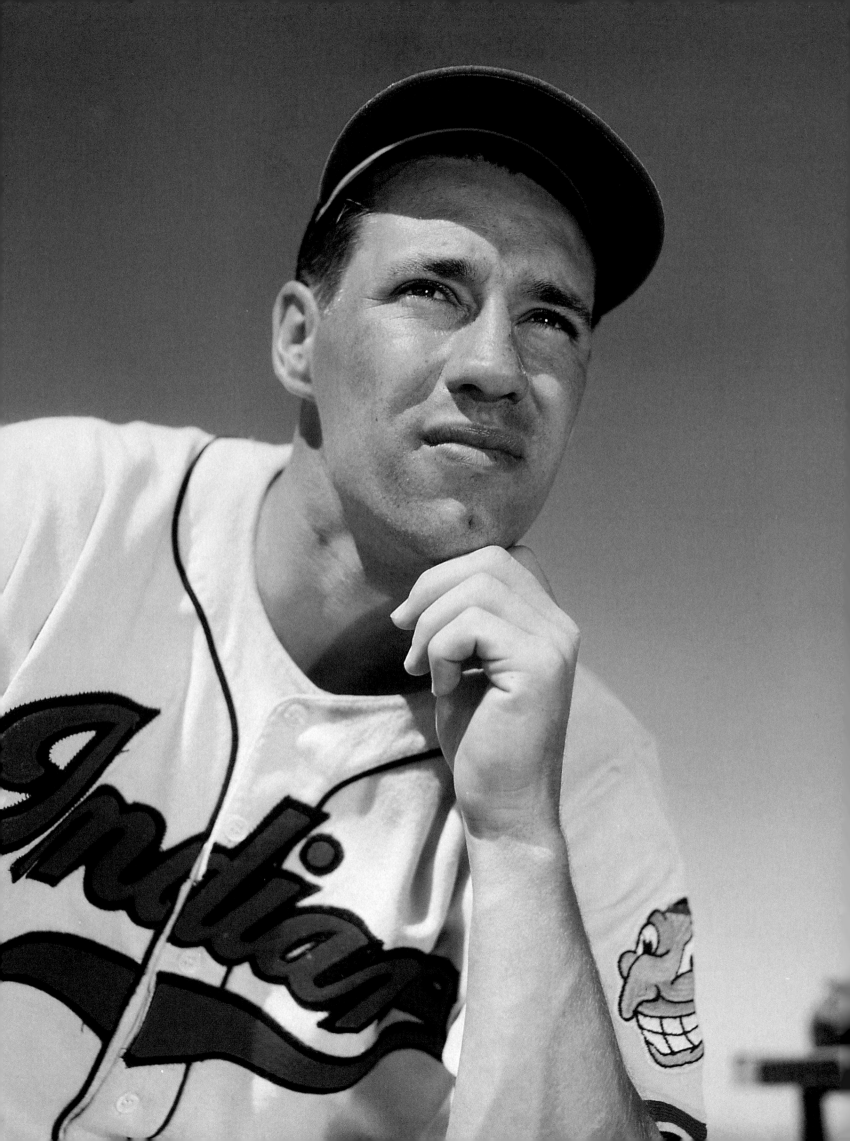

Bob Feller

- ◆ BORN: 1918

- ◆ PITCHER 1936–56 Indians

- ◆ 266–162 career won–lost record

- ◆ 3.25 career ERA

- ◆ 2,581 career strikeouts

- ◆ 3 no-hitters

- ◆ All-Star 1938–41, '46–48, '50

- ◆ Elected to the Hall of Fame 1962

One of Feller's three no-hitters came on Opening Day of the 1940 season against the White Sox. Mike Kreevich, at bat in the first inning, turned to the umpire to protest a called strike. The umpire asked him what was wrong with the pitch and Kreevich, in a testimony to Feller's peerless velocity, said, "It sounded a little high."

FOLLOWING PAGES 136–137: Indian shortstop Lou Boudreau (left) and second baseman Joe Gordon

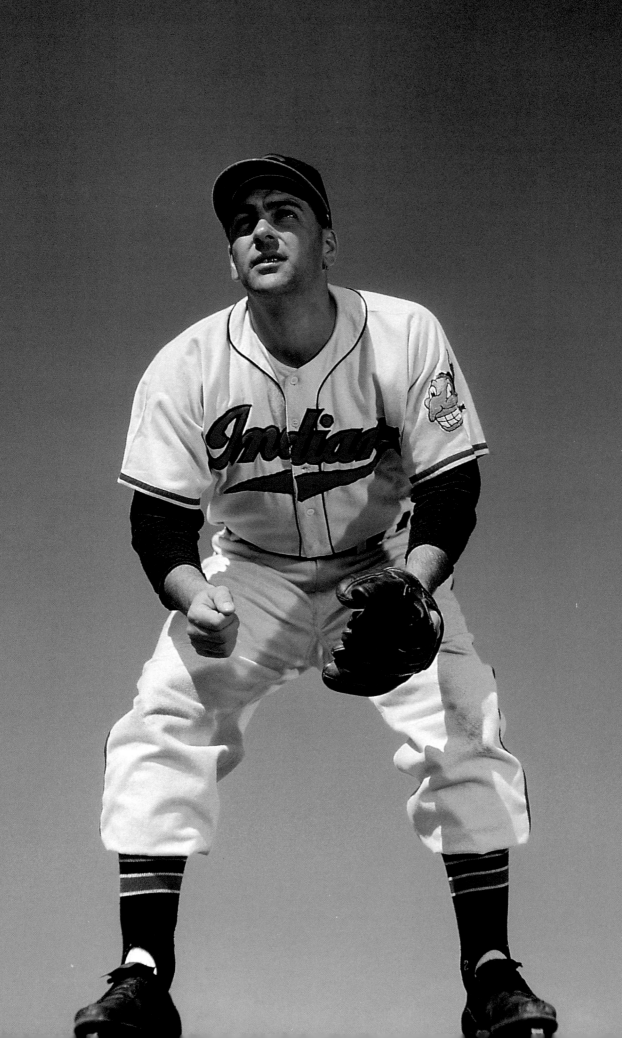

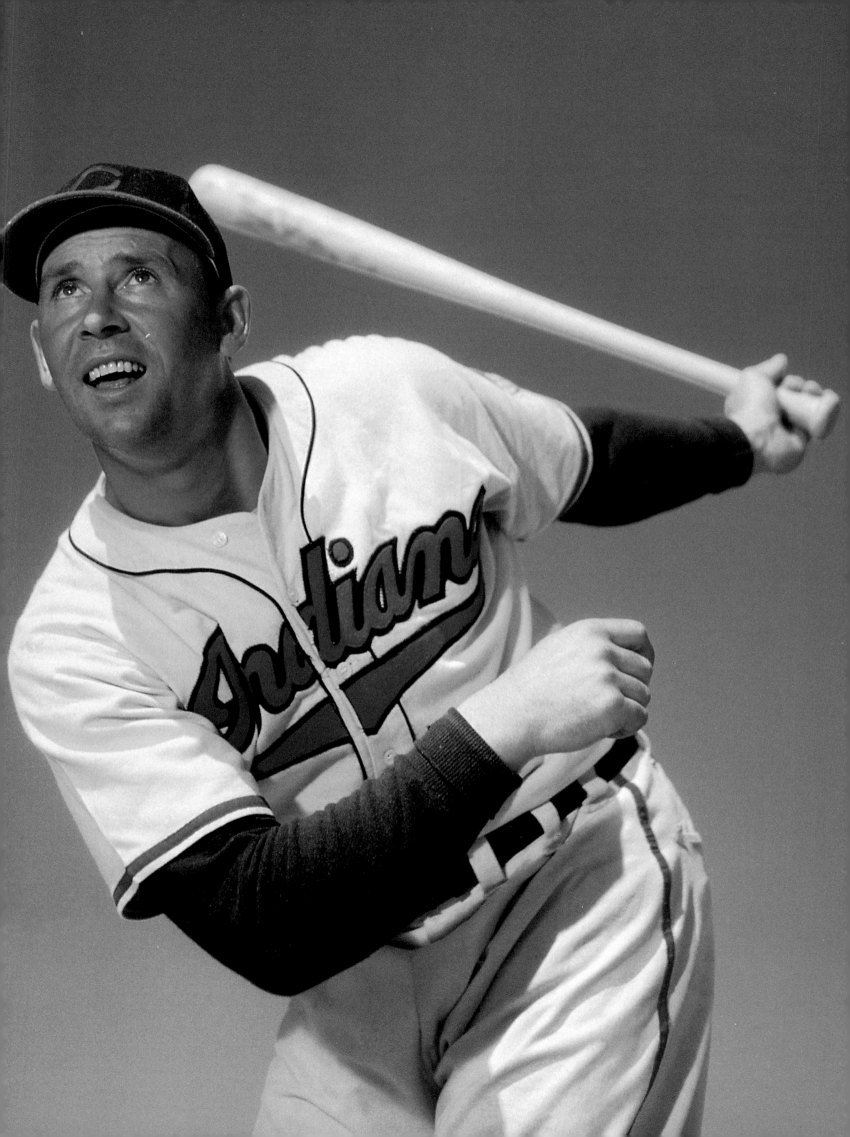

Bob Lemon

◆ BORN: 1920

◆ THIRD BASEMAN, PITCHER 1941–58
Indians

◆ MANAGER 1970–72, '77–79, '81–82
Royals, White Sox, Yankees

◆ 207–128 career won–lost record

◆ 3.23 career ERA

◆ 1,277 career strikeouts

◆ All-Star 1948–54

◆ Elected to the Hall of Fame 1976

A weak hitter for a third base-man, Lemon actually learned to pitch in the major leagues, and in 9 seasons from 1948 to 1956, he won at least 20 games 7 times. As a player and later as a manager, the easy-going Lemon was immensely popular. "I never took the game home with me," he said. "I always left it in some bar."

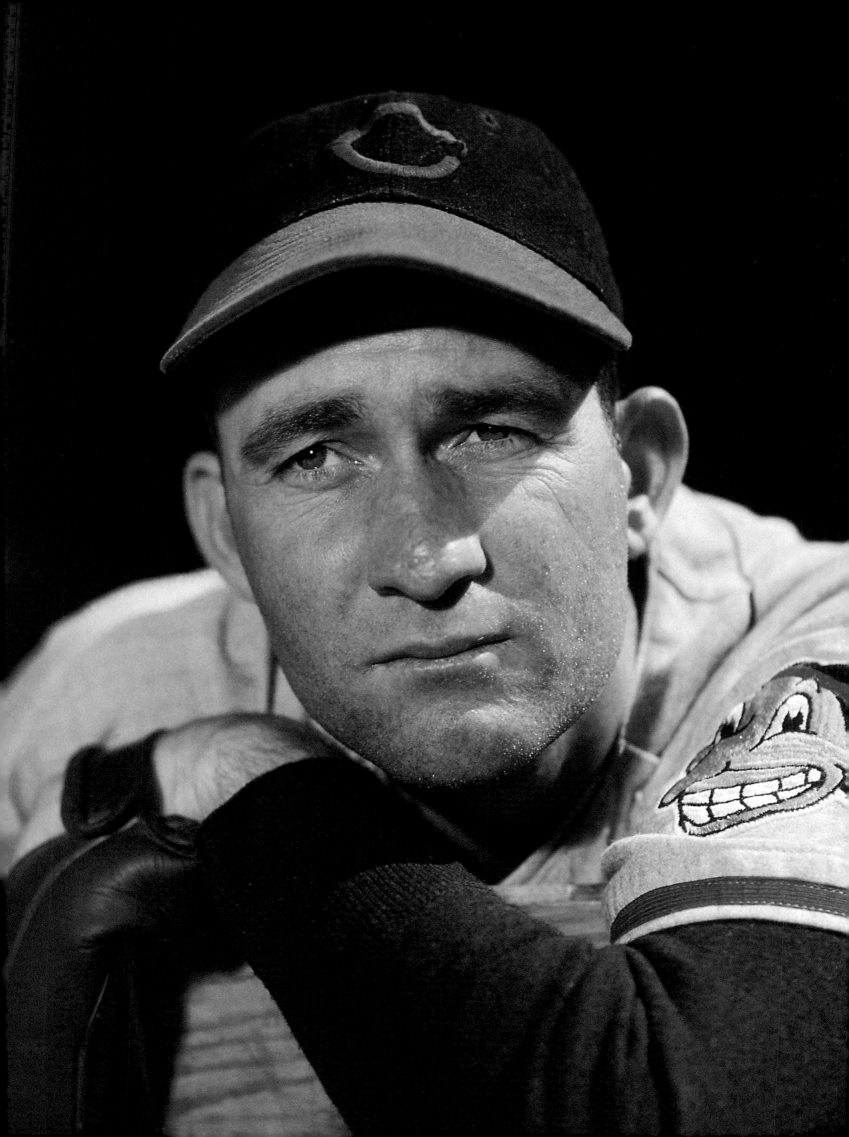

Larry Doby

- ◆ BORN: 1923

- ◆ OUTFIELDER 1947–59 Indians, White Sox, Tigers

- ◆ MANAGER 1978 White Sox

- ◆ .283 career batting average

- ◆ 253 career home runs

- ◆ 969 career RBIs

- ◆ All-Star 1949–55

- ◆ First African-American in AL

Doby was signed by the Indians four months after Jackie Robinson broke the color line. A dangerous power hitter and a fine outfielder, Doby's career stats fell short of Hall of Fame material. But he got his reward in 1978 when, as manager of the White Sox, he discovered that one of his catchers, a kid from Cleveland, was named Larry Doby Johnson.

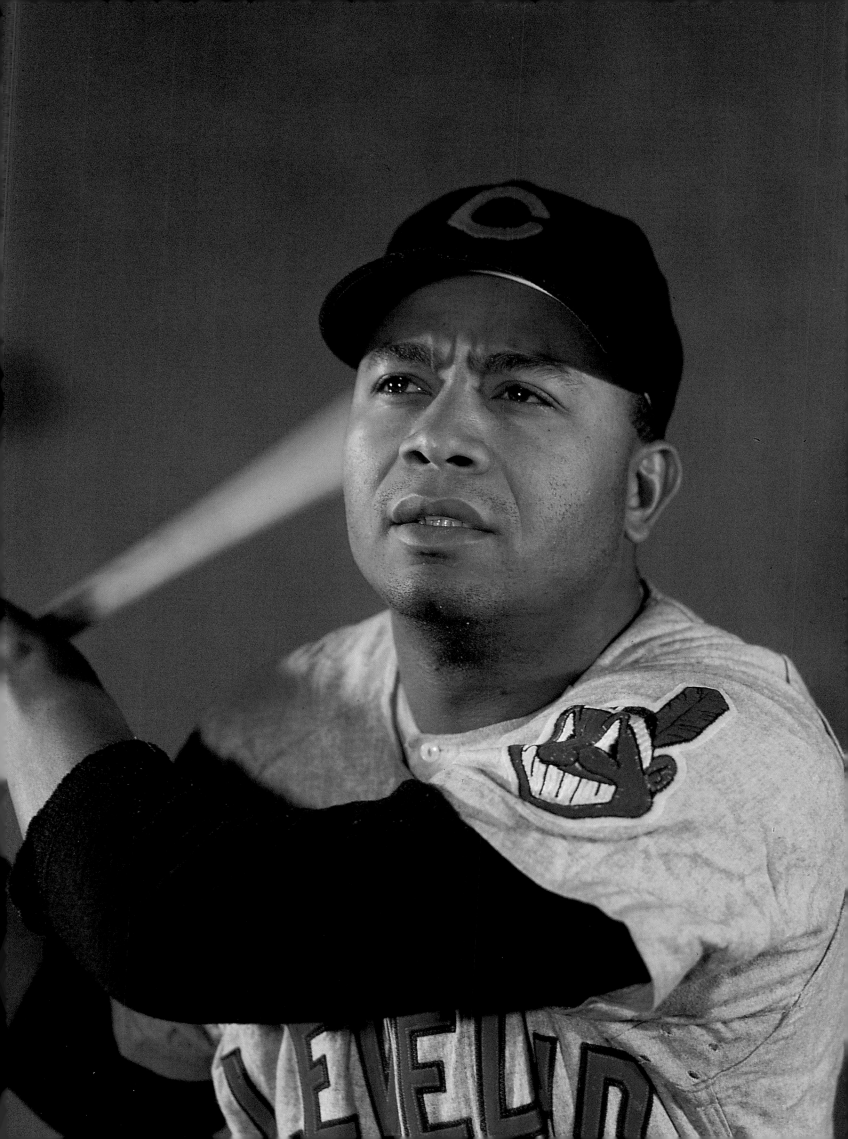

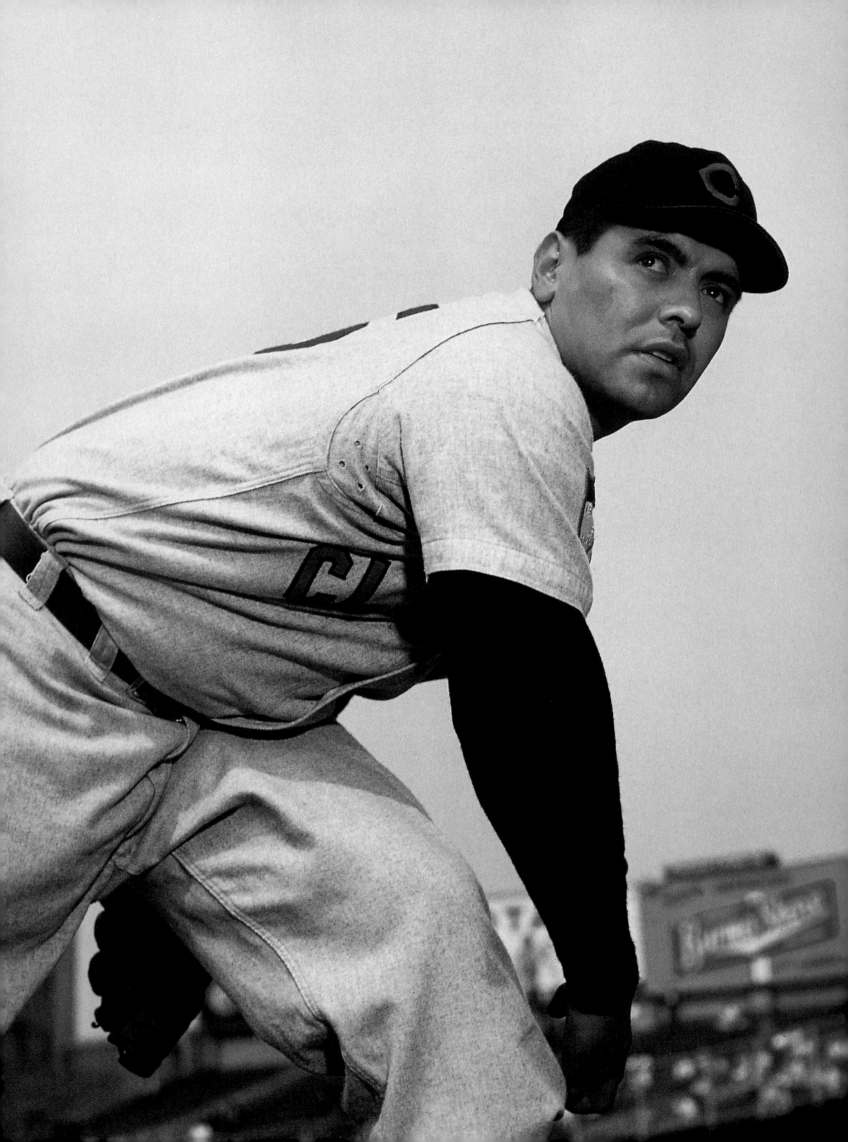

Mike Garcia

- BORN: 1923 DIED: 1986
- PITCHER 1948–61 Indians, White Sox, Senators
- 142–97 career won–lost record
- 3.27 career ERA
- All-Star 1954–56

The pitching staff for the 1954 Indians—a team that won a record 111 regular-season games—included Bob Lemon, Early Wynn, Bob Feller, and Hal Newhouser, but the best of that lot might have been Garcia, who led the league in ERA (2.64) while winning 19 games, 5 of them shutouts. But the Big Bear was never the same after that.

Al Rosen

- ◆ BORN: 1924

- ◆ INFIELDER 1947–56 Indians

- ◆ .285 career batting average

- ◆ 192 career home runs

- ◆ MVP 1953

- ◆ All-Star 1952–55

- ◆ President Yankees, Astros, Giants

"The greatest thrill in the world," said Rosen, "is to end the game with a home run and watch everybody else walk off the field while you're running the bases on air." Although he almost won the Triple Crown in 1953, Rosen's playing career was relatively short. The third baseman known as Flip quit to become a stockbroker when he was 32, partly because of whiplash, partly because of fan backlash. Twenty years later, his good friend George Steinbrenner lured him back into baseball.

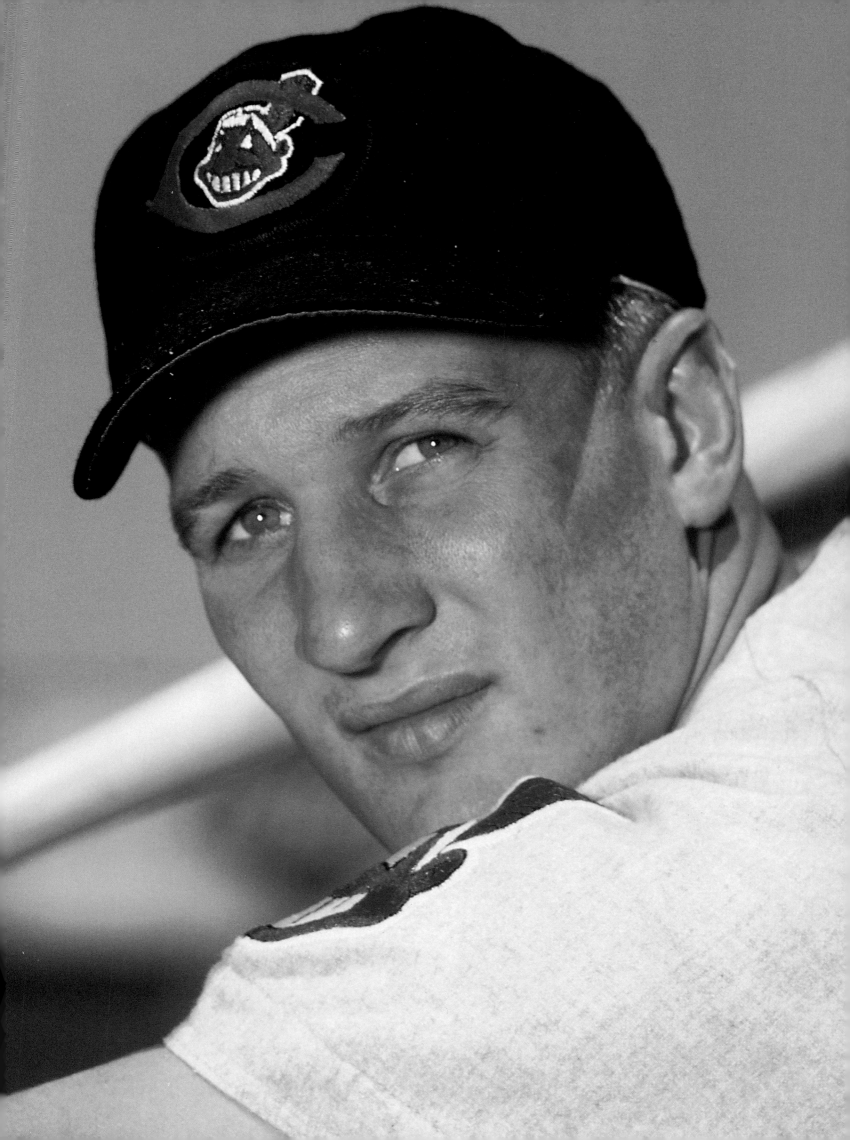

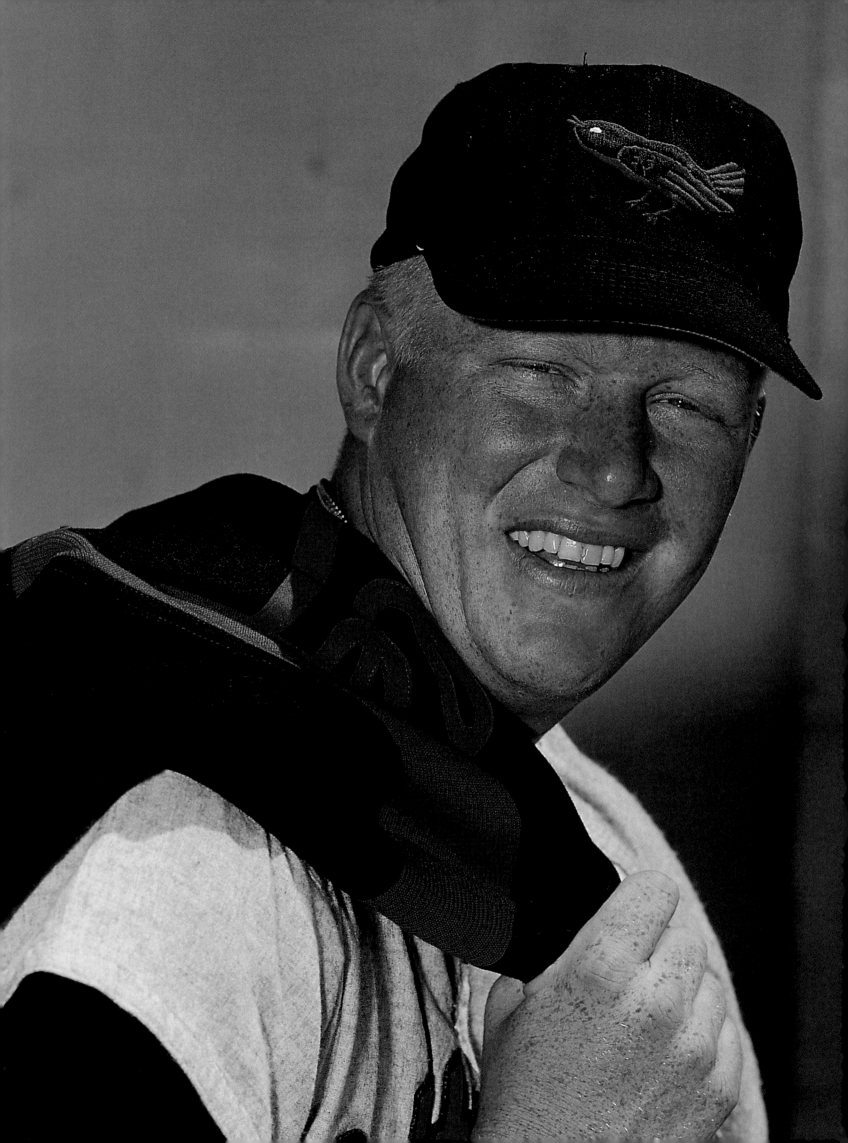

Boog Powell

- BORN: 1941

- FIRST BASEMAN 1961–77 Orioles, Indians, Dodgers

- .266 career batting average

- 339 career home runs

- 1,187 career RBIs

- MVP 1970

- All-Star 1968–71

Powell had more problems with his stomach than with opposing pitchers. The immense slugger once said, "Sometimes when you're driving, the car just seems to turn by itself into a McDonald's, and while you're there you might as well get a large order of fries." Boog now owns the barbecue restaurant beyond the right-field wall at Camden Yards in Baltimore.

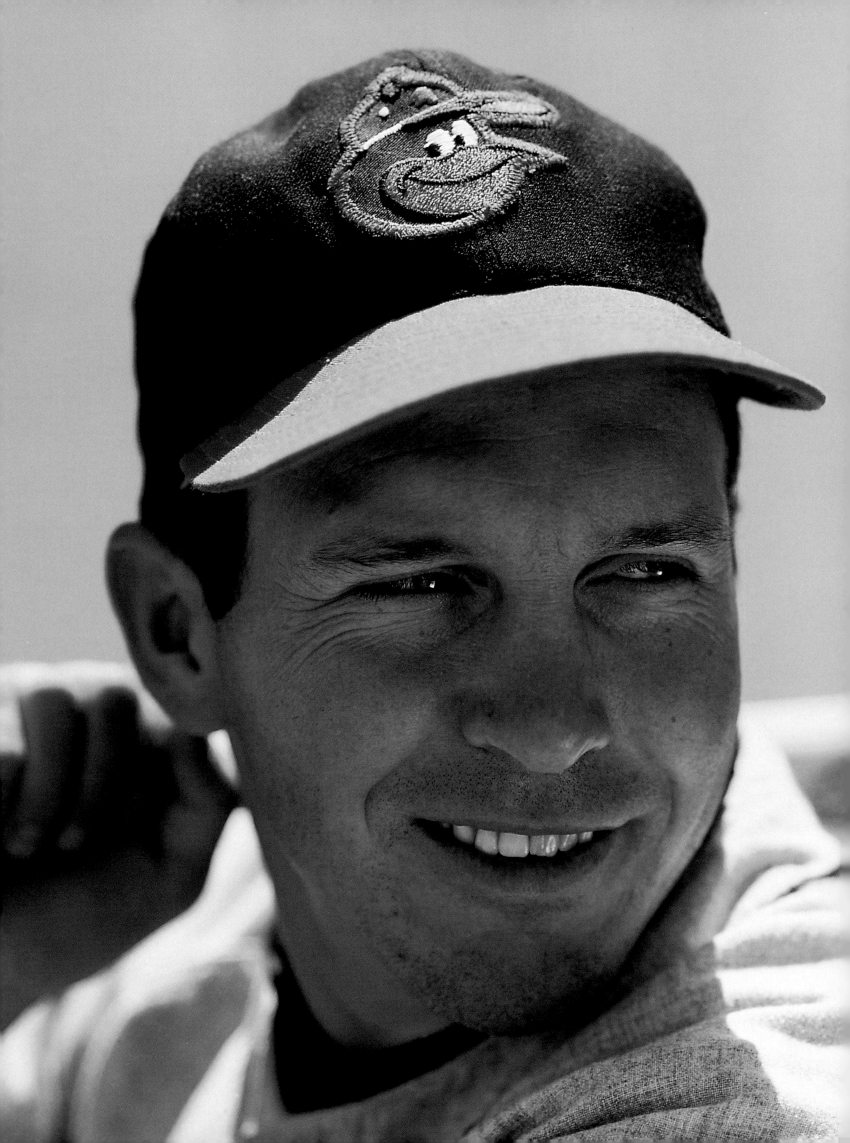

Brooks Robinson

- BORN: 1937

- THIRD BASEMAN 1955–77 Orioles

- .267 career batting average

- 268 career home runs

- 1,357 career RBIs

- MVP 1964

- All-Star 1960–75

- Led AL third basemen in fielding 11 times

- Elected to the Hall of Fame 1983

Brooks was even more sensational than usual in the 1970 World Series against the Reds, and after one of the games Rex Barney, the Orioles' public-address announcer, told reporters, "Brooks is not at his locker yet, but four guys are over there interviewing his glove." After that series, Pete Rose said, "Brooks Robinson belongs in a higher league."

Minnie Minoso

- ◆ BORN: 1922

- ◆ OUTFIELDER 1949–80 Indians, White Sox, Cardinals, Senators

- ◆ .298 career batting average

- ◆ 186 career home runs

- ◆ 1,023 career RBIs

- ◆ 205 career stolen bases

- ◆ All-Star 1951–54, '57, '60

Minoso first retired after spending 1964 as a White Sox pinch-hitter. Twelve years later, White Sox owner Bill Veeck brought Minoso out of retirement to DH, and he went hitless against the Angels' Frank Tanana. "It's been many years since I've faced pitching like that," said Minoso. "I hope the fans forgive me." The next day he collected his final major league hit. In 1980 he was again activated, going 0-for-2 and becoming a five-decade major leaguer. In 1990, Commissioner Fay Vincent denied the ageless Cuban a chance to become a six-decade player.

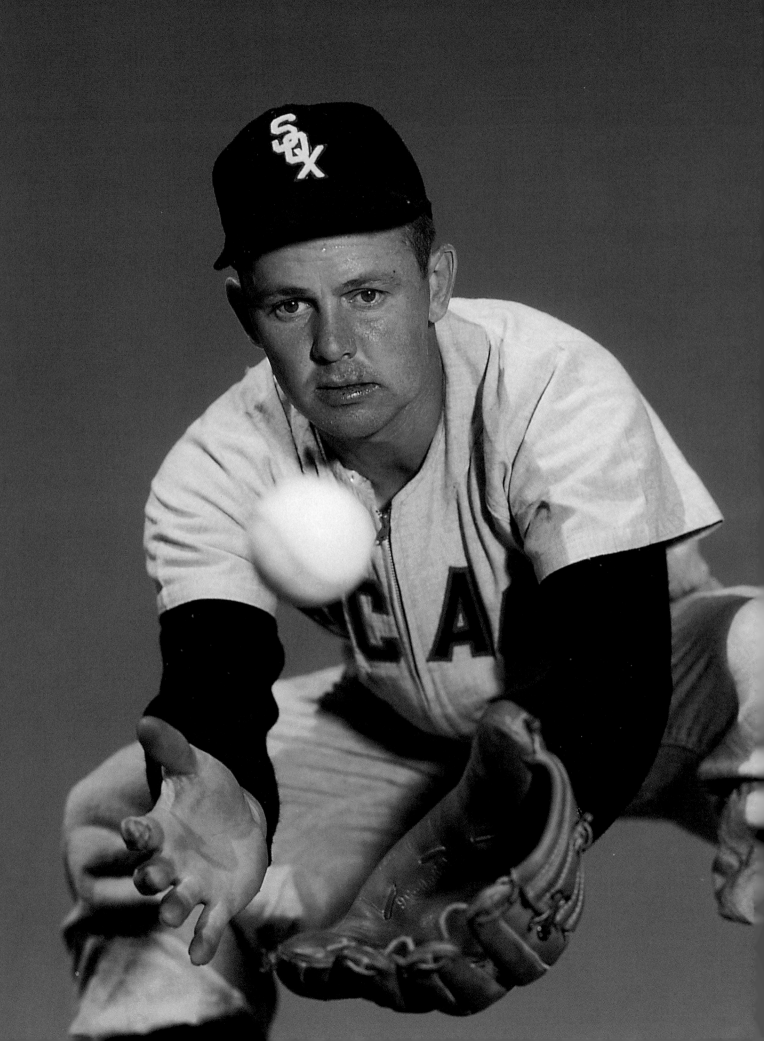

Nellie Fox

◆ BORN: 1927 DIED: 1975

◆ SECOND BASEMAN 1947–65 A's,
White Sox, Astros

◆ .288 career batting average

◆ Struck out only 216 times in 9,232
at-bats

◆ MVP 1959

◆ All-Star 1951–61, '63

Fox was one of the top second basemen of his time and one of only two honorary Martians ever to play in the major leagues. In a stunt organized by Bill Veeck, a helicopter landed in Comiskey Park and tiny Martians poured out to join Fox and the equally diminutive shortstop Luis Aparicio in their battle against the larger Earthlings. One of the Martians, by the way, was Eddie Gaedel, the midget Veeck had employed as a St. Louis Browns pinch-hitter in 1951.

Luis Aparicio

- BORN: 1934

- SHORTSTOP 1956–73 White Sox, Red Sox

- .262 career batting average

- 506 career stolen bases

- Led AL in stolen bases 1956–64

- Led AL shortstops in fielding 8 consecutive seasons

- Rookie of the Year 1956

- All-Star 1958–64, '70–72

- Elected to the Hall of Fame 1984

Fox and Aparicio really were almost other-worldly together, around second base for the double-play combination and also at the top of the White Sox batting order, where they formed a potent hit-and-run combo. Aparicio, the leadoff hitter, had such an appreciation for Fox that he named his son Nelson.

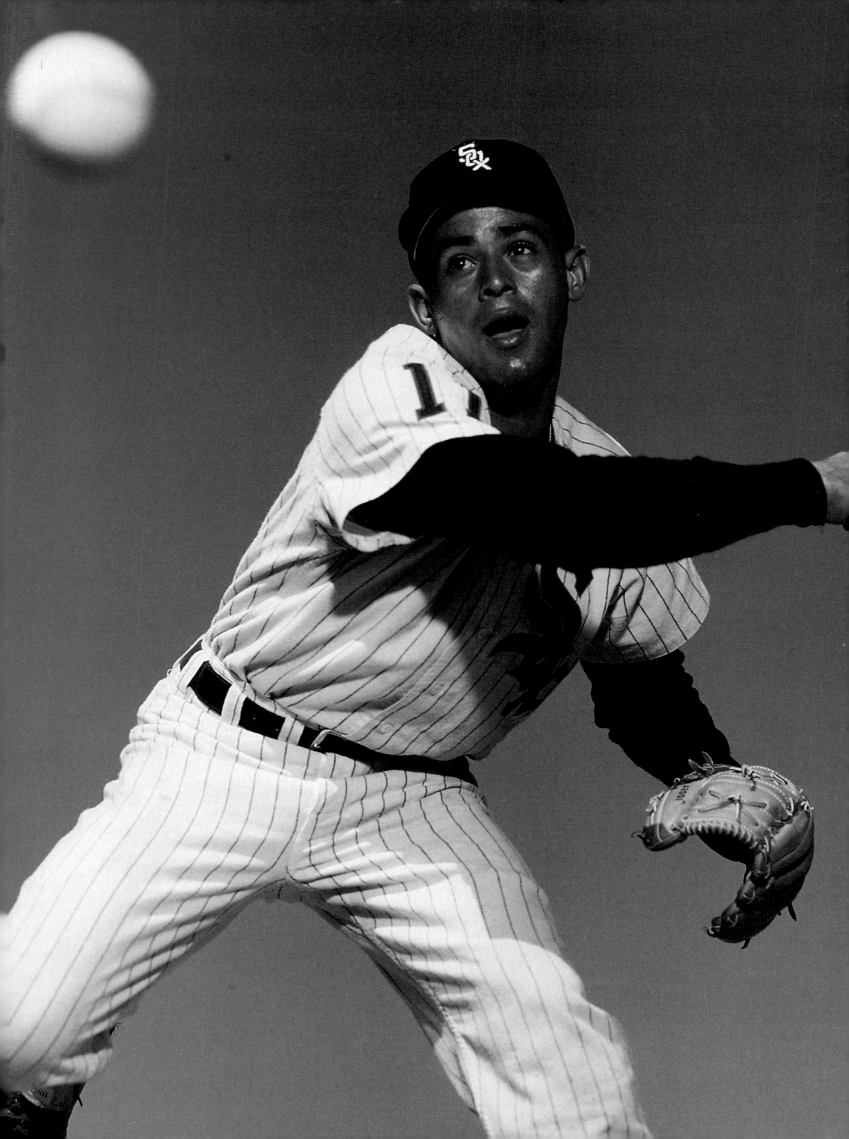

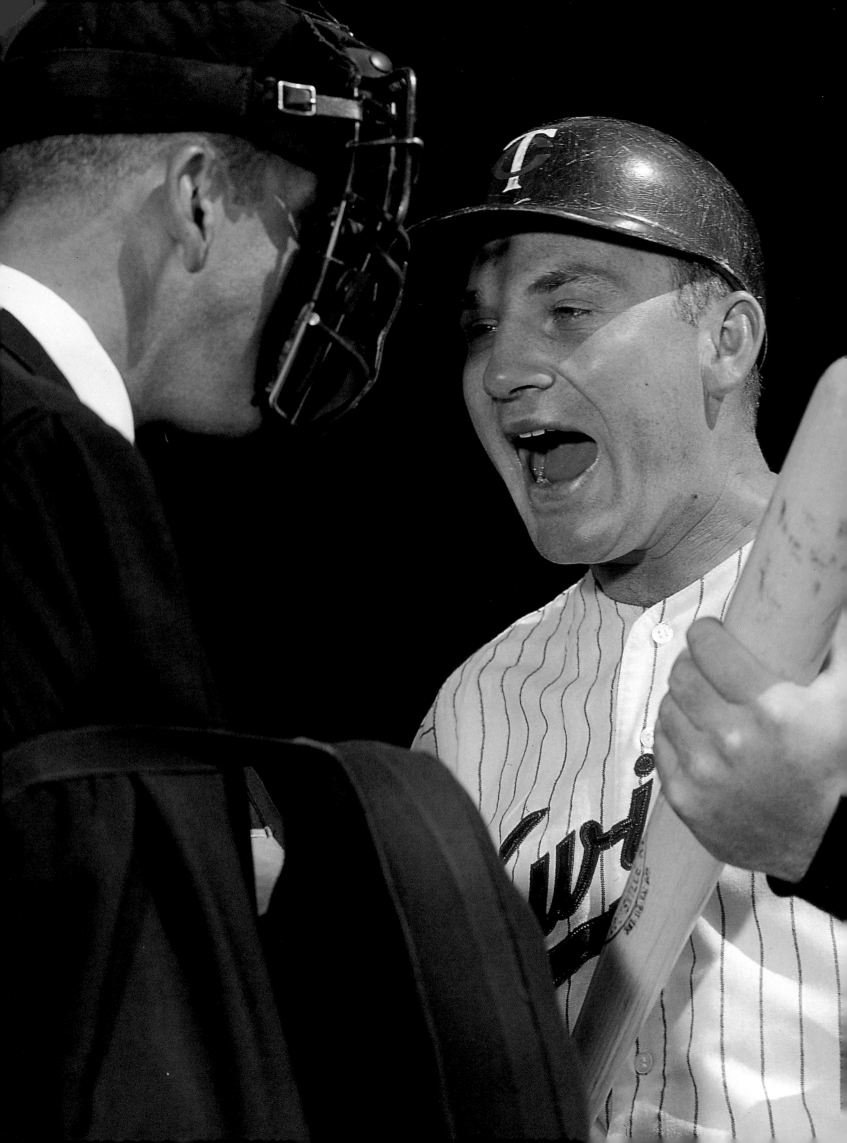

Harmon Killebrew

- ◆ BORN: 1936

- ◆ INFIELDER, OUTFIELDER 1954–75
 Senators/Twins, Royals

- ◆ .256 career batting average

- ◆ 573 career home runs

- ◆ 1,584 career RBIs

- ◆ MVP 1969

- ◆ All-Star 1959, '61, '63–71

- ◆ Elected to the Hall of Fame 1984

The picture opposite is sort of a joke, because Killebrew was a gentle giant. Quiet and unassuming, the Killer's most distinguishing characteristic was perhaps the best handwriting of anyone who ever played the game. Though he neither smoked nor drank, he asked writers not to print these facts for fear of offending his friends who did smoke and drink. Once asked what his hobbies were, Killebrew replied, "Well, I like to wash dishes, I guess."

Tony Oliva

- ◆ BORN: 1940
- ◆ OUTFIELDER 1962–76 Twins
- ◆ .304 career batting average
- ◆ 220 career home runs
- ◆ All-Star 1964–71
- ◆ Only player ever to win batting titles in first two seasons

Now it can be told: Oliva's real first name is Pedro, but he used his brother Tony's passport to enter the U.S. from Cuba in 1961, and he has been Tony ever since. Were it not for his right knee, which had to be operated upon seven times during his career, Tony—or, rather, Pedro—would be in the Hall of Fame.

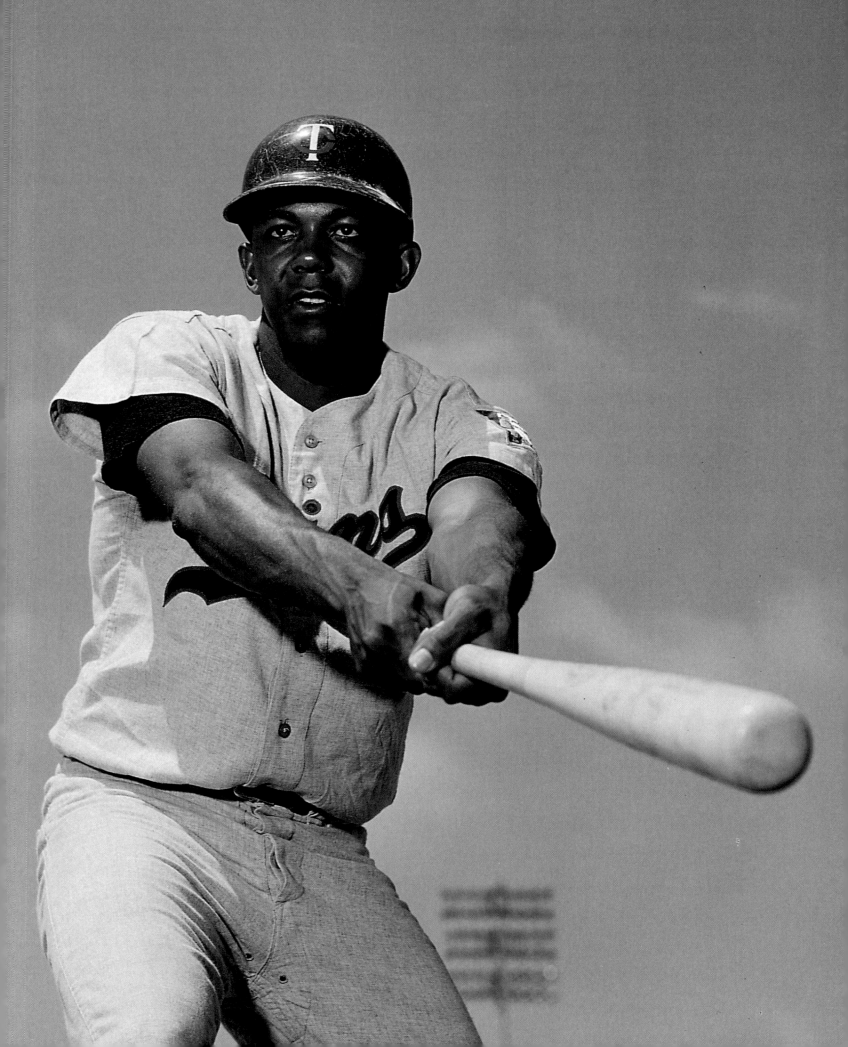

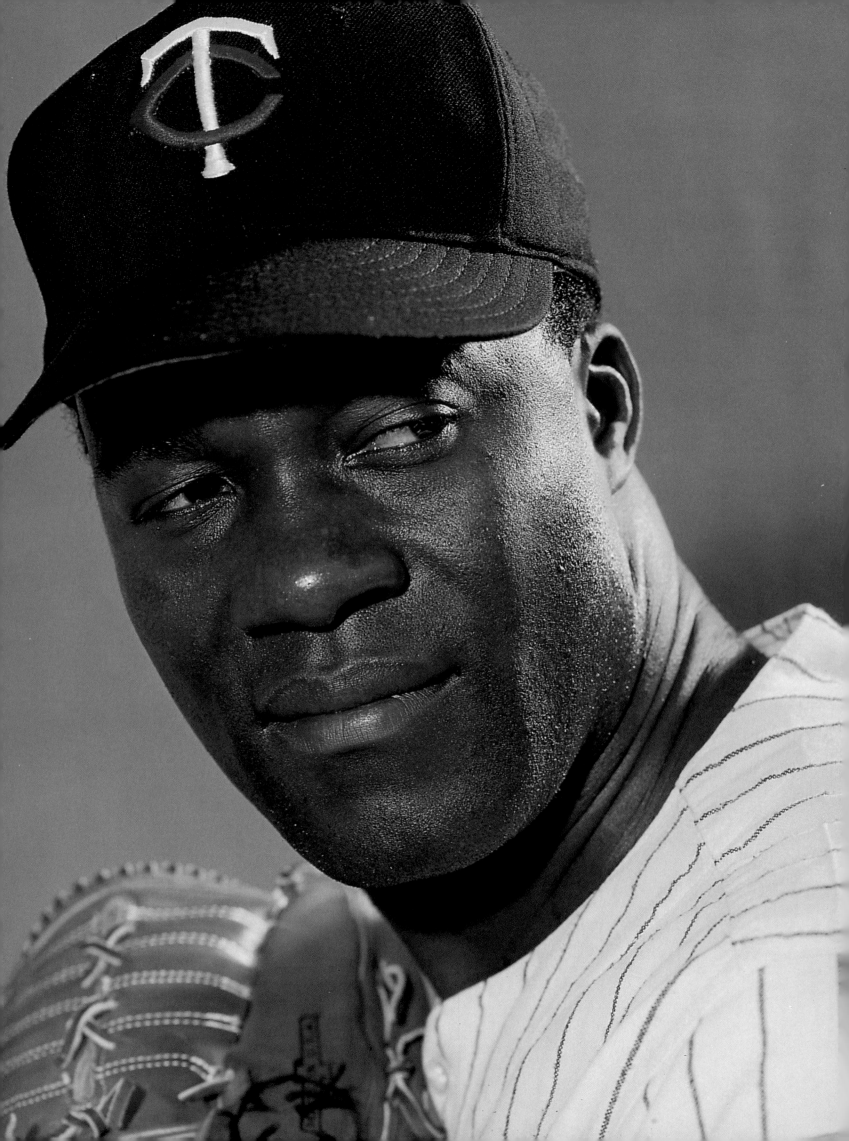

Mudcat Grant

- BORN: 1935

- PITCHER 1958–71 Indians, Twins, Dodgers, Expos, Cardinals, A's, Pirates

- 145–119 career won–lost record

- 3.63 career ERA

- All-Star 1965

For one glorious season (1965), and one season only, James Timothy Grant was the best pitcher in baseball, taking the Twins to the World Series with a 21–7 record and 6 shutouts. After baseball, he became a professional singer. Be sure to save your Mudcat and the Kittens album. It might be worth something some day.

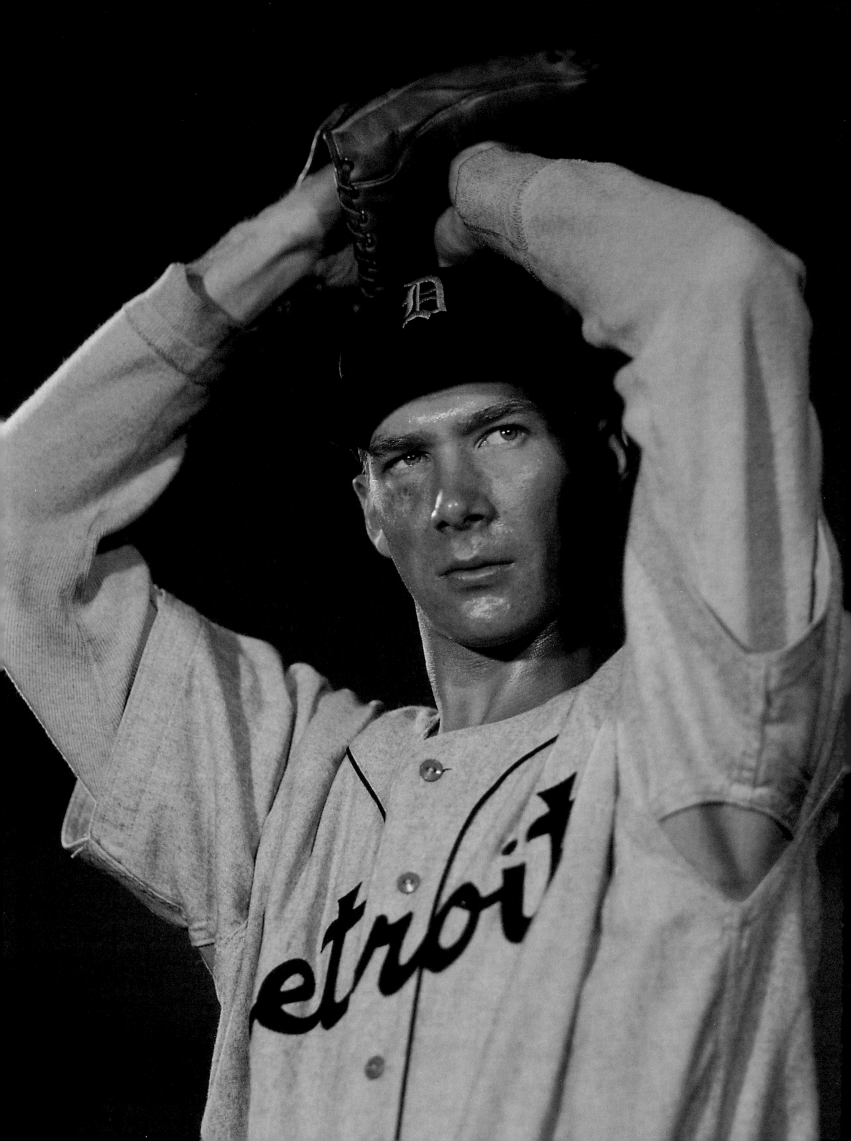

Hal Newhouser

- ◆ BORN: 1921
- ◆ PITCHER 1939–55 Tigers, Indians
- ◆ 207–150 career won–lost record
- ◆ 3.06 career ERA
- ◆ 1,796 career strikeouts
- ◆ MVP 1944–45
- ◆ All-Star 1942–44, '46–48
- ◆ Elected to the Hall of Fame 1992

Prince Hal is the only pitcher ever to win back-to-back MVP awards. The fact that they came during World War II—Newhouser had a heart condition that absolved him from service—somewhat diminishes the acomplishment. But even after the boys came home, Newhouser won 20 games in both '46 and '48.

Billy Martin

- BORN: 1928 DIED: 1989

- INFIELDER 1950–53, '55–61 Yankees,
 A's, Tigers, Indians, Reds, Braves, Twins

- MANAGER 1969, '71–83, '85, '88
 Twins, Tigers, Rangers, Yankees, A's

- .257 career batting average

- All-Star 1956

- World Series MVP 1953

- Manager of the Year 1974, '76, '80, '81

Martin and Casey Stengel were devoted to one another, dating back to their days together with the 1948 Oakland Oaks. But in 1957 Martin was traded to Kansas City in the aftermath of the infamous Copacabana scuffle, and he blamed Stengel. Years later, Mickey Mantle talked Billy into a reconciliation. "Look," said Mantle, "you're a lot younger than him, and one of these days he'll be gone, and you'll regret it." Mantle led Martin over to the dugout and, as Mantle later recalled, "Billy had tears in his eyes and he was crying, the old man had tears in his eyes and he was starting to cry. And I had tears in my eyes, too, and I was crying."

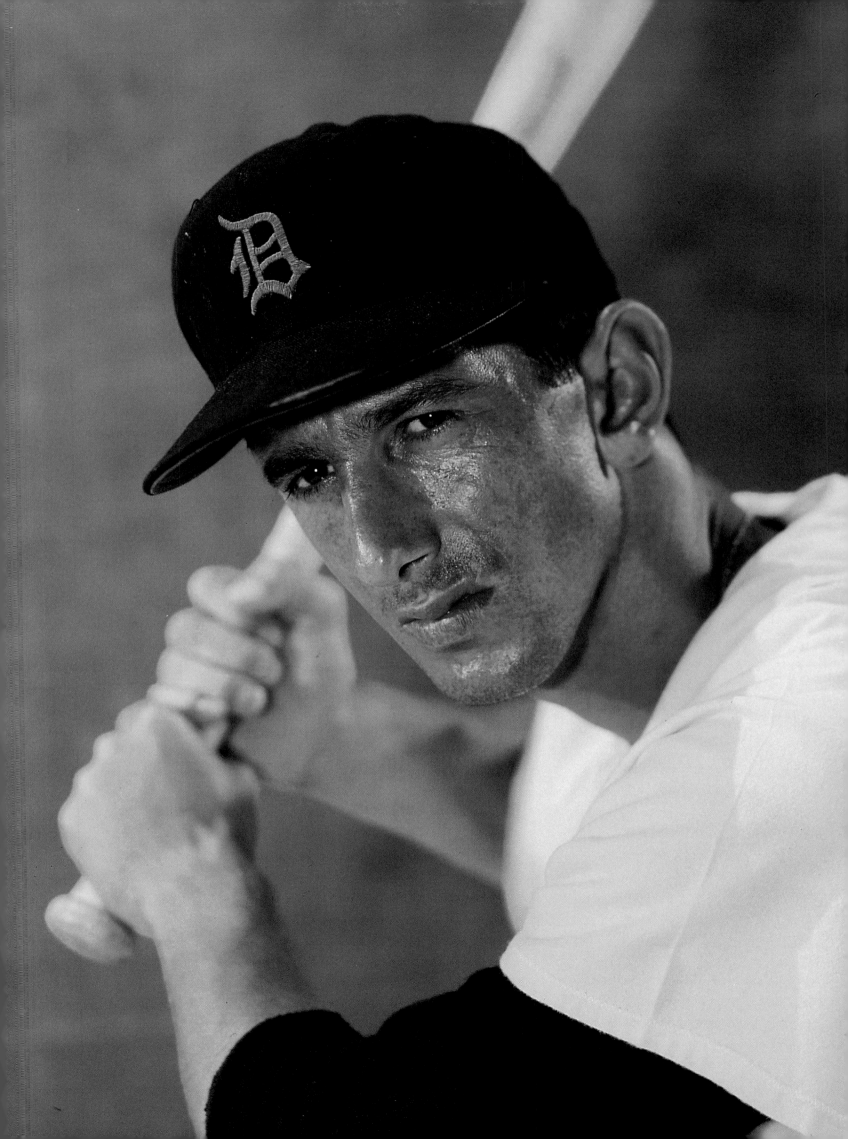

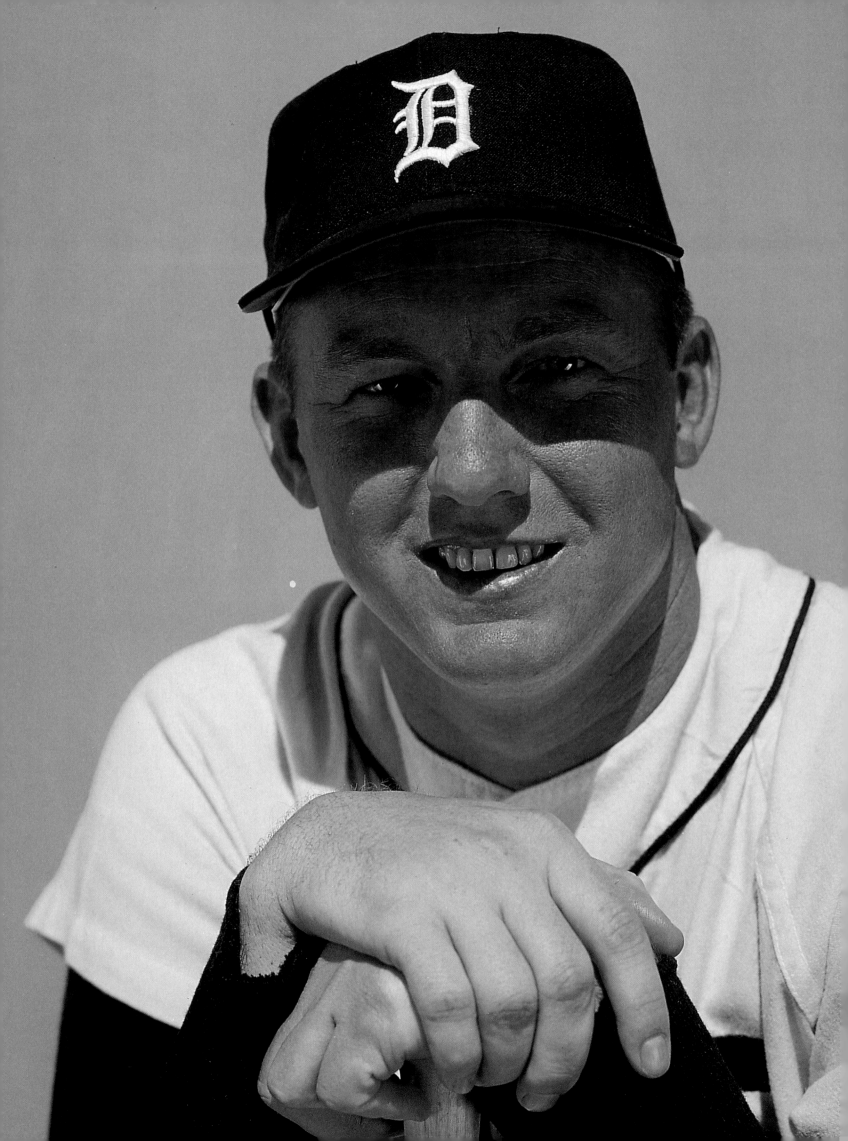

Al Kaline

- ◆ BORN: 1934
- ◆ OUTFIELDER 1953–74 Tigers
- ◆ .294 career batting average
- ◆ 399 career home runs
- ◆ 1,583 career RBIs
- ◆ All-Star 1955–67, '71, '74
- ◆ Elected to the Hall of Fame 1980

*K*aline never played an inning in the minors, despite the fact that he was signed when he was only 18. In one game the following year against the White Sox, the young right fielder threw out Fred Marsh trying to score from second on a single, Minnie Minoso trying to stretch a single into a double, and Chico Carrasquel trying to go from first to third on a single. Always humble, Kaline responded to the Tigers' offer of a $100,000 contract in 1971 by saying, "I don't deserve such a salary. I didn't have a good enough season last year. This ballclub has been so fair and decent to me that I'd prefer to have you give it to me when I rate it."

Norm Cash

- BORN: 1934 DIED: 1986

- FIRST BASEMAN 1958–74
 White Sox, Tigers

- .271 career batting average

- 377 career home runs

- 1,103 career RBIs

- All-Star 1961, '66, '71, '72

In 1961 Cash won the AL batting title with a .361 average while clubbing 41 homers and driving in 132 runs. If it weren't for Roger Maris hitting 61 homers, Cash would have been the AL MVP. Near the end of his career, Cash said, "I owe my success to expansion pitching, a short right field fence, and my hollow bats." It seems that Cash would bore a hole in the top of his bat, fill it with cork, sawdust, and glue, and then sand the top so nobody would notice the illegal doctoring.

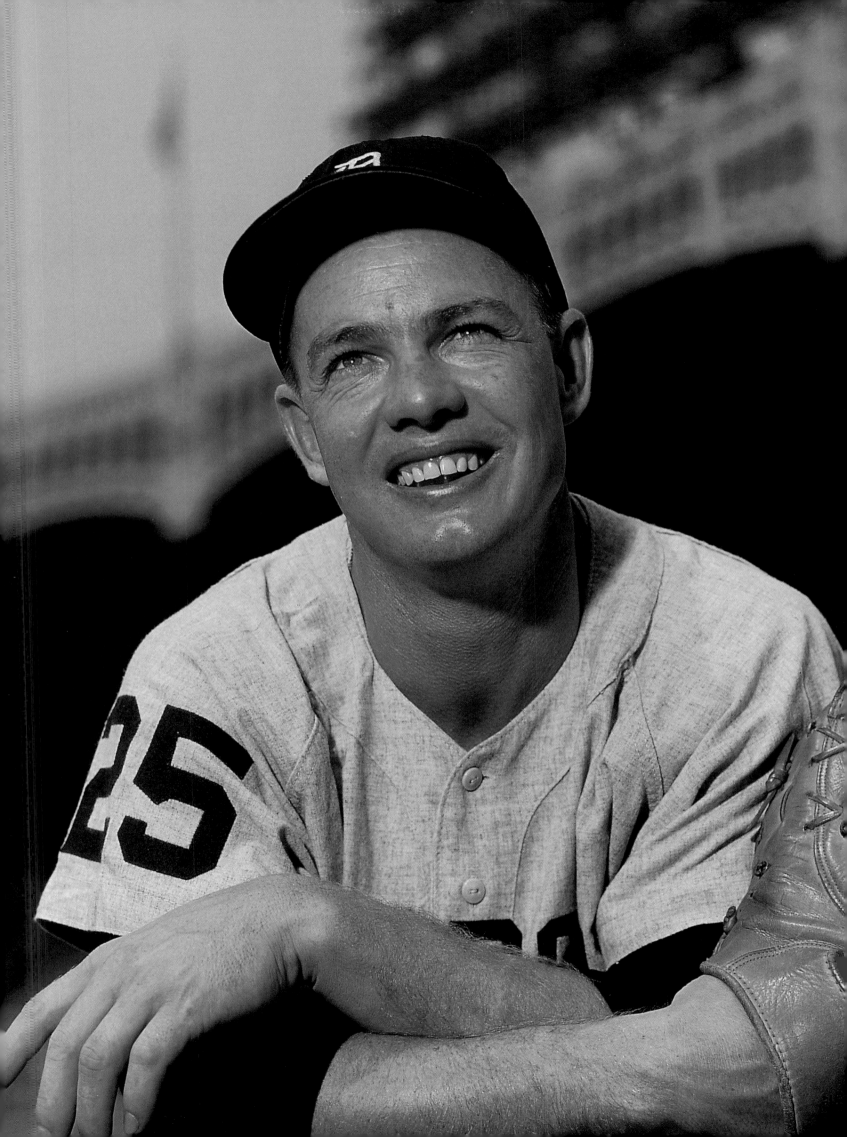

Rocky Colavito

- BORN: 1933

- OUTFIELDER 1955–68 Indians, Tigers, A's, White Sox, Dodgers, Yankees

- .266 career batting average

- 374 career home runs

- 1,159 career RBIs

- All-Star 1959, '61, '62, '64–66

"Don't knock the Rock" was the anthem in Cleveland when the good-looking, power-hitting Colavito played for the Indians. But in April of 1960, Colavito was traded to the Tigers even-up for batting champion Harvey Kuenn. The swap was so unpopular in Cleveland that general manager Frank Lane was hung in effigy. The fans didn't calm down until 1965, when the Rock was reacquired.

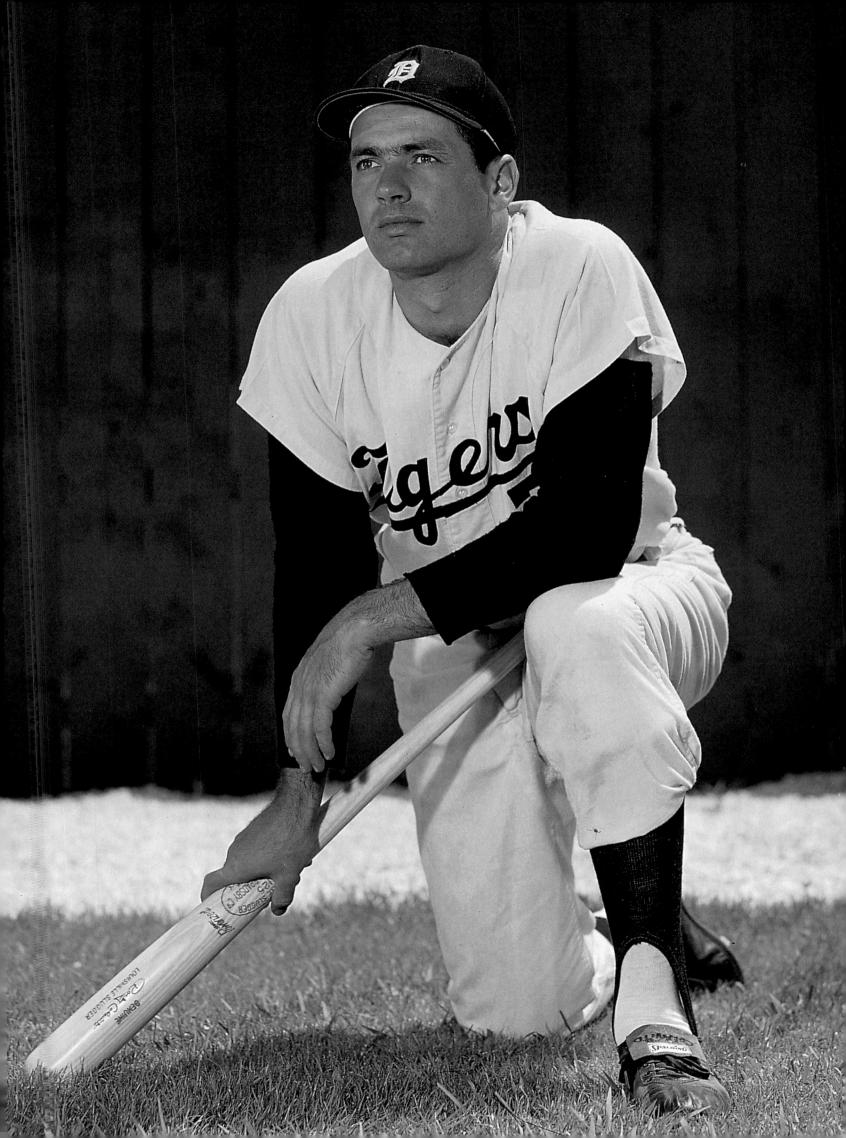

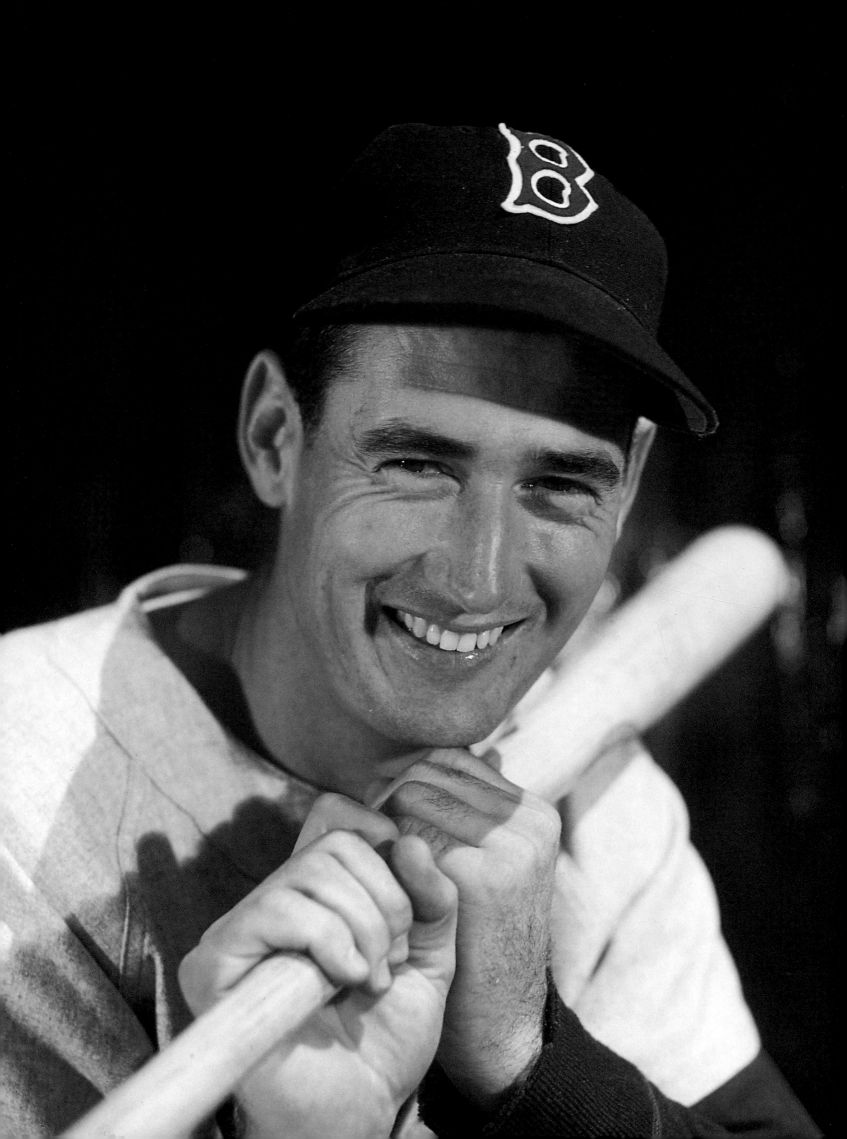

Ted Williams

◆ BORN: 1918

◆ OUTFIELDER 1939–60 Red Sox

◆ MANAGER 1969–72
Senators/Rangers

◆ American League MVP 1946, 1949

◆ Six-time AL Batting Champion,
four-time AL Home Run
Champion

◆ Hit .406 in 1941

◆ .344 career batting average

◆ Elected to the Hall of Fame 1966

The Splendid Splinter is baseball's version of John Wayne. Who knows how many records he would have broken had he not missed five seasons, flying for the Marines in World War II and the Korean War. He used to stand in a batting cage and say to himself, "My name is Ted (bleeping) Williams, and I'm the greatest hitter in baseball."

*When Williams came out of
retirement in 1969 to manage the
Washington Senators, baseball people
were surprised. They were even more
surprised when he led the moribund
Senators to an 86–76 record, a 21-
game improvement over the previous
season. But after they moved to Texas
and changed their name to the
Rangers, they reverted to form and
Williams called it a day.*

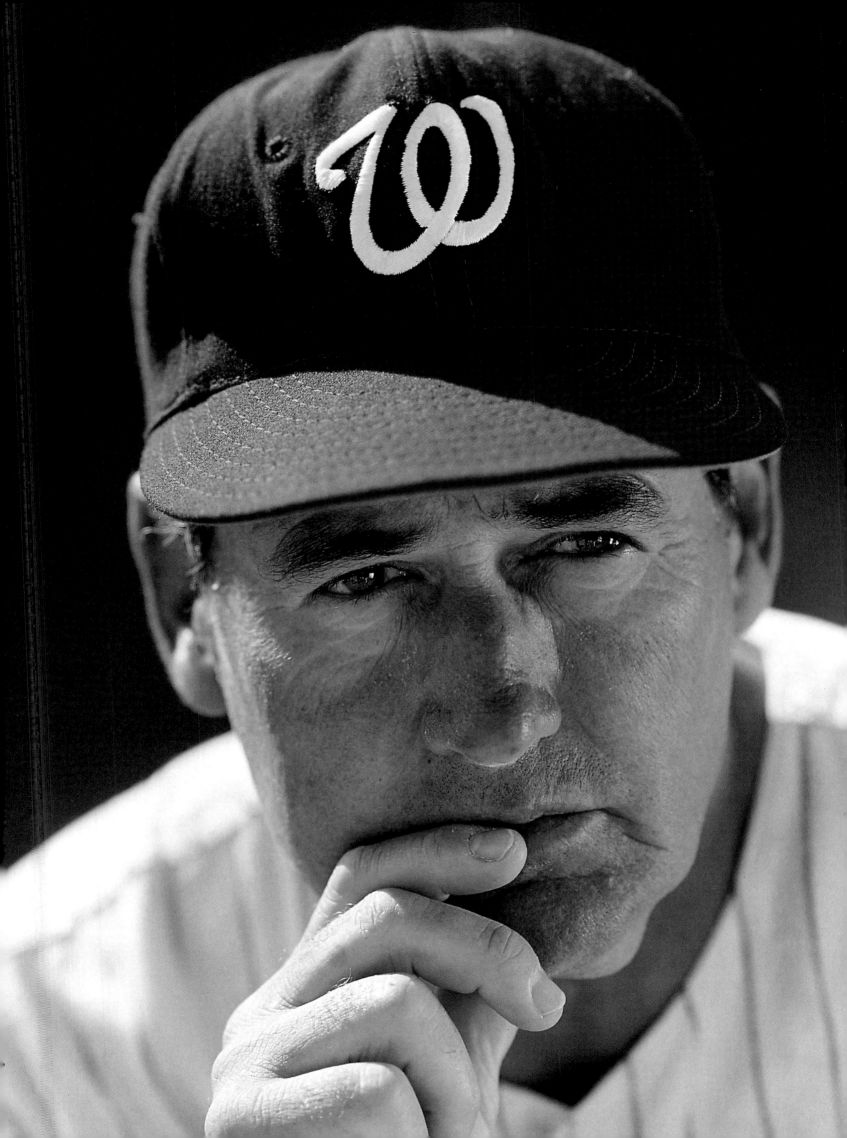

Tony Conigliaro

◆ BORN: 1945 DIED: 1990

◆ OUTFIELDER 1964–67, '69–71
 Red Sox, Angels

◆ .264 career batting average

◆ 166 career home runs

◆ All-Star 1967

◆ Comeback Player of the Year 1969

The Red Sox went from ninth place in 1966 to the pennant in 1967, but for Tony C., the Impossible Dream became a nightmare. Going into a game against the Angels on August 18th of that year, Conigliaro had 20 homers and 67 RBIs. But a pitch from hard-throwing Jack Hamilton beaned Conigliaro, fracturing his left cheekbone and leaving him with reduced vision in his left eye. He tried to come back that season, but he couldn't hit the ball out of the infield against the Red Sox bat boy. While his teammates celebrated on the last day of the season, Conigliaro sat in front of his locker crying.

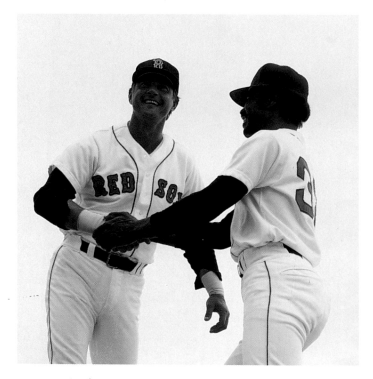

ABOVE: Carl Yastrzemski gets a hand

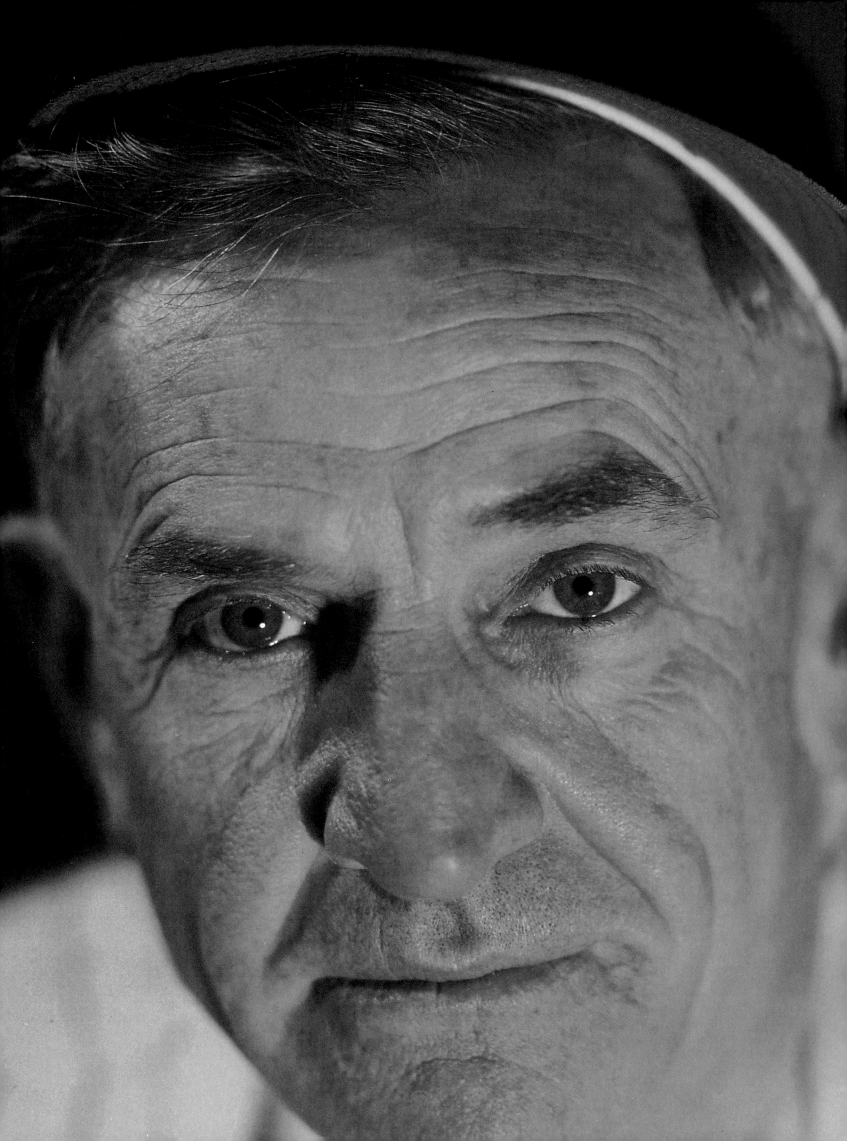

Casey Stengel

- BORN: 1889 DIED: 1974

- OUTFIELDER 1912–25, Dodgers, Pirates, Phillies, Giants, Braves

- MANAGER 1934–36 Dodgers, 1938–43 Braves, 1949–60 Yankees, 1962–65 Mets

- .284 career batting average

- Hit two game-winning homers for Giants in 1923 World Series

- Managed Yankees to 10 pennants and 7 world championships in 12 years

- Elected to the Hall of Fame 1966

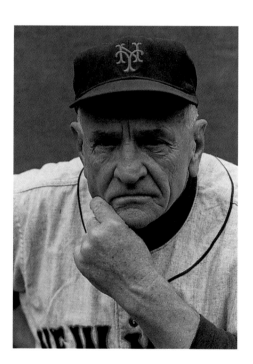

ABOVE: Stengel called his expansion Mets Amazin'

As a player Stengel was something of a cutup—he once tipped his cap to a jeering crowd and a bird flew out—and as a manager, the Old Professor entertained his public with Stengelese, a comical language all his own. But he had his serious side as well. When asked if managing the hapless Mets might somehow tarnish his reputation, Stengel replied, "What does it matter if the statues they've built for you tilt a little?"

179

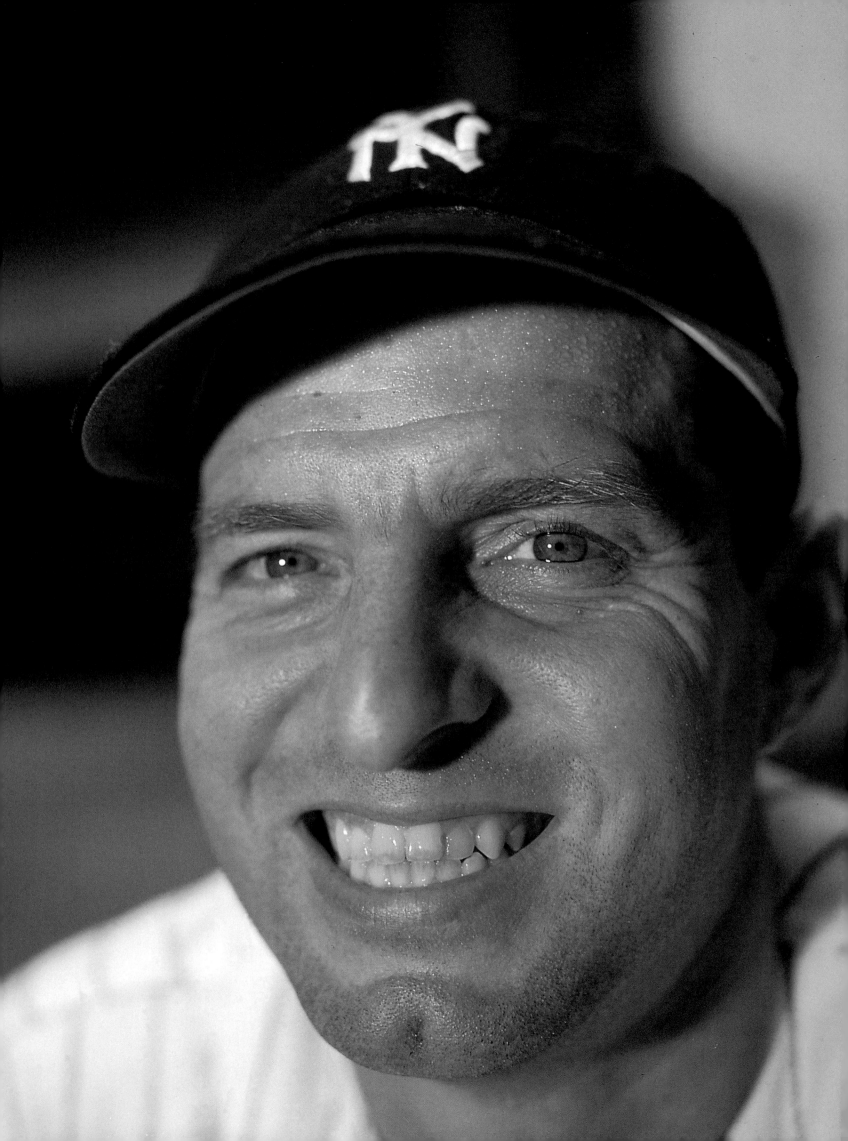

Tommy Henrich

◆ BORN: 1913

◆ OUTFIELDER 1937–50 Yankees

◆ .282 career batting average

◆ 183 career home runs

◆ All-Star 1942, '47–50

Henrich was one-third of the best outfield in baseball; Joe DiMaggio and Charlie Keller were the other thirds. Known as Old Reliable for his fine fielding and clutch hitting, Henrich summed up outfielding this way: "Catching a fly ball is a pleasure, but knowing what to do with it is a business."

Joe DiMaggio

- BORN: 1914

- OUTFIELDER 1936–51 Yankees

- American League MVP 1939, 1941, 1947

- 13-time All-Star

- Hit in major league record 56 straight games in 1941

- .325 career batting average

- Elected to the Hall of Fame 1955

Red Smith once wrote of Joltin' Joe: "Sometimes a fellow gets a little tired of writing about DiMaggio. A fellow thinks, 'There must be some other ballplayer in the world worth mentioning.' But there isn't really, not worth mentioning in the same breath as DiMaggio."

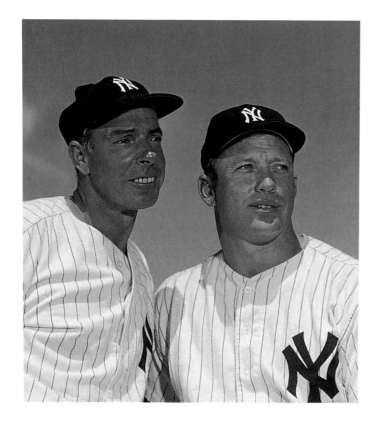

Mantle was such a perfect name for Mickey because that's what Joe D passed to him in 1951. This picture was taken a few years later, but the mutual admiration society between the two great Yankee center fielders was still evident.

LEFT: A meeting of the two greatest Yankee center fielders, DiMaggio and Mantle

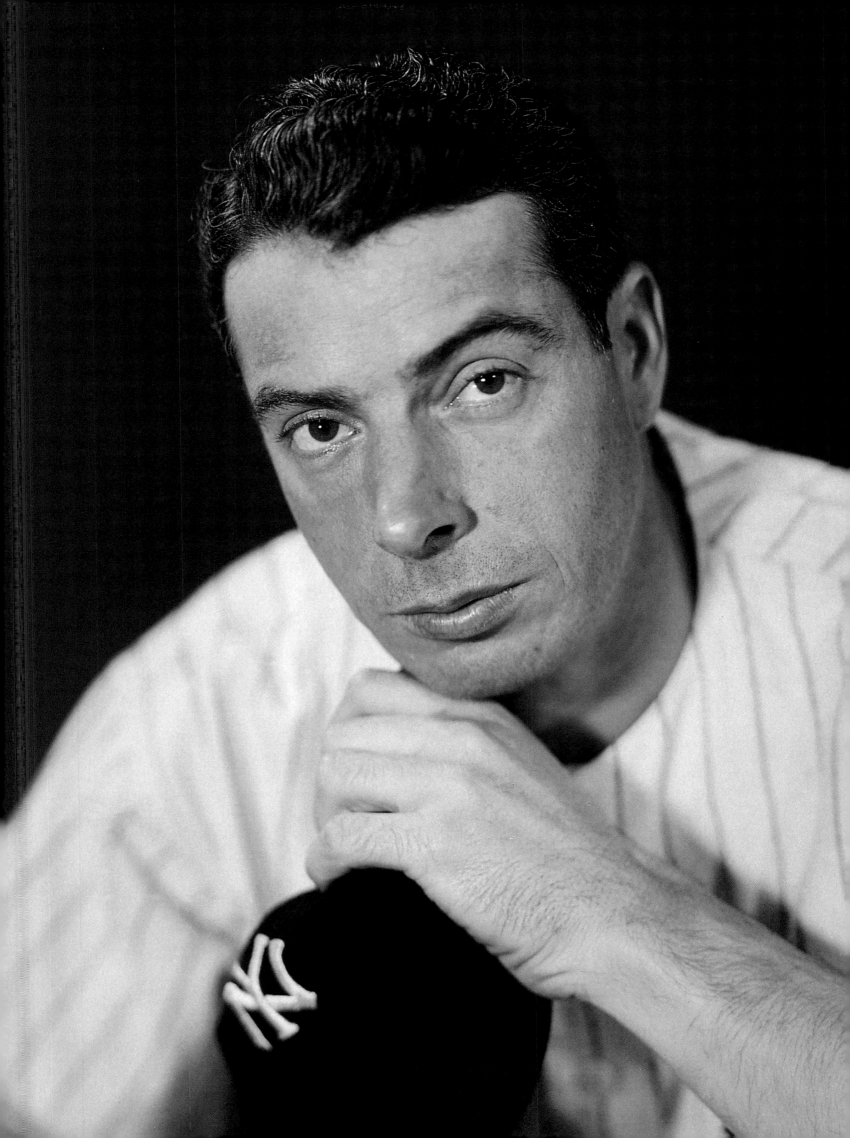

Mickey Mantle

- BORN: 1931

- OUTFIELDER 1951–68 Yankees

- .298 career batting average

- 536 career home runs

- 1,509 career RBIs

- Triple Crown 1956

- MVP 1956, '57, '62

- All-Star 1952–65, '67, '68

- Elected to the Hall of Fame 1974

*A*s good as he was, Mantle was a constant source of frustration for Casey Stengel. "He should lead the league in everything," said Stengel. "With his combination of speed and power, he should win the Triple Crown every year." Mantle had bad legs, of course, but he also had bad habits. As Whitey Ford once put it, "Everybody who roomed with Mickey said he took five years off their career."

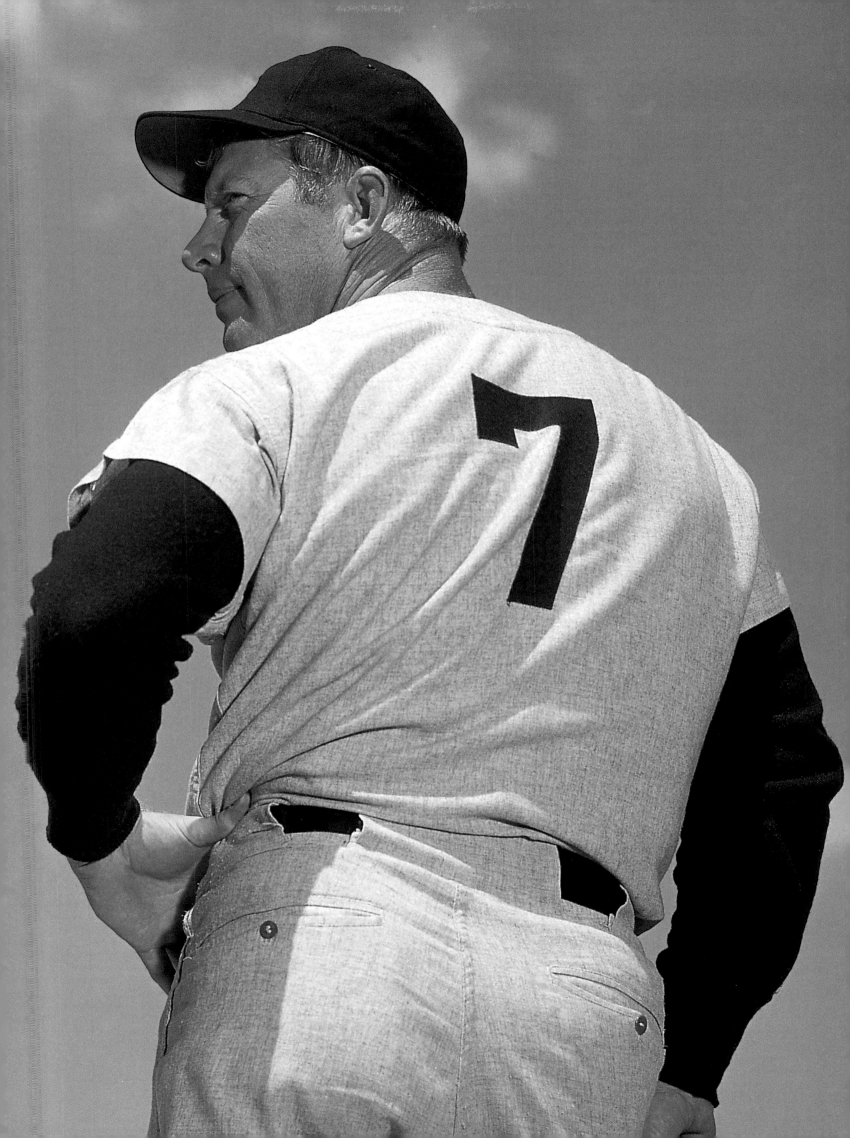

BELOW: Mantle in 1952

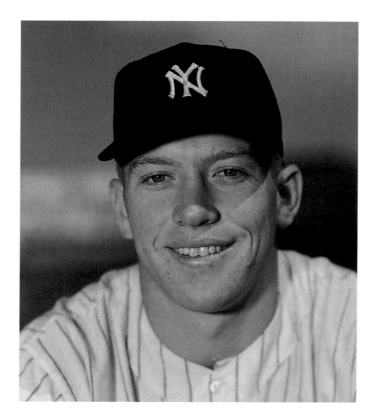

OPPOSITE: The Mick in 1967

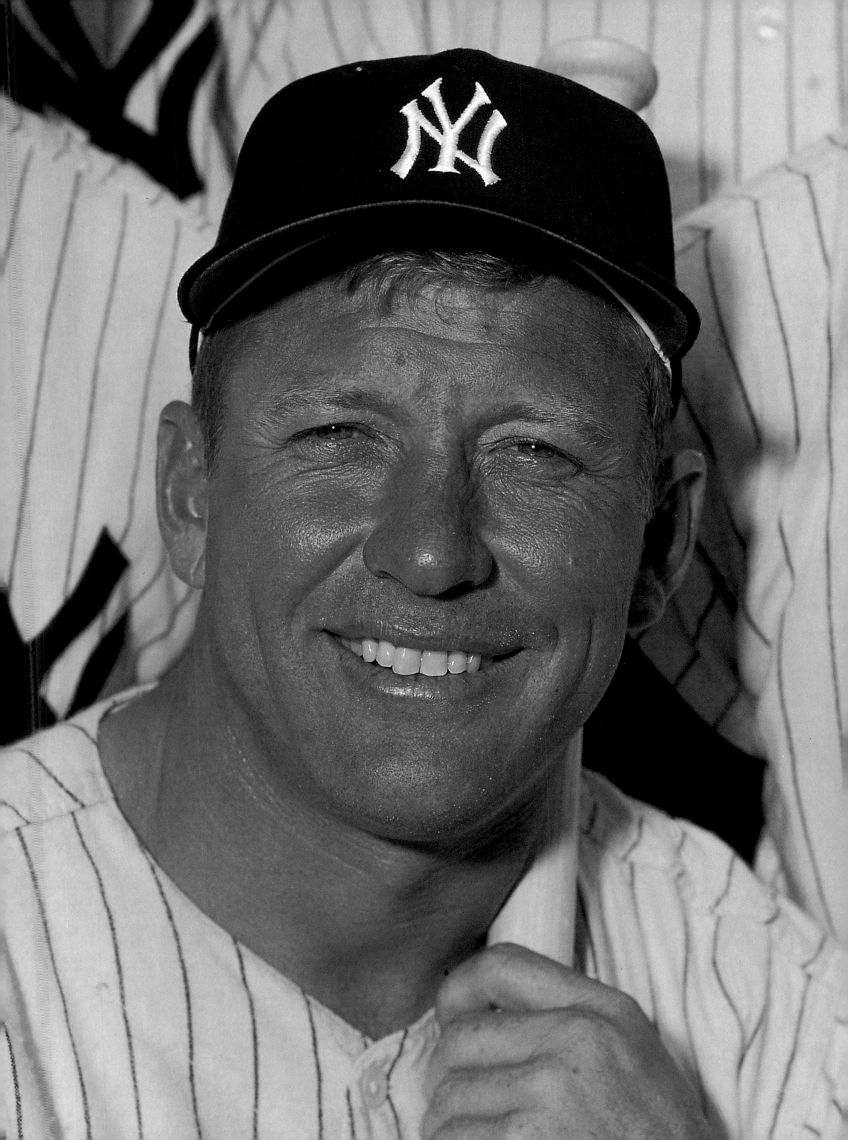

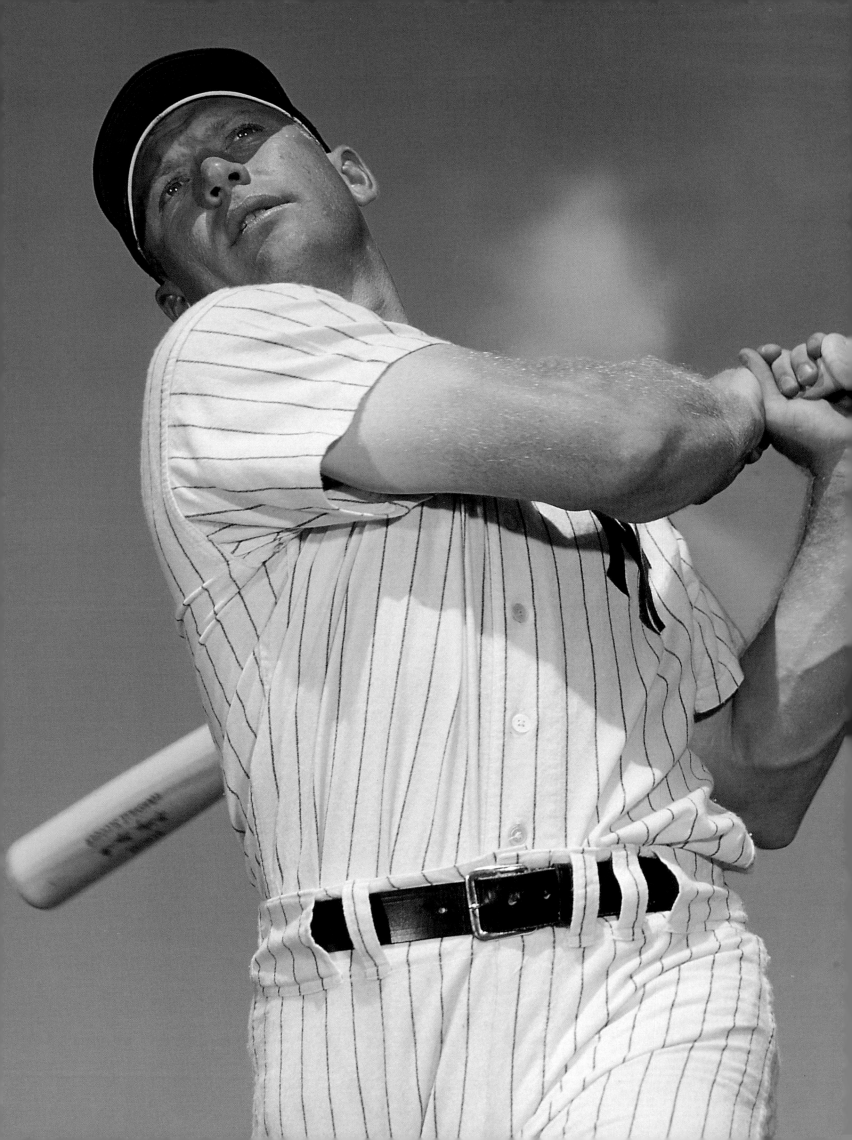

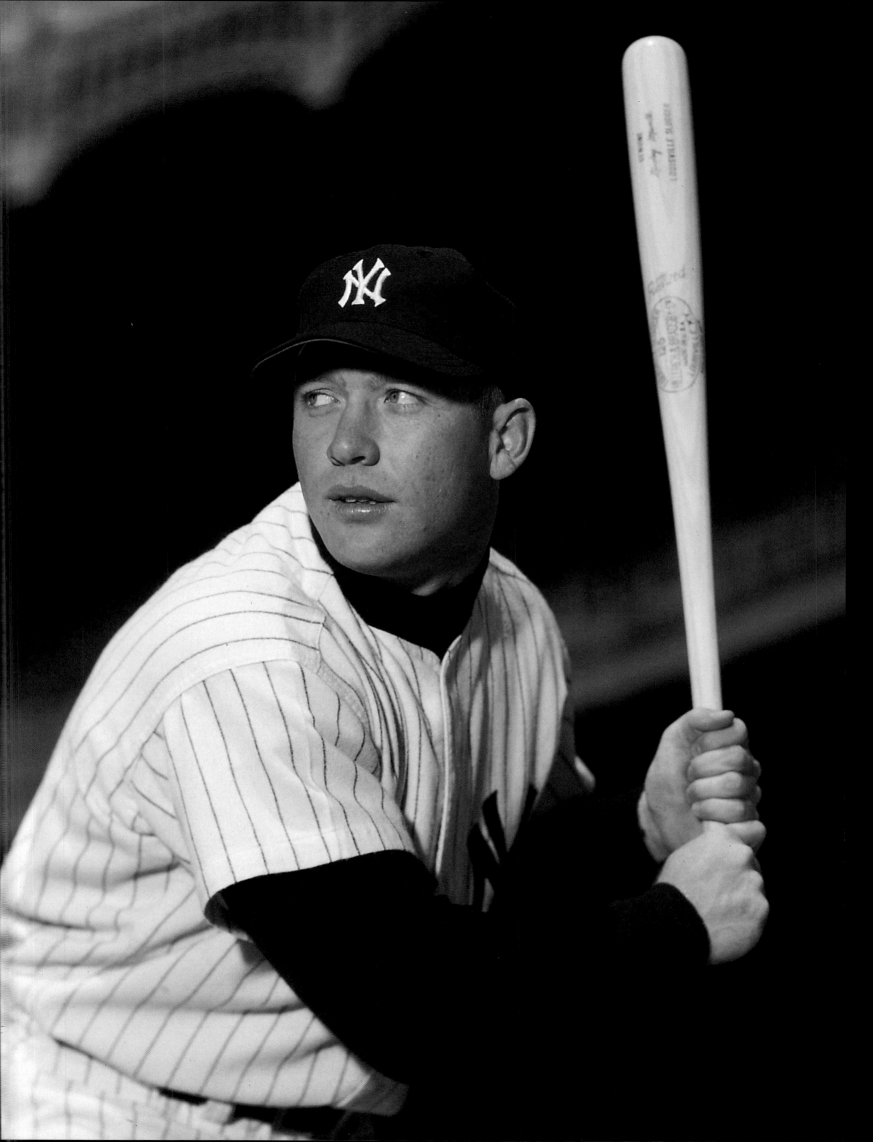

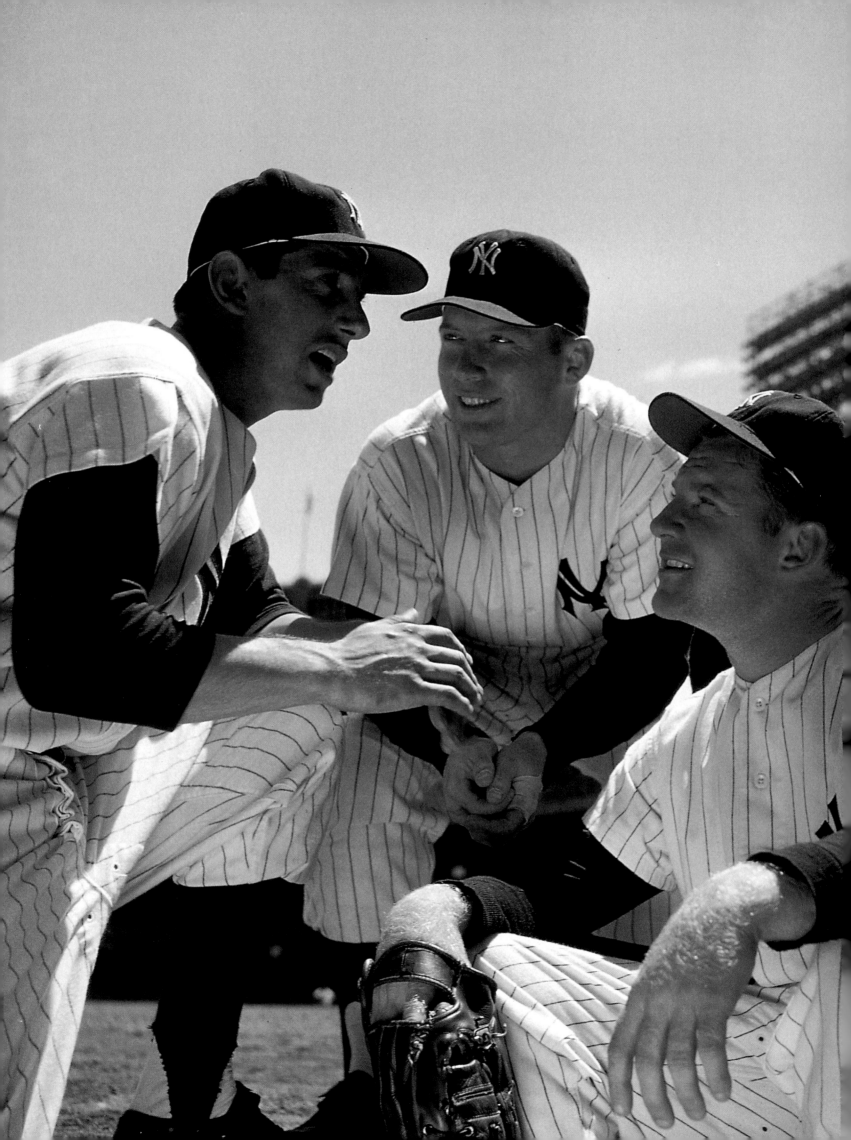

\mathcal{M}antle was an imposing pres-

ence in center field, in the batter's box,

and even on the top step of the dugout

talking with his buddies.

PRECEDING PAGES 188—189: Mantle
shows his right-handed swing . . .
. . . and his left-handed stance

OPPOSITE: Martin has a word with
Mantle and Ford

Whitey Ford

- BORN: 1926

- PITCHER 1950–67 Yankees

- 236–106 career won–lost record

- 2.75 career ERA

- 1,956 career strikeouts

- Cy Young Award 1961

- All-Star 1954–56, '58–61, '64

- Elected to the Hall of Fame 1974

Ford was so confident of his pitching that he used to give the bullpen the night off, setting up a table with a red-checkered tablecloth, a candle in a Chianti bottle, and Italian food. Said Mantle of his buddy, "I don't care what the situation was, how high the stakes were—the bases could be loaded and the pennant riding on every pitch—it never bothered Whitey."

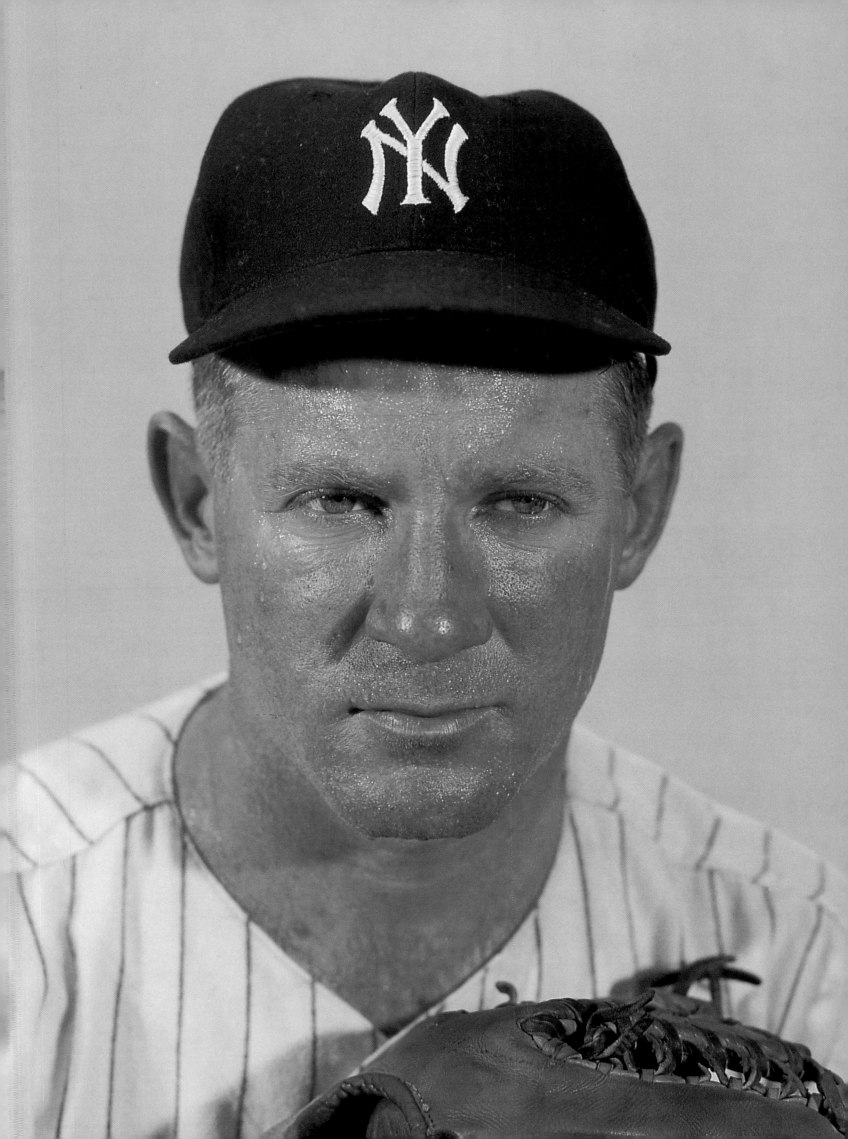

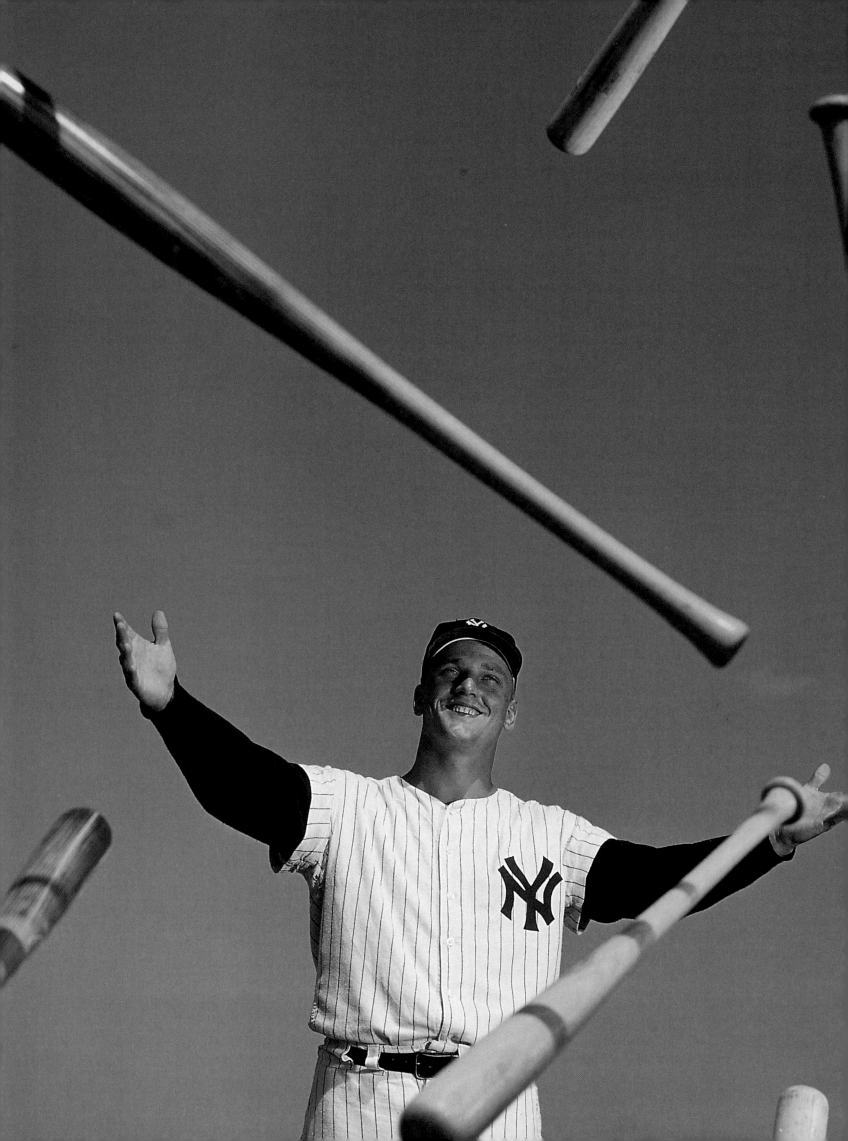

Roger Maris

- BORN: 1934 DIED: 1985

- OUTFIELDER 1957–68 Indians, A's, Yankees, Cardinals

- .260 career batting average

- 275 career home runs

- Broke Babe Ruth's single-season home run record with 61 in 1961

- MVP 1960, '61

- All-Star 1960

The 1961 season was a terrible ordeal for Maris, what with the constant pressure, the suffocating attention, and the resentment that he was surpassing Babe Ruth. One of his few respites came during a game in Detroit late in the season. With Terry Fox on the mound, Maris stepped out of the box and stared at a flock of Canada geese migrating south. He stood there for the longest time, gazing off into the distance at the birds, but nobody disturbed him. Finally, Maris stepped back in and hit Fox's first pitch into the upper deck in right field for Home Run No. 58.

FOLLOWING PAGE 196: The M&M Boys in '61. **FOLLOWING PAGE 197:** Maris's bat wrote his name into the record books.

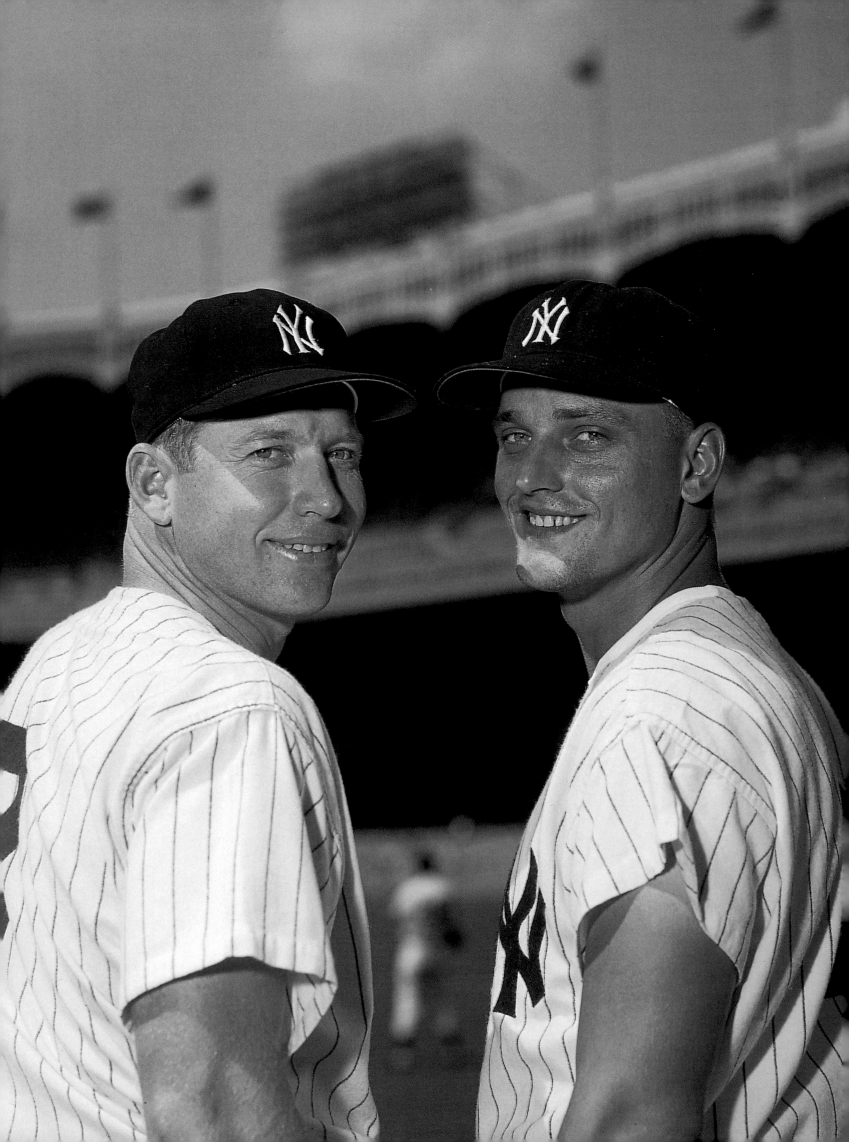

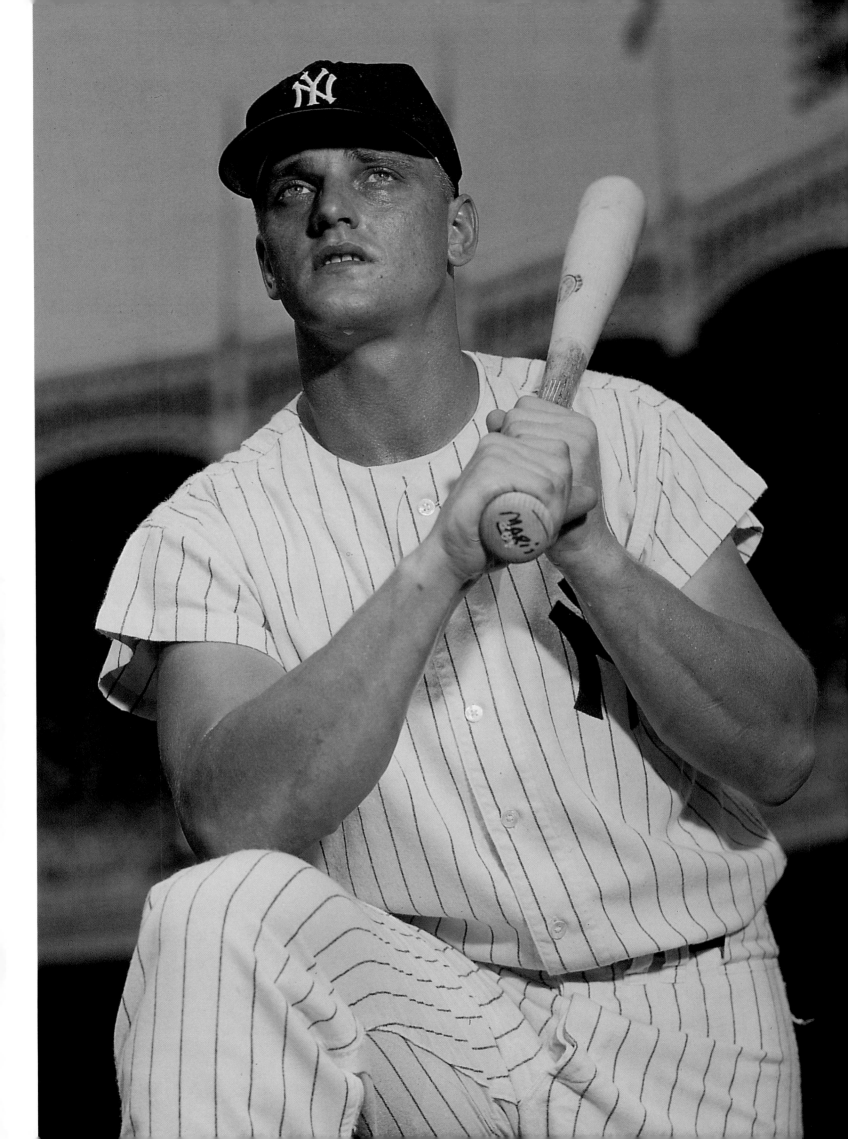

Yogi Berra

- BORN: 1925

- CATCHER, OUTFIELDER 1946–65
 Yankees, Mets

- MANAGER 1964, '72–75, '84–85
 Yankees, Mets

- .285 career batting average

- 358 career home runs

- 1,430 career RBIs

- MVP 1951, '54, '55

- All-Star 1948–62

- Played on 10 World Series
 championship teams

- Elected to the Hall of Fame 1972

The mind of Yogi Berra is a wonderful thing. A radio interviewer once tried to engage him in free association. On the air the announcer said, "I'm here tonight with Yogi Berra, and we're going to play free association. I'm going to mention a name, and Yogi's just going to say the first thing that comes to mind. Okay, Yogi?" "Okay," said Yogi. "All right," said the announcer, "here we go then. Mickey Mantle." "What about him?" asked Berra.

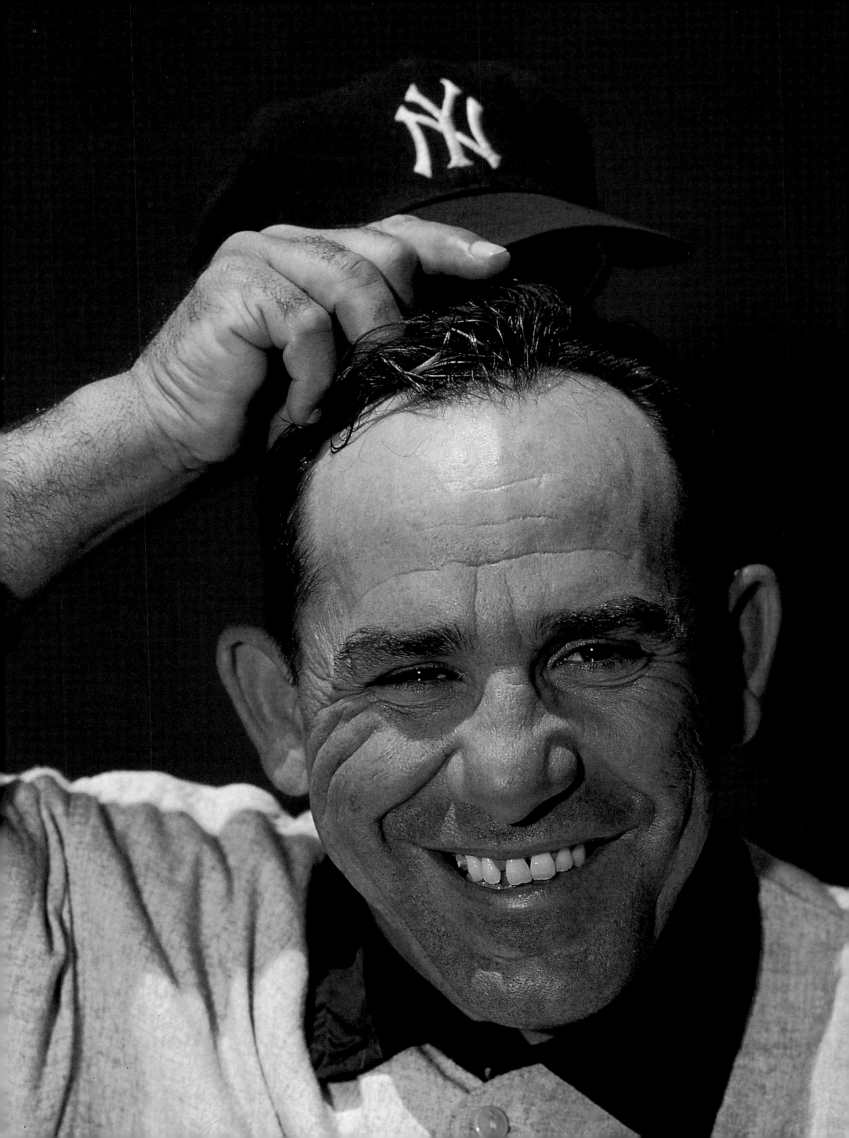

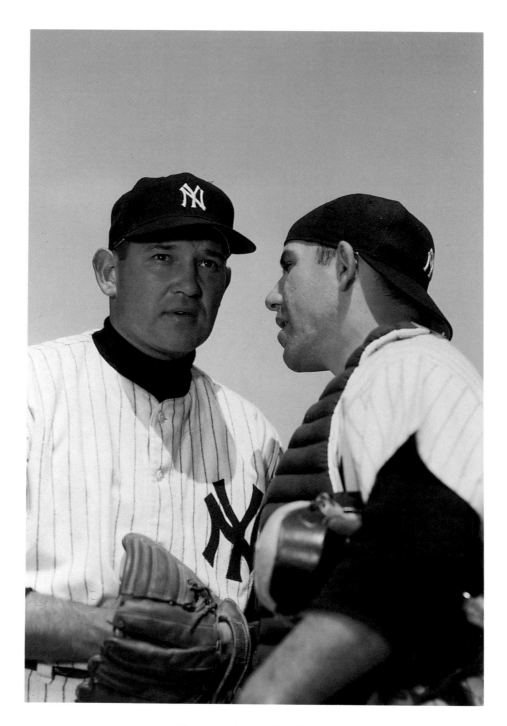

ABOVE: Yogi confers with Allie
Reynolds

O*ver the years, Yankee pitchers had
to take a backseat to DiMaggio,
Mantle, et al., but the Bronx Bombers
couldn't have won so many titles with-
out their hurlers.*

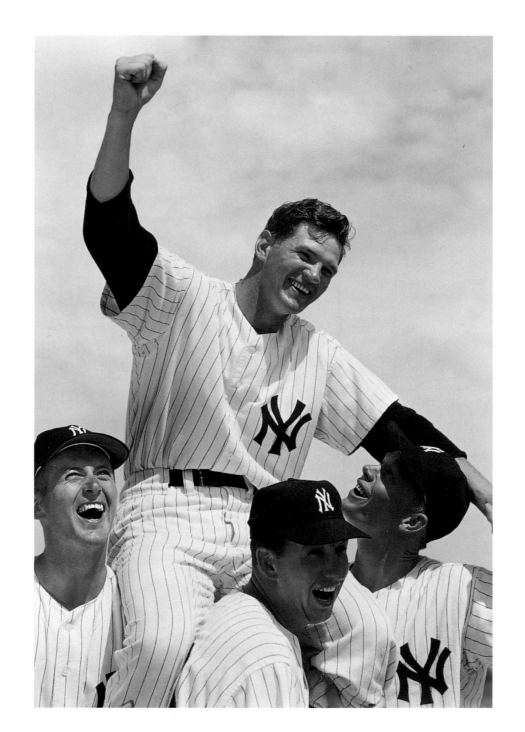

ABOVE: Pitcher Ralph Terry gets carried away

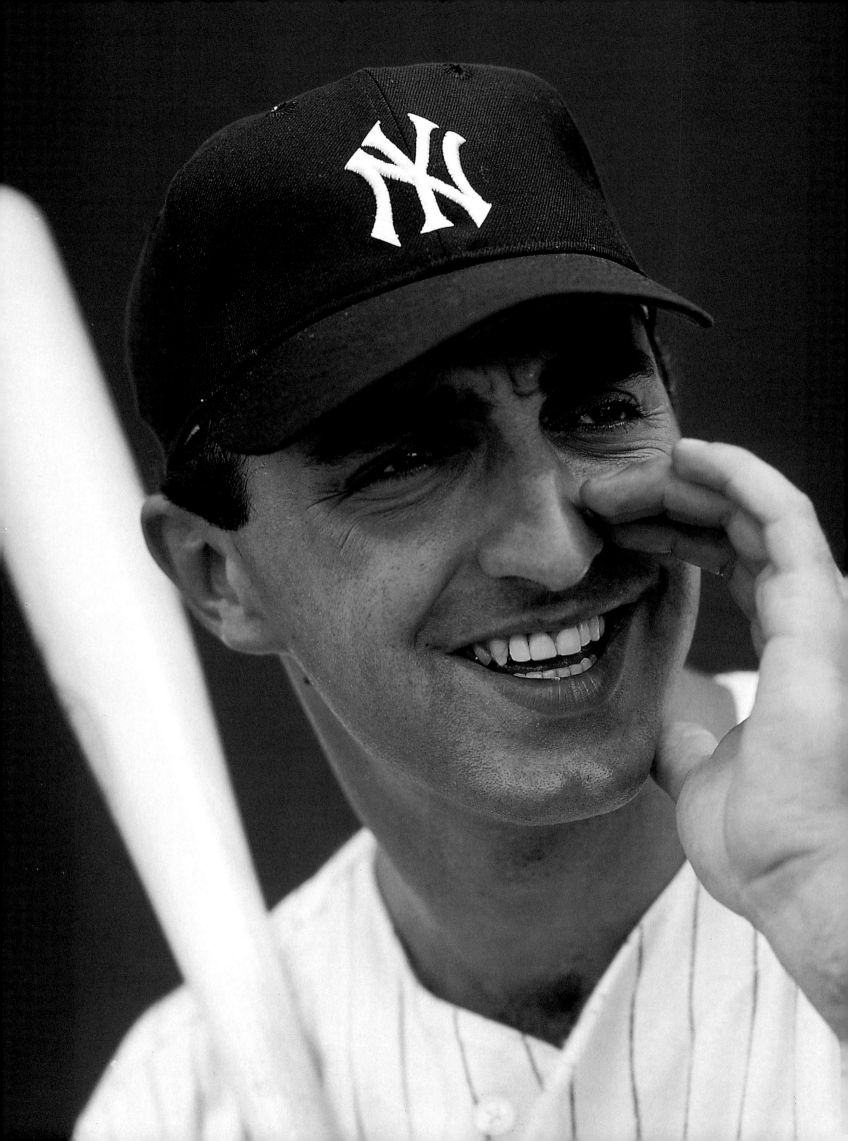

Joe Pepitone

BORN: 1940

◆ FIRST BASEMAN, OUTFIELDER
1962–73 Yankees, Astros, Cubs,
Braves

◆ .258 career batting average

◆ 219 career home runs

◆ All-Star 1963–65

A true pioneer in the use of the hair dryer, Pepitone had considerable talent, but a considerably larger ego. Mickey Mantle once told him, "I wish I could buy you for what you're really worth, and sell you for what you think you're worth."

Other Sports

\mathcal{Y}es, there are sports other than baseball.

And not all of Ozzie Sweet's gems are from the diamond. This section is devoted to his football, basketball, hockey, golf . . . heck, photographs of everything from bowling to water skiing.

Look at them and suddenly you might be wearing a raccoon coat at Soldier Field in Chicago, or listening to Don Dunphy at ringside, or practicing your two-handed set shot. The ice from Bobby Orr's skates will sting your face, and so will the sand from Koming's bunker shot. You'll feel glad you didn't have to tackle Jim Brown, and you'll feel sad you didn't get to see Bob Cousy play.

Three of Ozzie's subjects are worth closer examination here because they illustrate the three Ins of his photography: Ingratiation, Ingenuity, and Indefatigability. Back before Rocky Marciano became heavyweight champion, Ozzie spent a lot of time with him and his family in Brockton, Massachusetts. "I was more than part of the entourage, I was part of the family," says Ozzie. "It was a wonderful experience. Rocky's mother and I hit it right off—I told her about my Italian grandmother in Stamford, Connecticut. Oh, could Rocky's mother cook. I began to understand why they had to padlock the refrigerator at

OPPOSITE: An Army invasion

RIGHT: Miami quarterback George Mira

205

night so that Rocky wouldn't be tempted to eat himself out of shape. And do you know what? A few weeks after the assignment, Mrs. Marciano went to Stamford and visited my grandmother."

It's doubtful that any other photographer could have gotten that warm photograph of Rocky with his daughter, Mary Ann, on page 241. When Ozzie was assigned to shoot Cousy, the challenge was to capture the wizardry of the great Boston Celtics guard. "I got the simple idea of using two-sided tape," says Ozzie. "Now of course, to keep something as large as a basketball attached to a hand, you need a heckuva lot of tape, and Cousy's hand was wrapped up pretty good. Even to this day, I'm amazed at how well it turned out. It looks like an honest-to-goodness behind-the-back pass in motion, when in actuality, Cousy was standing still. I guess you could call it stick-to-itiveness."

The very last photograph in this book is a hoot. Ozzie went to Cypress Gardens in the early '60s for one of the Sunday newspaper magazines that were popular at the time, and he came up

BELOW, LEFT: Bob Cousy puts one up

BELOW, RIGHT: Rick Casares of the Bears

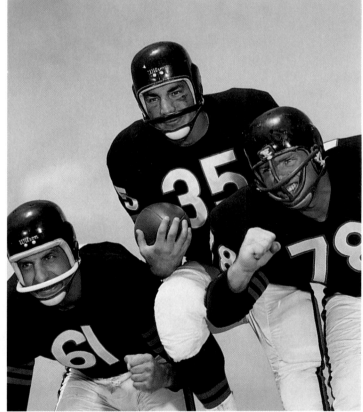

ABOVE, LEFT: Golfer Lloyd Mangrum

ABOVE, RIGHT: Young Bobby Orr of the Bruins

with a panoramic photograph that feels like a motion picture. "It was a big production," says Ozzie, "but fortunately, the man behind Cypress Gardens, Dick Pope, did everything he could for the sake of publicity. The girls on dry land were his most beautiful hostesses, and I had Cypress Gardens's entire wardrobe of bathing suits at my disposal. The boat and the skiers made at least a half-dozen passes before I got the shot I wanted. I know the photograph seems a little dated now, but it's fun, isn't it?" Yes it is.

One final note: The picture of Oscar Robertson and Jack Twyman on page 252 still hangs on at least one wall. It's in the Cincinnati-area home of Jack Twyman. "The picture was the cover of the March 1961 SPORT," says Twyman, a basketball Hall of Famer. "The headline is 'New Look in Cincinnati.'" That was Oscar's rookie year with the Royals, and I think it was my only magazine cover. Gosh, we looked so young . . . I just flashed back a few decades."

So have we all.

Johnny Lujack

- BORN: 1925

- QUARTERBACK, DEFENSIVE BACK
 1943, '46–47 Notre Dame, 1948–51
 Chicago Bears

- Completed 144 passes in 280
 attempts for 2,080 yards at Notre Dame

- Heisman Trophy Winner 1947

- Elected to the College Football
 Hall of Fame 1960

- Completed 404 passes in 808 attempts
 for 6,295 yards and 41 touchdowns
 in the NFL

- All-Pro defensive back 1948

- All-Pro quarterback 1950

A great all-around athlete, Lujack lettered in four sports at Notre Dame. He once played in a baseball game against Western Michigan and competed in a track meet against DePauw on the same day, getting three hits while winning the javelin throw between innings.

Sid Luckman

- BORN: 1916

- QUARTERBACK 1936–38
 Columbia University, 1939–47
 Chicago Bears

- All-American 1938

- Elected to the College Football
 Hall of Fame

- Completed 904 passes in 1,744 attempts
 for 14,686 yards and 139 touchdowns
 in the NFL

- Led Bears to four NFL Championships
 between 1940 and '46

Ranked among the best NFL quarterbacks for a decade, Luckman was also the most famous Jewish football player in American history. He led the Bears in their 73–0 rout of the Washington Redskins in the 1940 NFL title game, and he once passed for seven touchdowns in a single game. After the '47 season, Luckman was replaced by alphabetical mate Lujack.

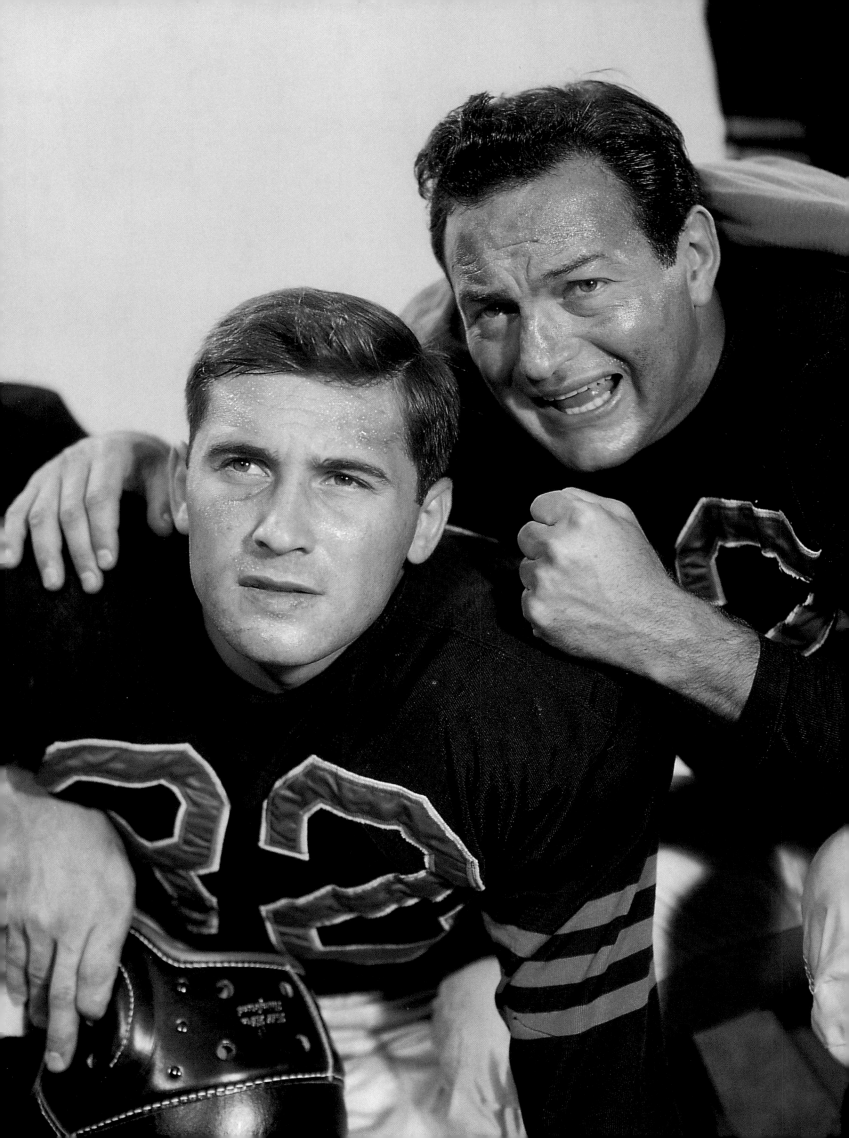

The 1953 Michigan State Backfield

Leroy Bolden, Evan Slonac, Billy Wells, and Tom Yewcic were collectively known as The Light Brigade.

After Michigan State came west for the Rose Bowl, one Los Angeles columnist wrote, "When the

Spartans lined up for the photogs yesterday, everyone in the backfield except quarterback

Tom Yewcic seemed to be standing in a hole." Nobody had a bigger Rose Bowl week

than Wells, though. He was not only named the outstanding player

in MSU's 28–20 win over UCLA, but he also went on a

date with Debbie Reynolds.

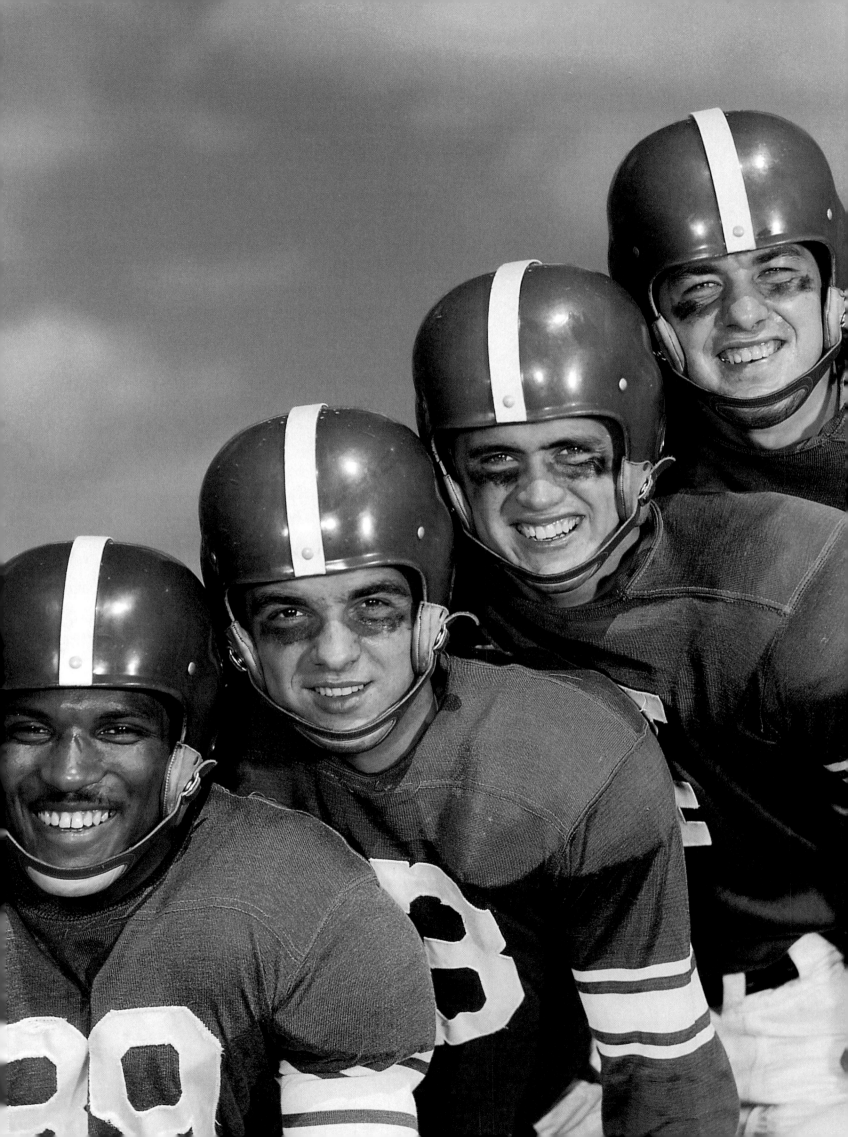

Pete Vann

\mathcal{V}ann was one of the finest quarterbacks Army has ever had, leading the team back to respectability after 44 players were dismissed in a 1951 Honor Code violation. He was also a personal favorite of legendary coach Red Blaik, who said, "By diligent effort, Pete became a very fine quarterback. He was a more than acceptable passer and field general, a solid defensive back in a crisis, and as a ball handler and faker he was one of the best we've ever had at the Academy." In the 1954 Army–Navy game Vann and Navy quarterback George Welch hooked up in a memorable duel, which Welch eventually won, 27–20.

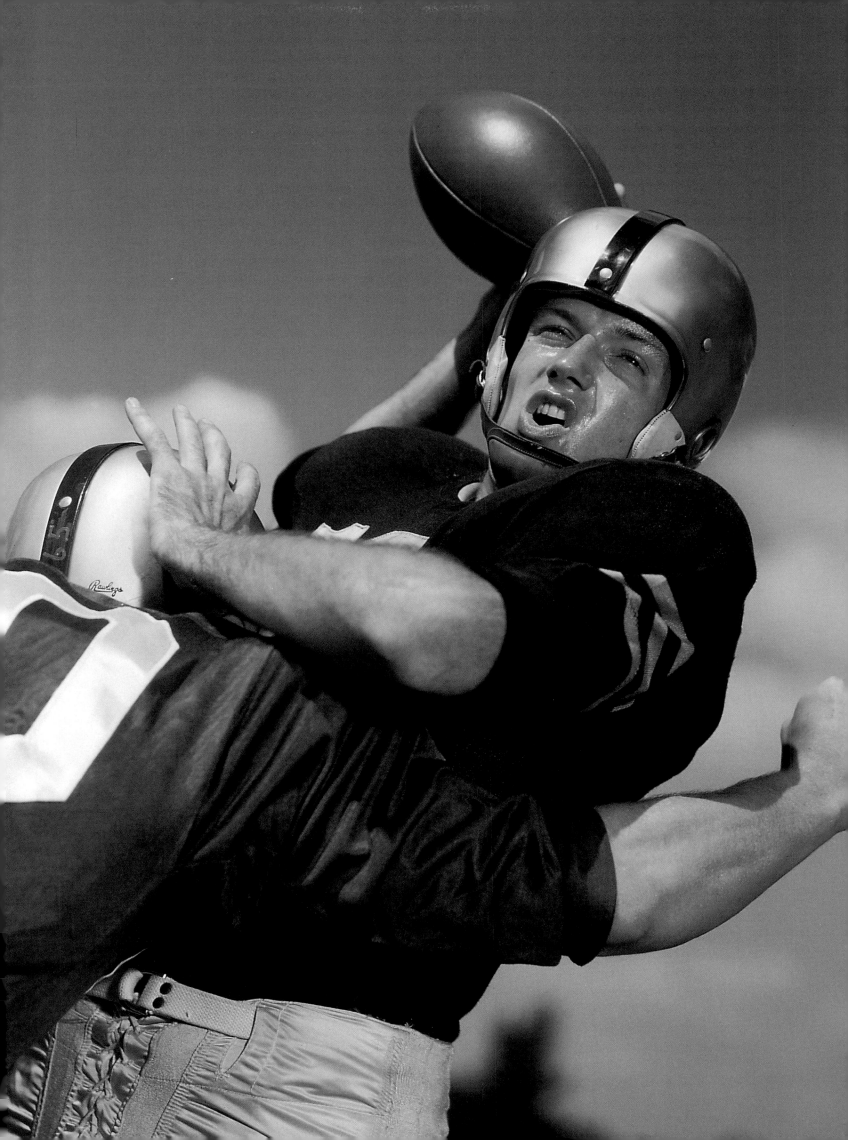

Bobby Layne

◆ BORN: 1926 DIED: 1986

◆ QUARTERBACK 1945–48 University of Texas, 1948–62 Chicago Bears, New York Bulldogs, Detroit Lions, Pittsburgh Steelers

◆ Elected to the College Football Hall of Fame 1956

◆ In the NFL completed 1,814 passes in 3,700 attempts for 26,769 yards and 196 touchdowns

◆ Made 34 of 50 field goals attempted

◆ Made 120 of 124 extra points attempted

◆ Pro Bowl 1953 '54, '57

◆ Elected to the Pro Football Hall of Fame 1967

Nicknamed the Gadabout Gladiator, Layne had a colorful lifestyle that Joe Namath could only imitate. Asked why he needed only five fours of sleep, Layne said, "I sleep fast and wake up movin'." On the field, he was at his best in the closing minutes of a ballgame. Said Chicago Bears' patriarch George Halas, "If I wanted a quarterback to handle any team in the final two minutes, I'd have to send for Layne."

FOLLOWING PAGES 216-217: Layne was a great passer . . . and a great charmer

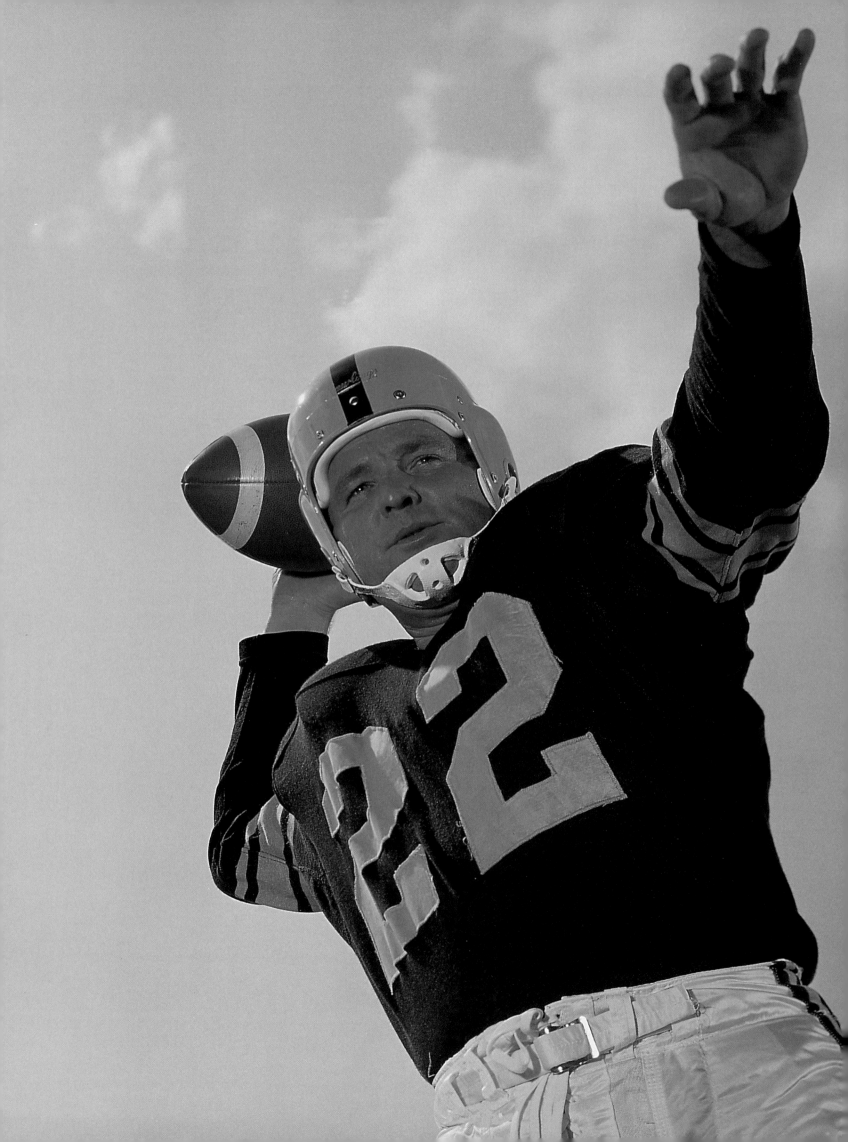

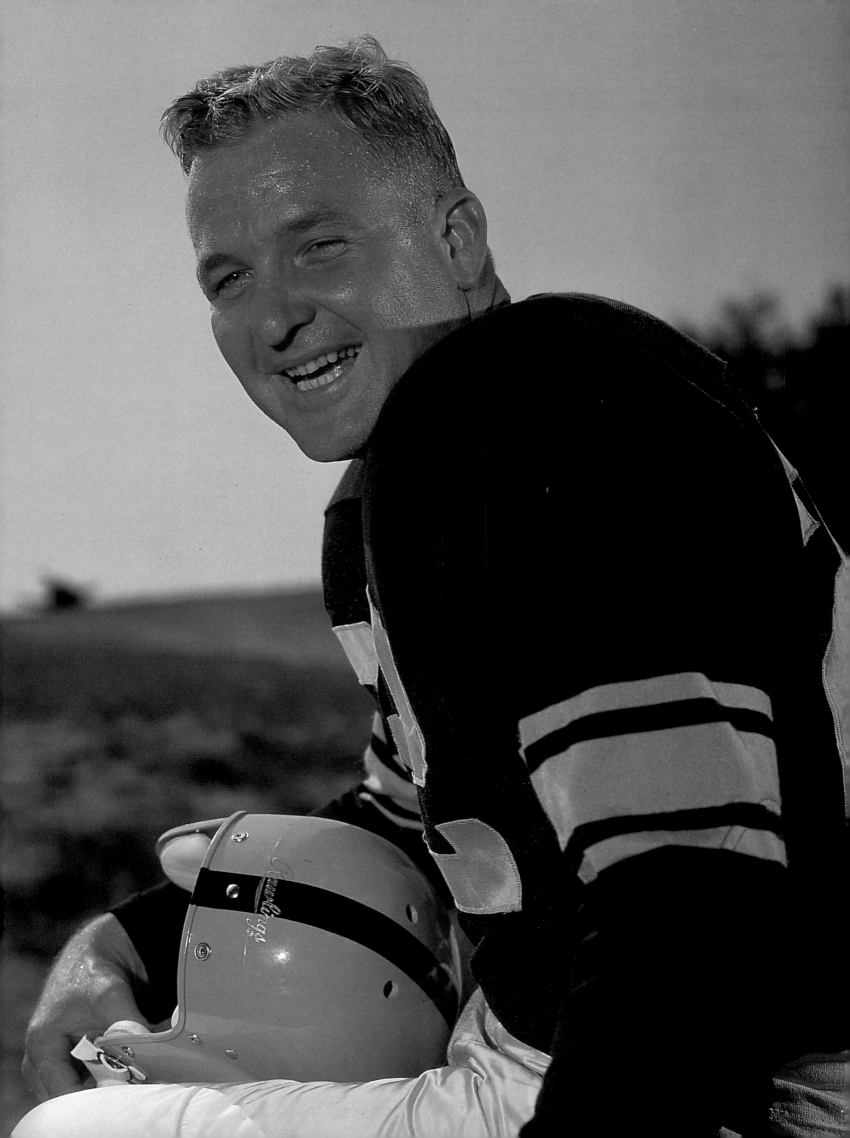

Jim Brown

- ◆ BORN: 1936

- ◆ RUNNING BACK 1954–56 Syracuse University, 1957–65 Cleveland Browns

- ◆ 1956 All-American in both football and lacrosse

- ◆ As a pro, he ran for 12,312 yards on 2,359 carries (5.2 yards a carry)

- ◆ Scored 106 rushing touchdowns

- ◆ Rookie of the Year 1957

- ◆ MVP 1958, '65

- ◆ Led NFL in rushing 8 times

- ◆ Elected to the Pro Football Hall of Fame 1971

Considered by many to be the greatest running back in history, Brown combined power with speed and durability: He never missed a game in nine years as a pro because of injury. He retired from football to become an actor, but not even Ice Station Zebra could match the sight of Brown coming around right end on a sweep.

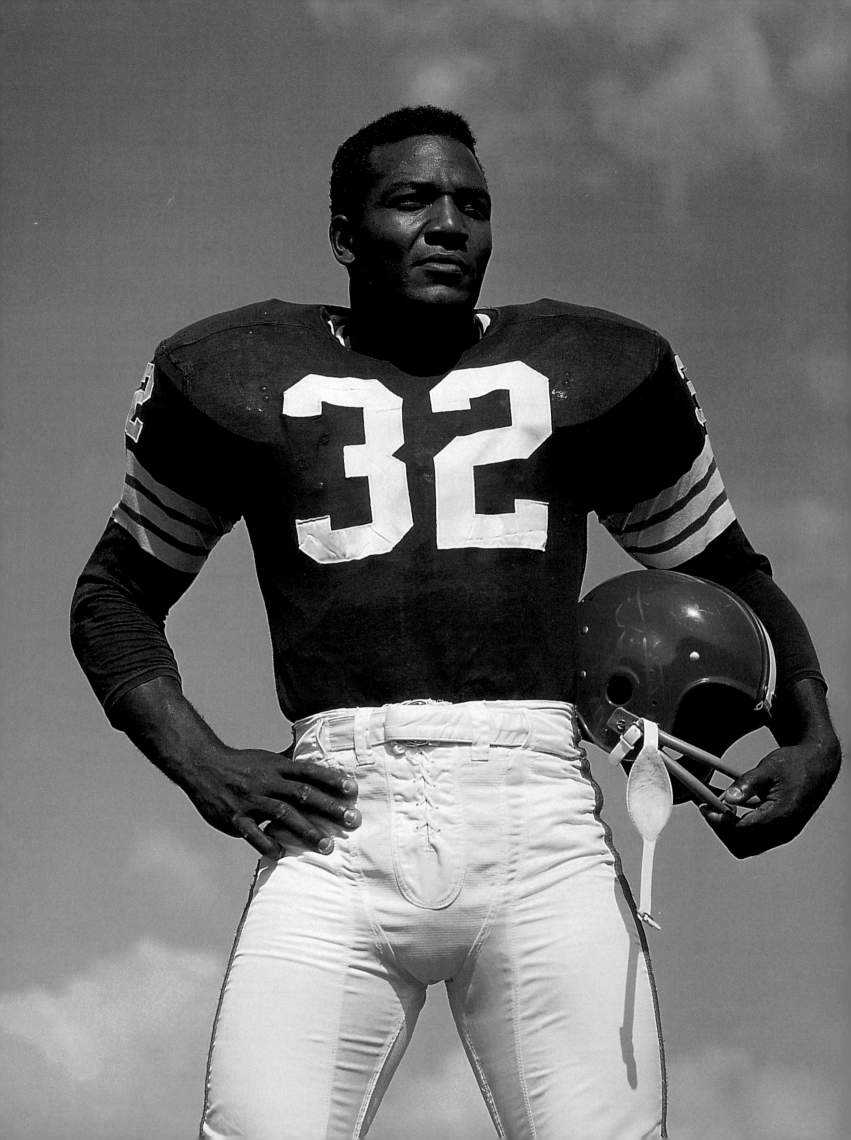

BELOW: The view of a would-be tackler

OPPOSITE: Brown strikes a Hollywood pose

T here was no bigger or more fierce-some star in the NFL during the 1950s and 1960s than Jim Brown.

The changing face of football can be seen in the helmets worn by these great receivers.

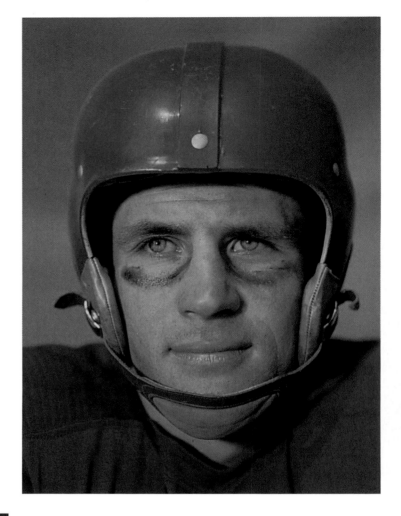

RIGHT: The great SMU end Doak Walker

BELOW: The great Detroit Lions end Gale Cogdill

ABOVE: Another fine receiver, Sonny Randle of the Cardinals

LEFT: Del Shofner, the superb Giants pass-catcher

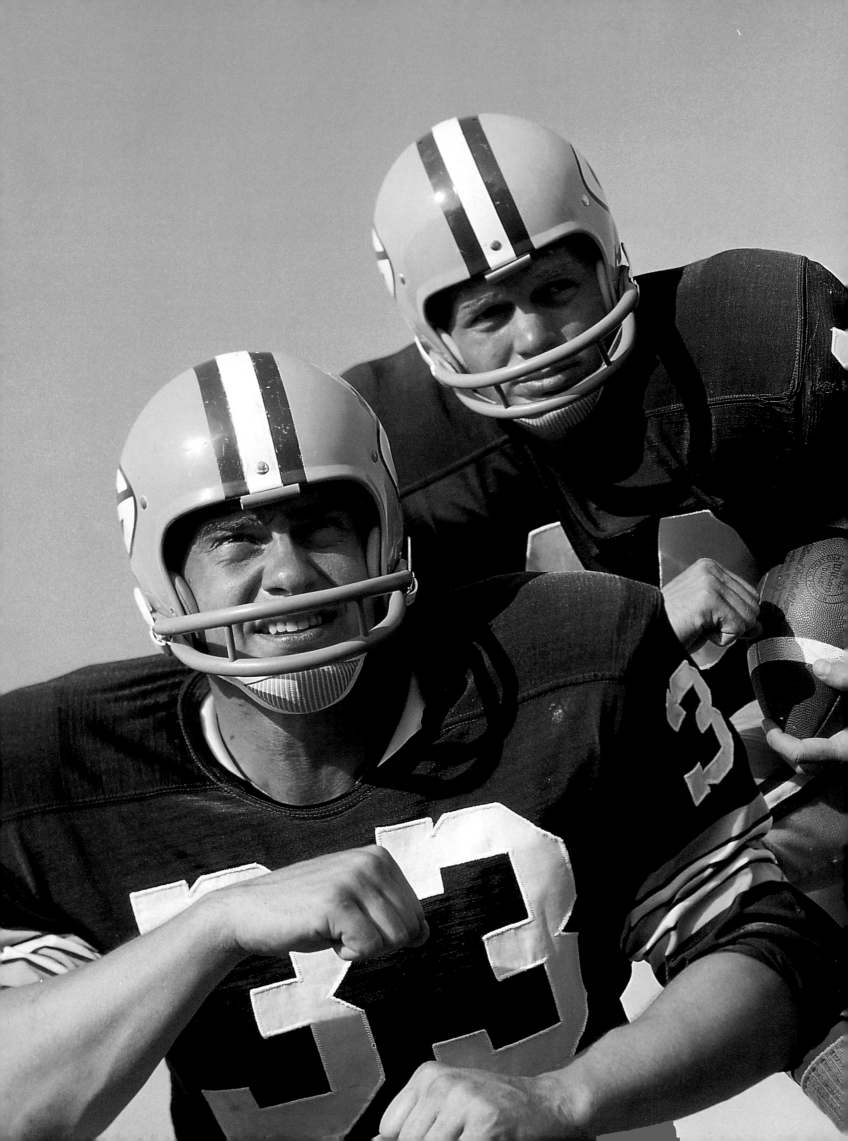

Jim Grabowski (33) and Donny Anderson (44)

Fullback Grabowski, the Packers' first-round draft choice in 1966 out of Illinois, and halfback Anderson, their first selection in '65 out of Texas Tech, were supposed to be the heirs to Jim Taylor and Paul Hornung, but they never quite lived up to their promise. While they did have their moments, when the Pack began to slide downhill after the '67 season, Anderson and Grabowski had to shoulder some of the blame.

Paul Hornung

- ◆ BORN: 1935

- ◆ QUARTERBACK, RUNNING BACK
 1954–56 Notre Dame, 1957–62,
 '64–67 Green Bay Packers

- ◆ All-American 1955–56

- ◆ Awarded Heisman Trophy 1957

- ◆ Elected to the College Football
 Hall of Fame 1985

- ◆ In NFL ran for 3,711 yards on
 893 carries

- ◆ Scored 50 touchdowns

- ◆ Kicked 190 of 194 extra points

- ◆ Scored 760 career points

- ◆ Pro Bowl 1959, '60

- ◆ Elected to the Pro Football
 Hall of Fame 1986

Paul Hornung was the Golden Boy of the Green Bay Packers, a great offensive player who could run, pass, catch, block, and kick. As this photo shows, he also had matinee idol looks. But he fell from grace in 1963 when the NFL suspended him for a year for gambling on NFL games.

RIGHT: Hornung displays his
movie-star profile

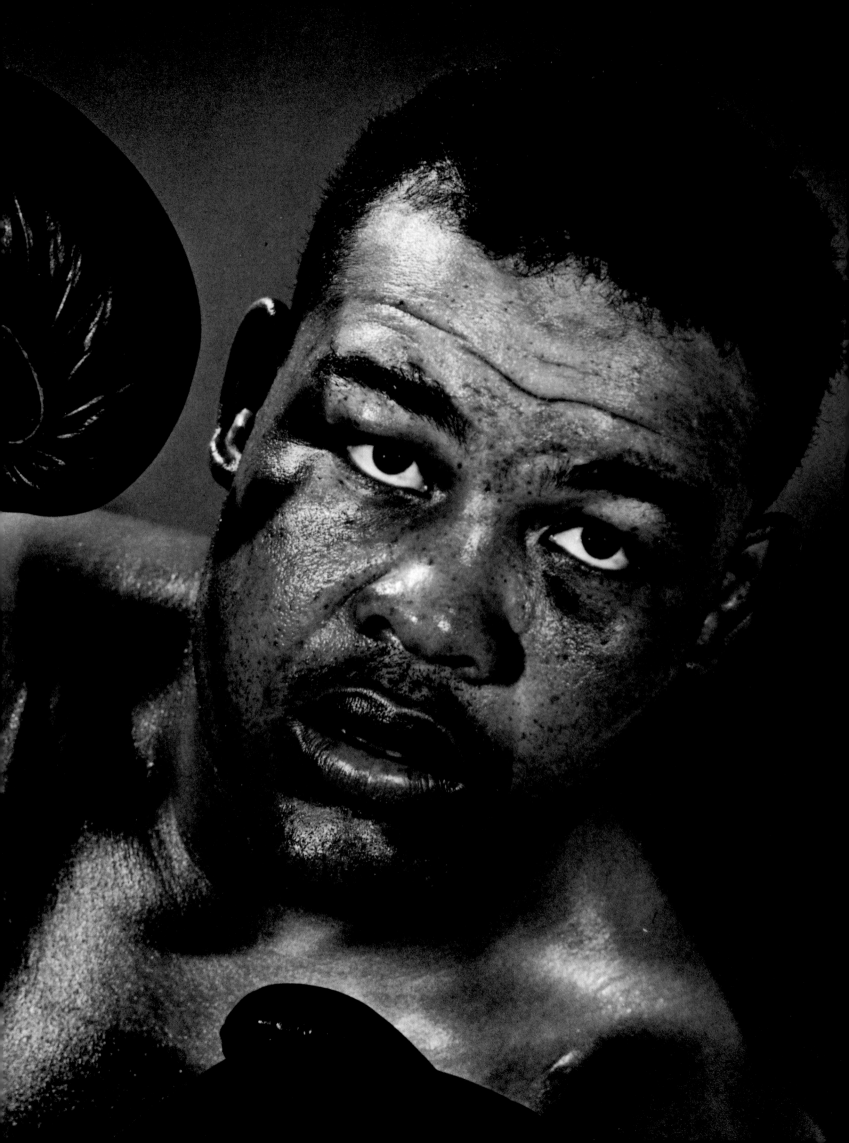

Joe Louis

- BORN: 1914 DIED: 1981

- 63–3 career record

- 49 KOs

- Heavyweight Champion 1937–48

- Elected to the Boxing Hall of Fame 1954

The Brown Bomber was the most popular heavyweight champion in boxing history, at least until Muhammad Ali came along. The great boxing historian Nat Fleisher waxed poetic about Louis: "He was a pugilistic symphony with a tempo geared to bring him across the ring with all the grace of a gazelle and the cold fury of an enraged mountain lion." His one-round pounding of German Max Schmeling in 1938, avenging an earlier defeat, galvanized the entire nation.

Floyd Patterson

- ◆ BORN: 1935

- ◆ 1952 Olympic Middleweight Gold Medalist

- ◆ 55–8–1 professional record

- ◆ 40 KOs

- ◆ Heavyweight Champion 1956–59, '60–62

- ◆ Elected to the Boxing Hall of Fame 1976

This son of a Brooklyn railroad worker became the youngest heavyweight champion ever when he knocked out the favored light heavyweight champ Archie Moore in the fifth round of their November 30, 1956, fight to determine the successor to the retired Rocky Marciano. Patterson was a bit of an anomaly, an elegant boxer in a division normally ruled by punching power. He once retrieved an opponent's fallen mouthpiece for him. When Patterson avenged an earlier loss to Ingemar Johansson in 1960, he became the first boxer to regain the heavyweight title.

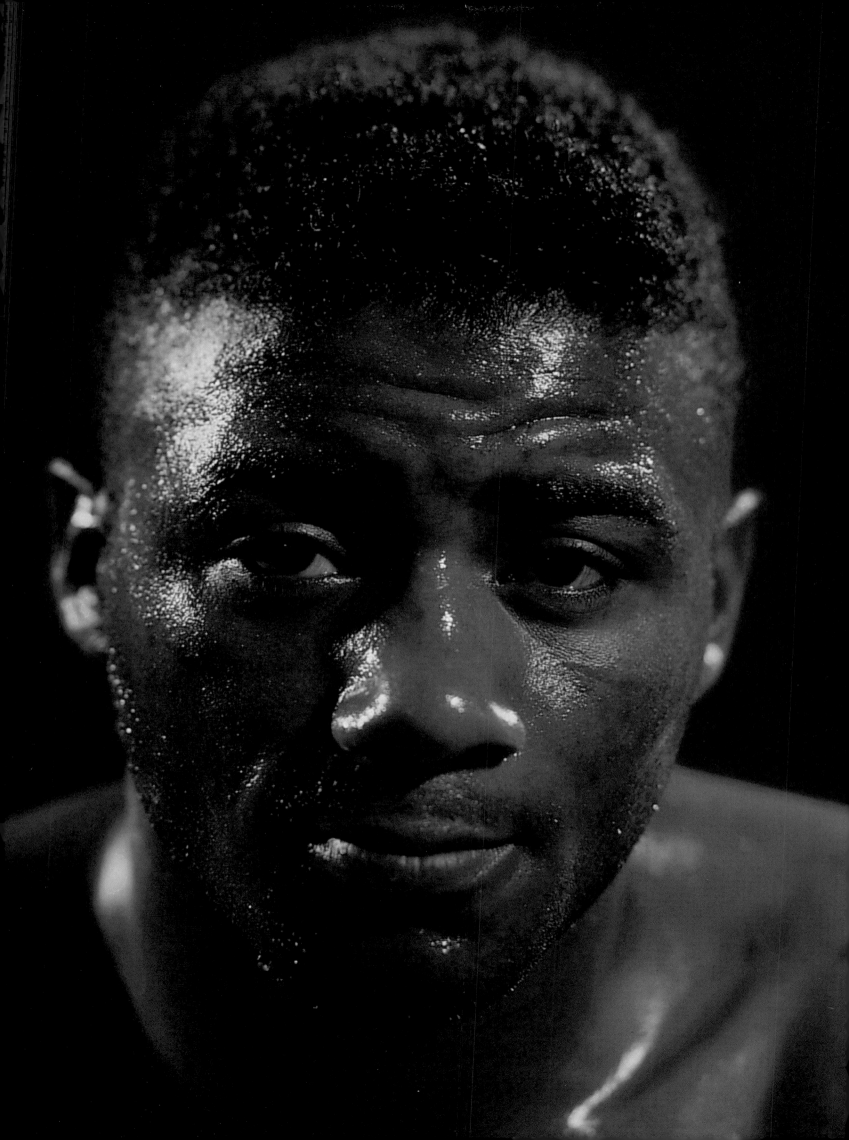

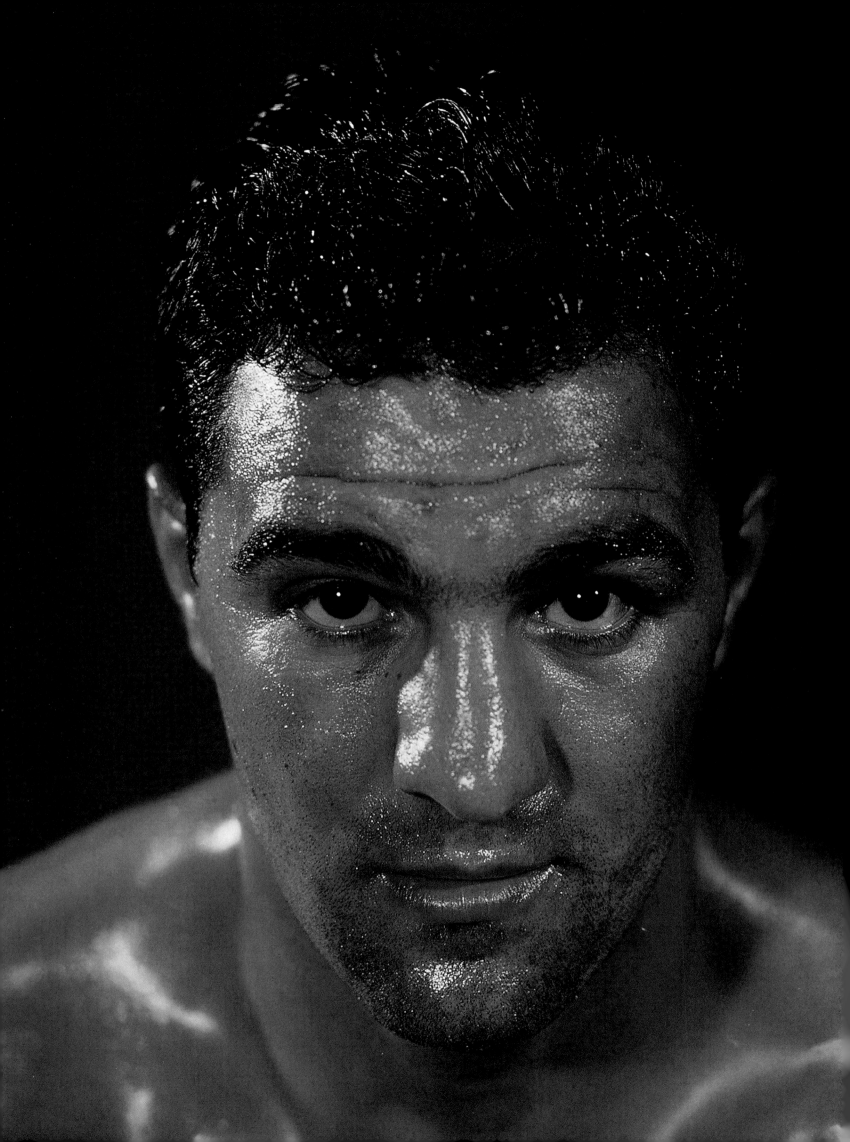

Rocky Marciano

- BORN: 1923 DIED: 1969
- 49–0 career record
- 43 KOs
- Heavyweight Champion 1952–56
- Elected to the Boxing Hall of Fame 1969

*B*orn Rocco Marchegiano, the Brockton Blockbuster began his career in 1947 as an unknown preliminary fighter, but on September 23, 1952, Marciano won the heavyweight title by knocking out Jersey Joe Walcott, who had been ahead on every card, with a devastating right in the 13th round. Only six men ever went the distance with the relatively small (5'11", 185 pounds) Marciano, who became the only heavyweight champion to retire undefeated. And unlike most of his fellow champs, he stayed retired. But on August 31, 1969, Rocky died in a plane crash in Newton, Iowa.

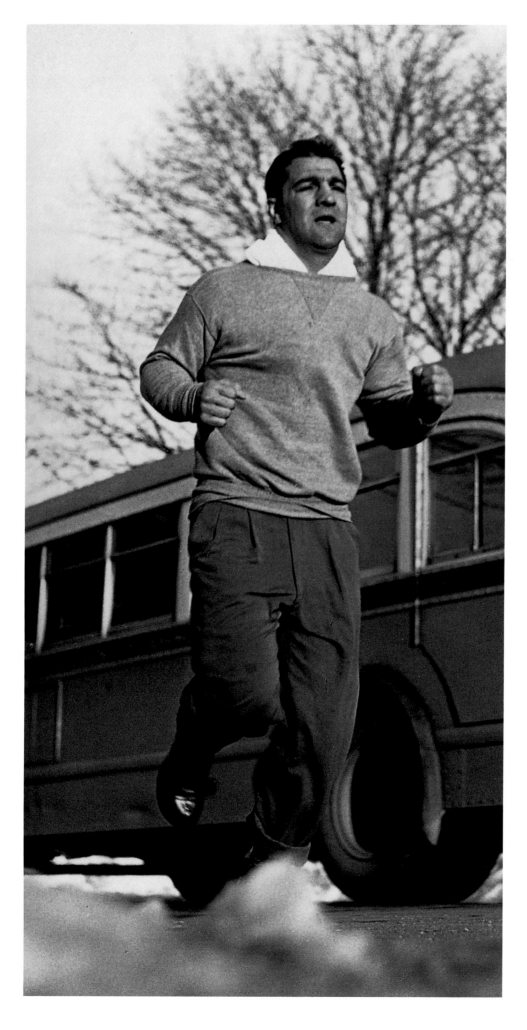

LEFT: The Rock in training in Brockton, MA.

OPPOSITE: Marciano on the couch, in the barber's chair, and on the training table

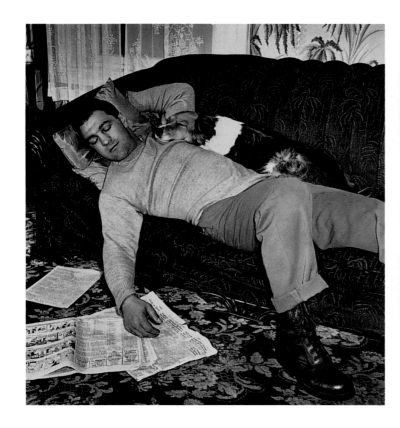

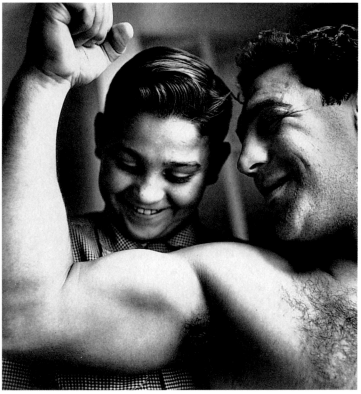

ABOVE AND LEFT: Rocky chowing down and showing off

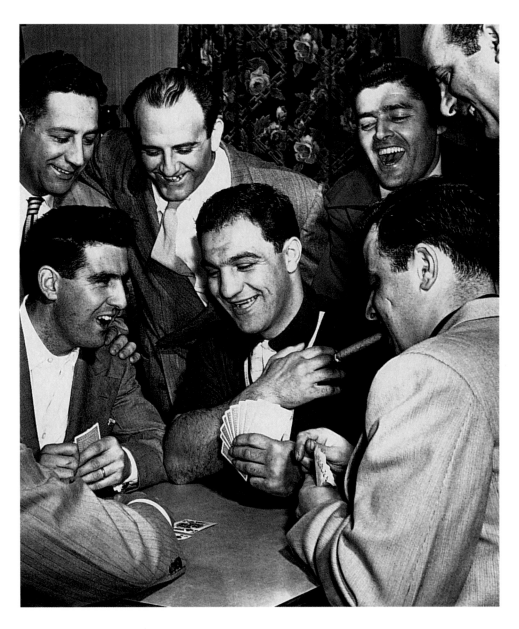

RIGHT: Playing and praying

For a man some say was our greatest heavyweight champion, a man who demonstrated such fury in the ring, Rocky was a surprisingly loving and friendly man. Nowhere can that be seen better than in this stirring portrait of the champ with his baby girl, Mary Ann.

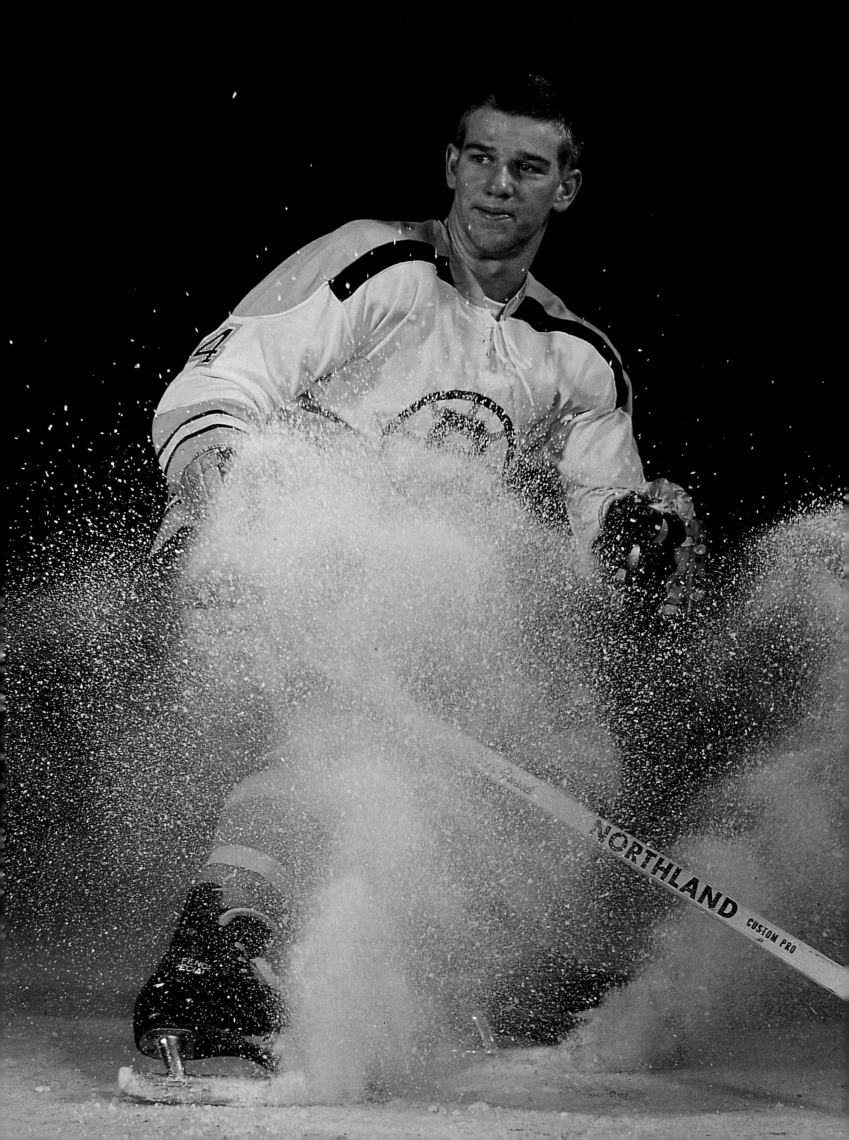

Bobby Orr

- ◆ BORN: 1948

- ◆ DEFENSEMAN 1967–77, '79 Boston Bruins, Chicago Blackhawks

- ◆ 270 career goals

- ◆ 645 career assists

- ◆ 915 career points

- ◆ Rookie of the Year 1967

- ◆ MVP 1970–72

- ◆ Norris Trophy 1968–75

- ◆ All-Star 1967–75

- ◆ Elected to the Hockey Hall of Fame 1970

Orr revolutionized hockey by becoming the first defenseman to lead the NHL in scoring (in 1970, the same year he led the Bruins to their first title since 1941). Five years later, Orr led the league again with 135 points (46 goals and 89 assists), which still remains the record for a defenseman. Unfortunately, Orr's knees gave out before his skills did.

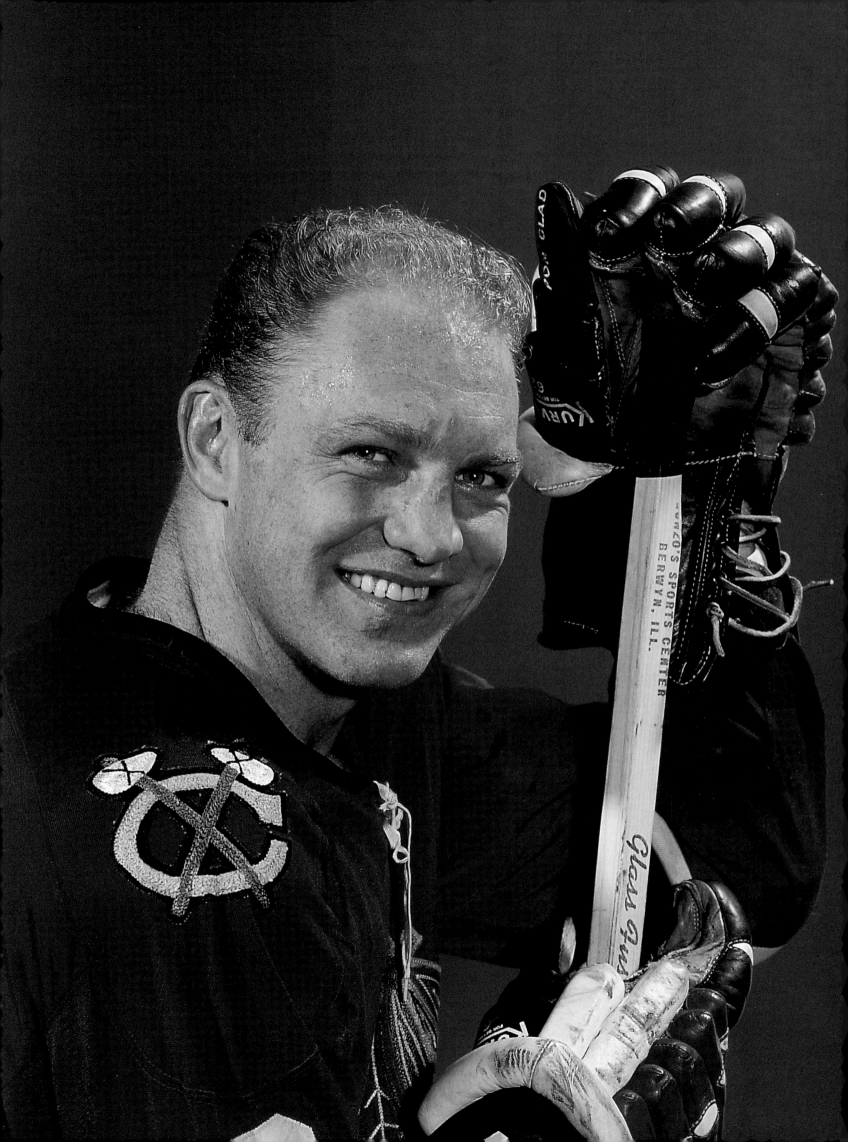

Bobby Hull

- BORN: 1939

- LEFT WING 1958–80 Chicago Blackhawks, Winnipeg Jets (WHA/NHL), Hartford Whalers

- 1,018 career goals

- 999 career assists

- 2,017 career points

- Led NHL in points 1960, '62

- All-Star 1960, '62, '64–72

- MVP 1965, '66

- Elected to the Hockey Hall of Fame 1983

The most frightening thing in sports may not have been a Marciano right or a Dick Butkus tackle or even a Ryne Duren fastball, but rather a Bobby Hull slap shot. Taken with his trademark curved stick, Hull's slap shot helped him become the first player to score 50 goals in a season (in 1966 in the season's 61st game). Though Bobby retired from the WHA in 1980, it's nice to know his son Bret is carrying on the family tradition.

Doug Harvey

- BORN: 1924 DIED: 1989

- DEFENSEMAN 1948–64, '66–68
 Montreal Canadiens, New York
 Rangers, Detroit Red Wings,
 St. Louis Blues

- COACH 1961–64 Rangers

- Norris Trophy 1955–58, '60–62

- All-Star 1952–62

- Elected to the Hockey Hall of
 Fame 1973

Before Orr came along, Harvey was acknowledged as the best defenseman in NHL history. He led the league in assists in 1954, and he made the All-Star team 10 times, but the best measure of Harvey's worth was the six Stanley Cup championships his Canadiens won.

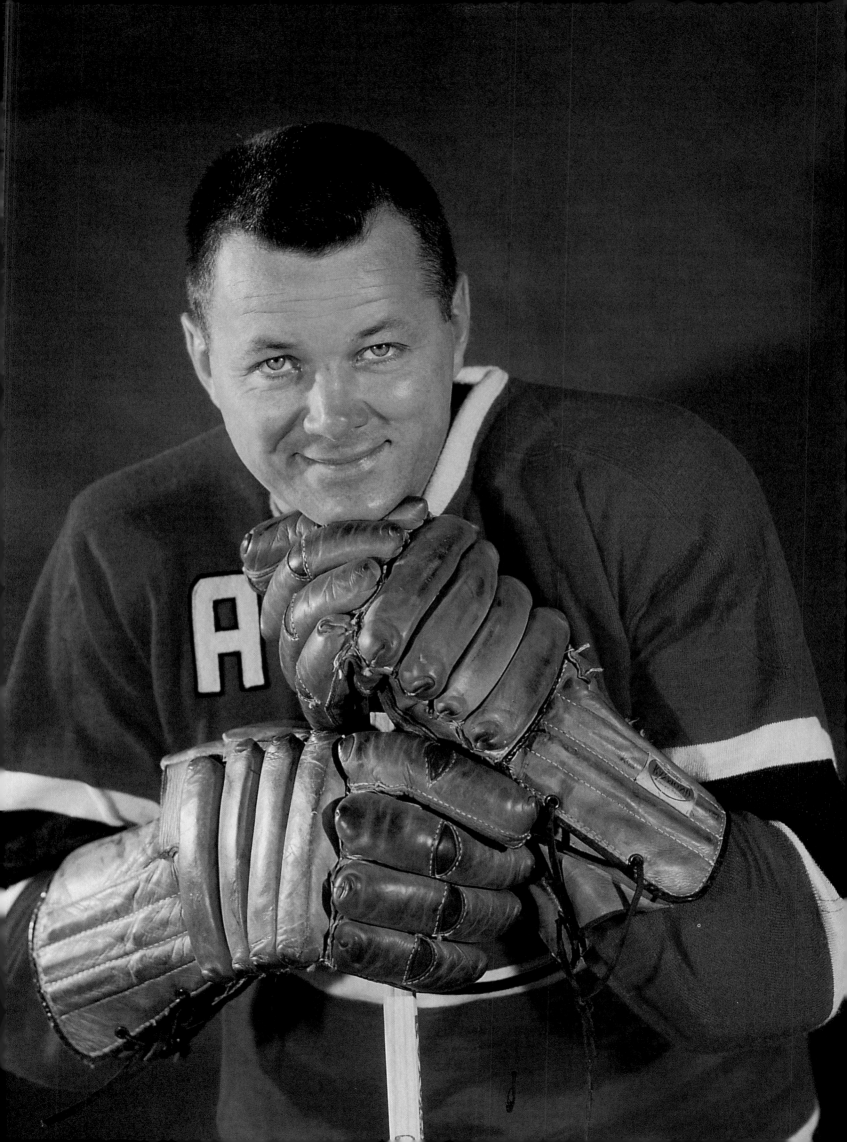

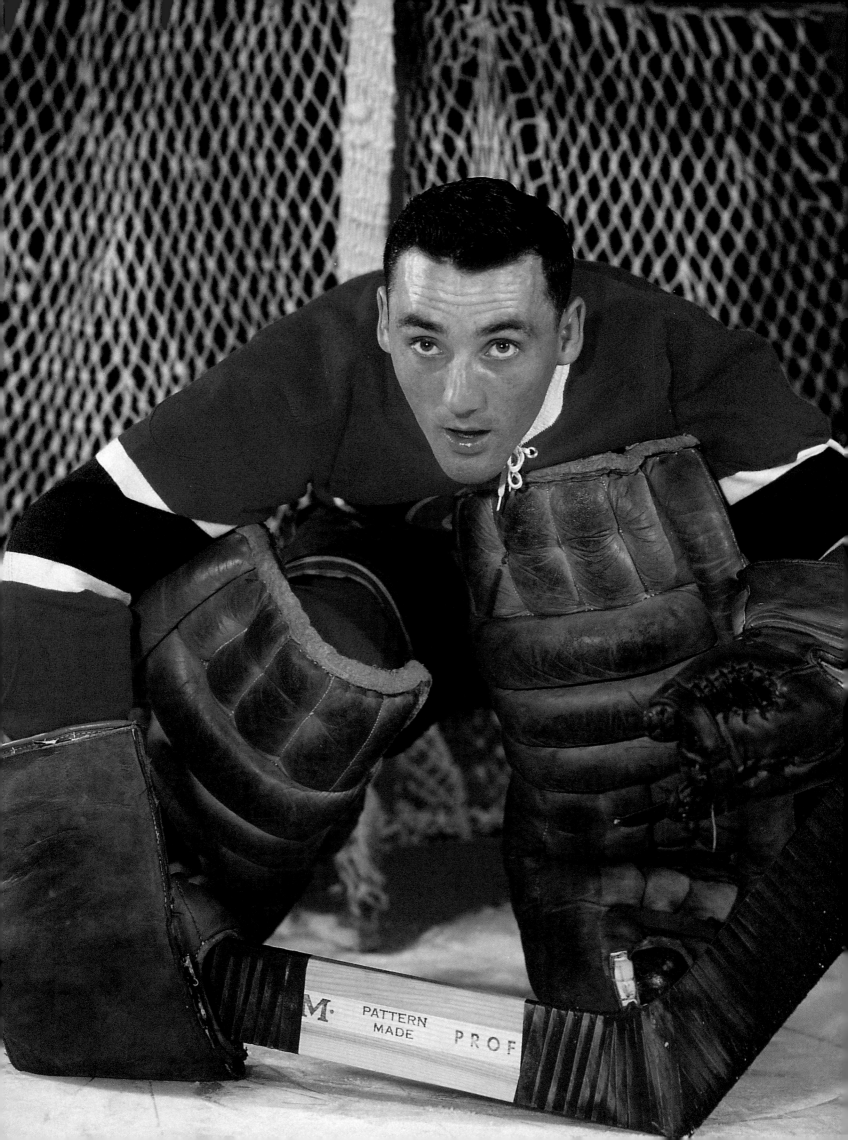

Jacques Plante

◆ BORN: 1929 DIED: 1986

◆ GOALTENDER 1953–75 Montreal
Canadiens, New York Rangers,
St. Louis Blues, Toronto Maple
Leafs, Boston Bruins, Edmonton
Oilers (WHA)

◆ 2.34 career goals-against average

◆ 82 shutouts

◆ Vezina Trophy 1956–60, '62

◆ All-Star 1956–60, '62

◆ Elected to the Hockey Hall of
Fame 1978

*P*lante is second all-time in wins
for a goalie, and his goals-against
average is also the second best in mod-
ern history, but his lasting legacy to
hockey was his common sense: Plante
was the first NHL goalie to wear a
mask.

Bob Cousy

- BORN: 1928

- GUARD 1946–50 Holy Cross
 College, 1951–63 Boston Celtics

- COACH 1963–69 Boston College,
 1970–74 Cincinnati Royals,
 Kansas City-Omaha Kings

- 16,960 career points in the NBA

- 6,959 career assists

- .803 career free-throw shooting
 percentage

- Rookie of the Year 1951

- All-Star 1951–63

- Elected to the Pro Basketball
 Hall of Fame 1970

When the Chicago Stags of the NBA disbanded after the 1950 season, three of their players—Max Zaslofsky, Andy Phillip, and an untested rookie from Holy Cross— were distributed among New York, Philadelphia, and Boston. The Celtics were given third choice and settled for the rookie, Bob Cousy. His wizardry with the ball was described this way by sportswriter Jack Kelly: "I saw him put salt and pepper on the ball, chew it up, then spit it into the basket."

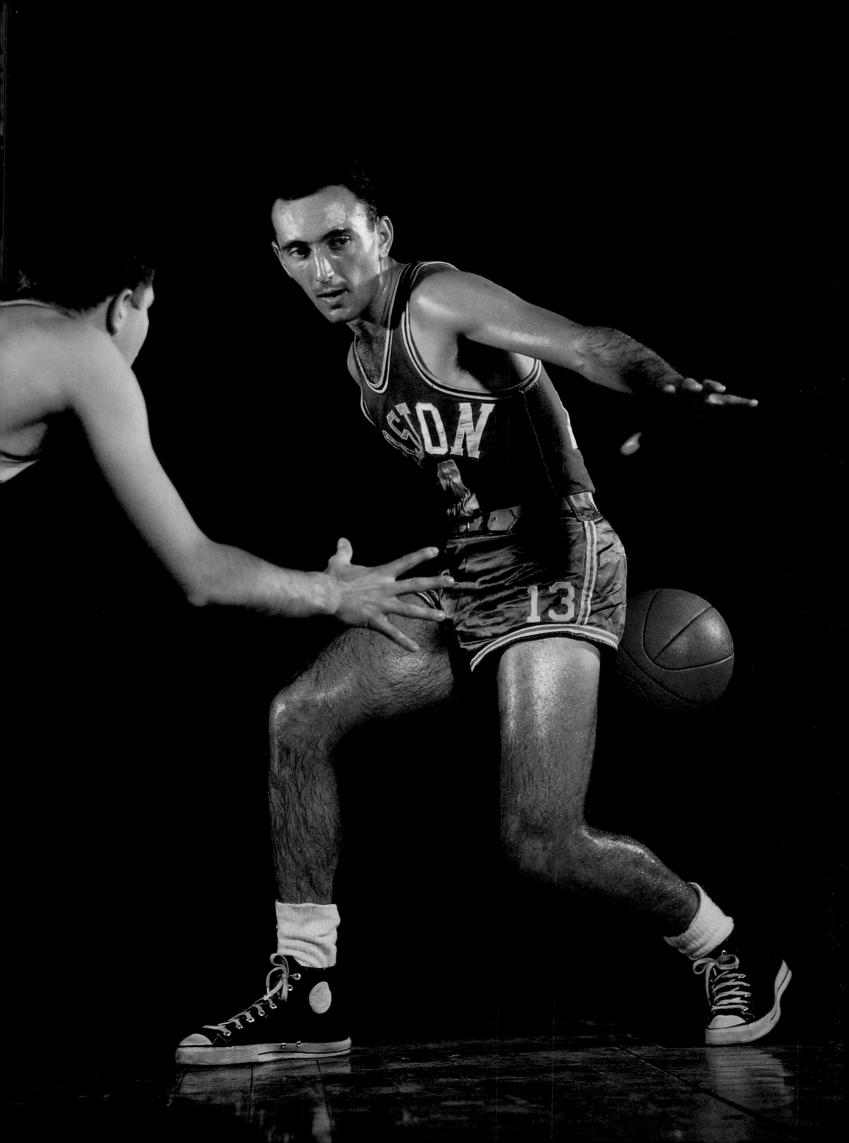

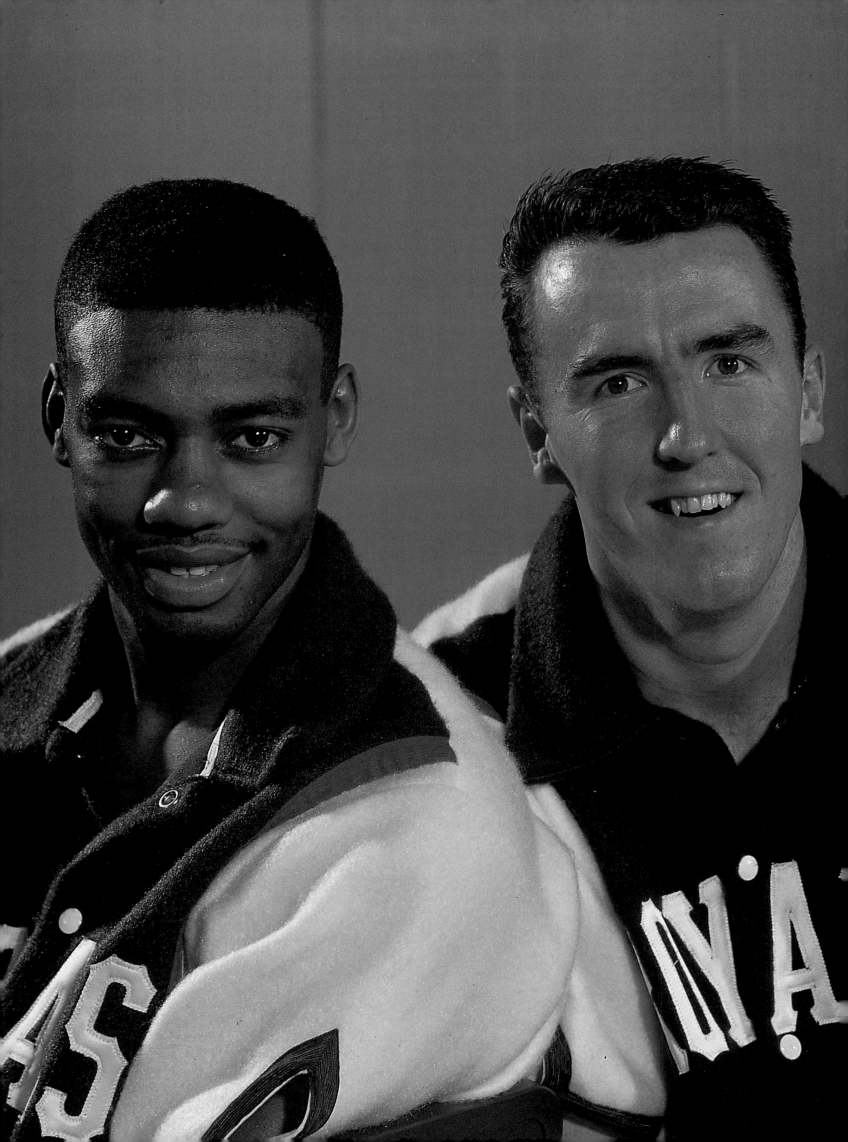

Oscar Robertson

- BORN: 1938

- GUARD, FORWARD 1956–60
 University of Cincinnati, 1961–74
 Cincinnati Royals, Milwaukee Bucks

- Captained 1960 Gold Medal-winning
 U.S. Olympic Team

- NBA MVP 1964

- 26,710 career points

- 9,887 career assists

- .838 career free-throw percentage

- Elected to the Basketball Hall of
 Fame 1979

The Big O, who stood 6'5", was the most versatile player the NBA had ever seen, averaging better than 25 points a game during his career while leading the league in assists six times. An NBA title eluded Oscar until his very last season, when he played for the Milwaukee Bucks and teamed with the youthful Kareem Abdul-Jabbar.

Jack Twyman

- BORN: 1934

- FORWARD 1951–55 University of
 Cincinnati, 1955–66
 Rochester/Cincinnati Royals

- All-American 1954, '55

- Six-time NBA All-Star

- 15,480 career points

- 5,421 career rebounds

- Elected to the Basketball Hall of
 Fame 1982

The 6'6" Twyman was one of the best shooting forwards of his era, thanks to a work ethic that enabled him to practice 200 jump shots, 150 set shots, and 100 foul shots every day during the offseason. Although Twyman was a good enough player to average 31.2 points a game in 1959–60, second only to Wilt Chamberlain that year, he is perhaps best known for his devotion to former Royals teammate Maurice Stokes, who was stricken with a crippling and ultimately fatal illness in 1958.

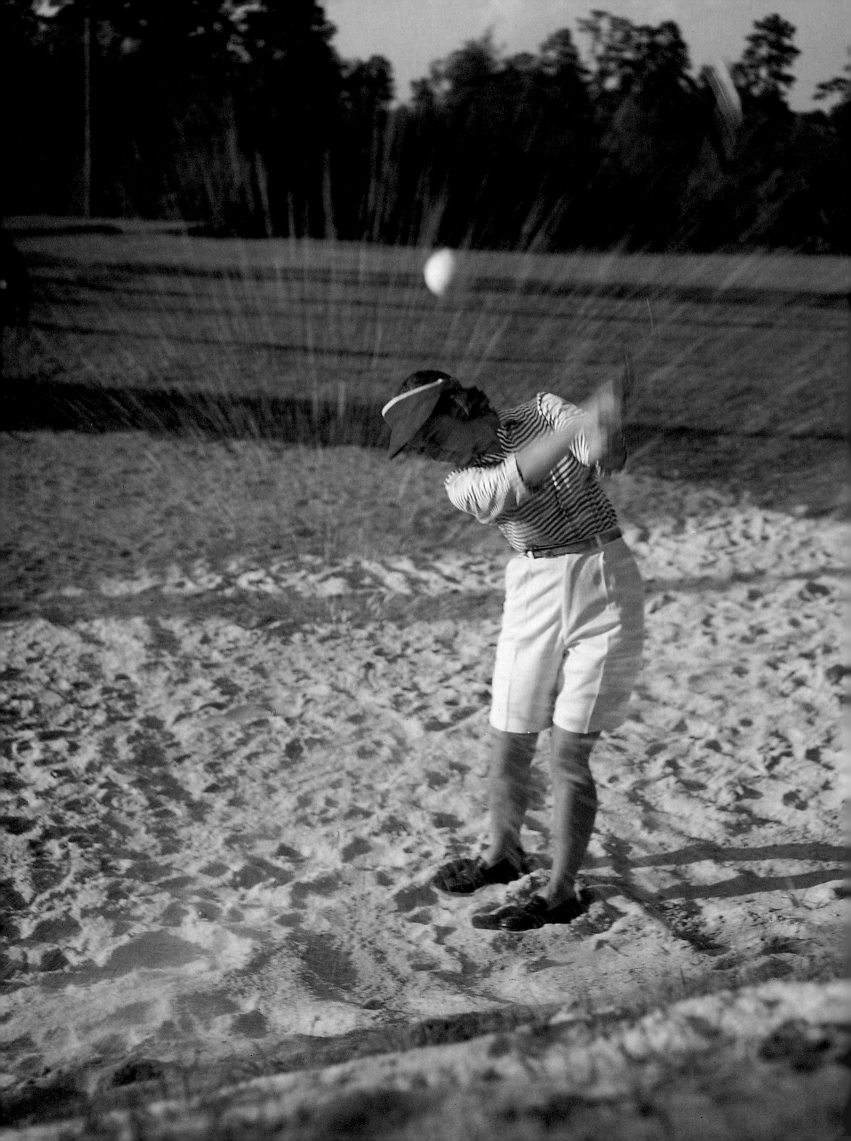

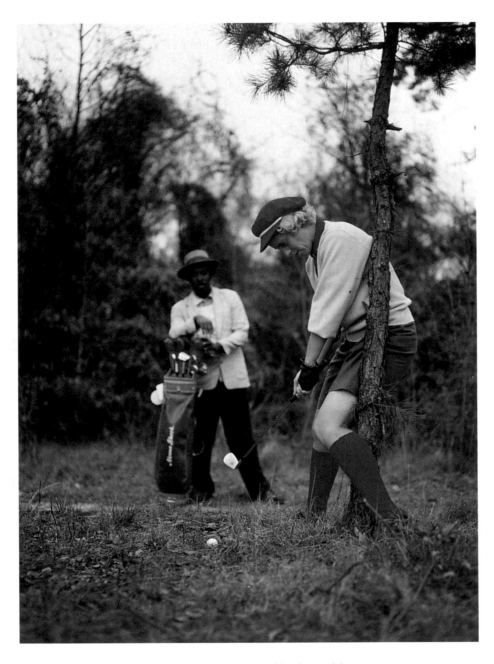

OPPOSITE: A woman golfer has a blast

ABOVE: Another lady has it pretty rough

Jack Nicklaus

- BORN: 1940

- U.S. Amateur Champion 1959, '61

- NCAA Champion 1961

- Masters Champion 1963, '65, '66, '72, '75, '86

- U.S. Open Champion 1962, '67, '72, '80

- British Open Champion 1966, '70, '78

- PGA Champion 1963, '71, '73, '75, '80

- PGA Player of the Year 1967, '72, '73, '75, '76

- 70 Career PGA Tournaments won

- Ryder Cup Team member 1969, '71, '73, '75, '77, '81

- Elected to the World Golf Hall of Fame 1974

The Golden Bear only seemed to get better over the years. The last of his 20 majors came in the '86 Masters when he was 46, and looking younger than he did when he became the youngest Masters champion in 1963. Nicklaus has received thousands of awards in his career, but one in particular seemed quite fitting: In 1988 he was named Golfer of the Century—and there were still 12 years to go. You might say he won the match 13 and 12.

zzie once did a fashion spread using athletes of the period.

ABOVE, LEFT: The Fisherman is football star Paul Christman

BELOW, LEFT: Tennis great Pancho Segura lights up his wife.

OPPOSITE: Basketballer Dick McGuire poses with a somewhat different ball for a fashion spread

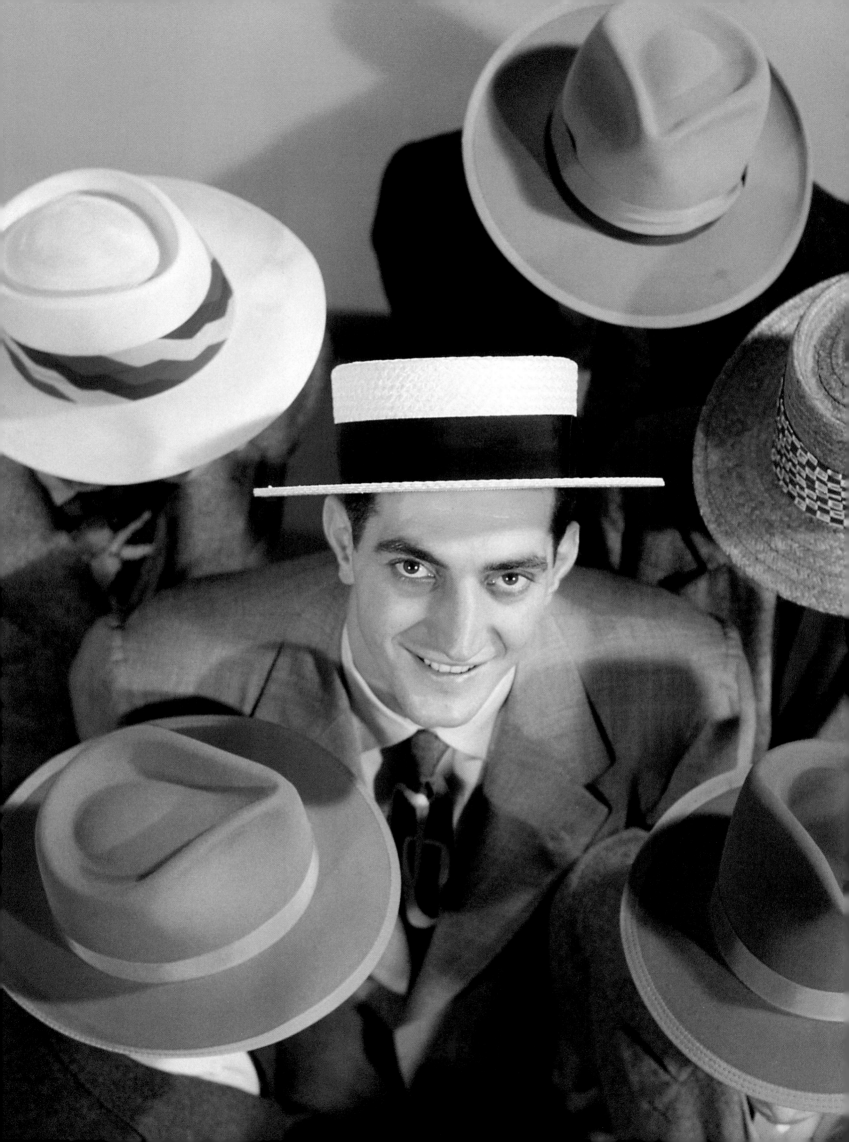

OPPOSITE: Ralph Branca dons some gay apparel

RIGHT: That's boxer Rocky Graziano with packages and a pooch.

261

That's water skier Nancy Rideout at left (barefoot!), and above, way above.

She was the star of the troupe at Cypress Gardens in the early 1950s.

FOLLOWING PAGES 264-265: These skiers and bathing beauties present a stunning tableau at world-famous Cypress Gardens.

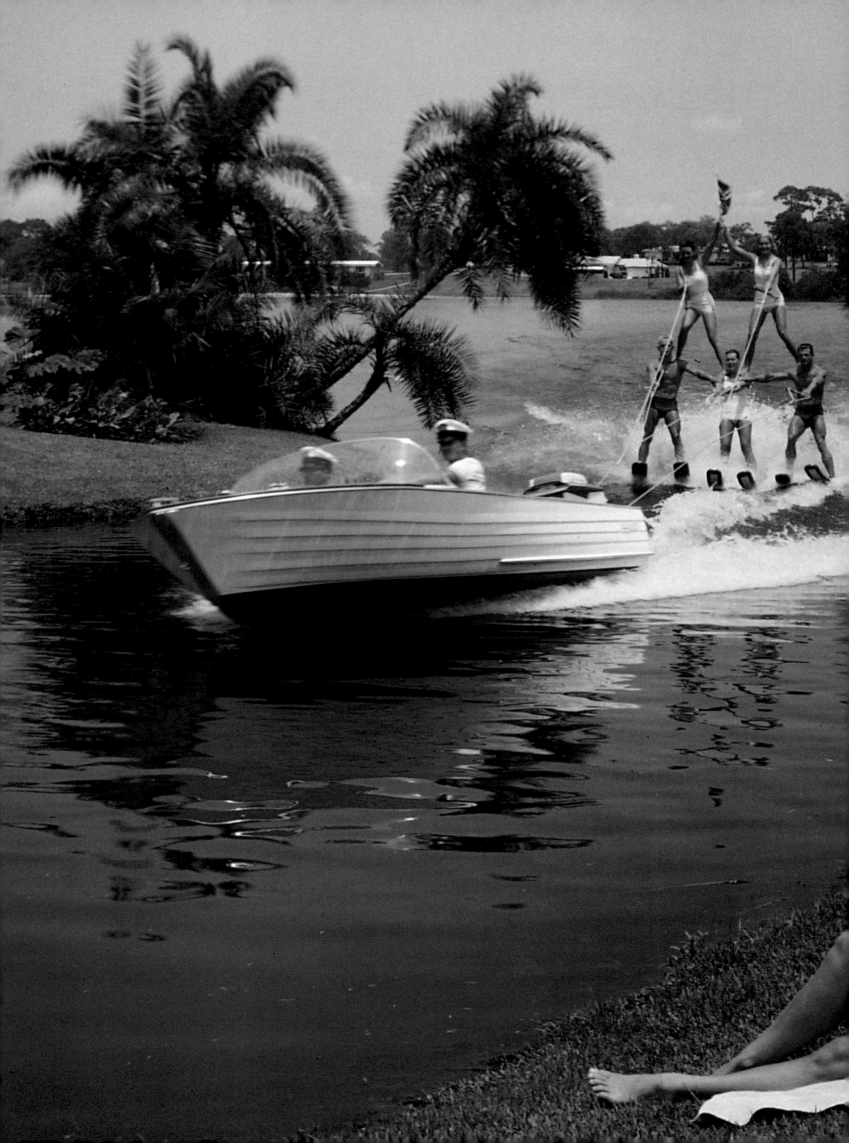

Index

Note: A page number in **bold italics** indicates a photograph.